LIVING ARTISTS

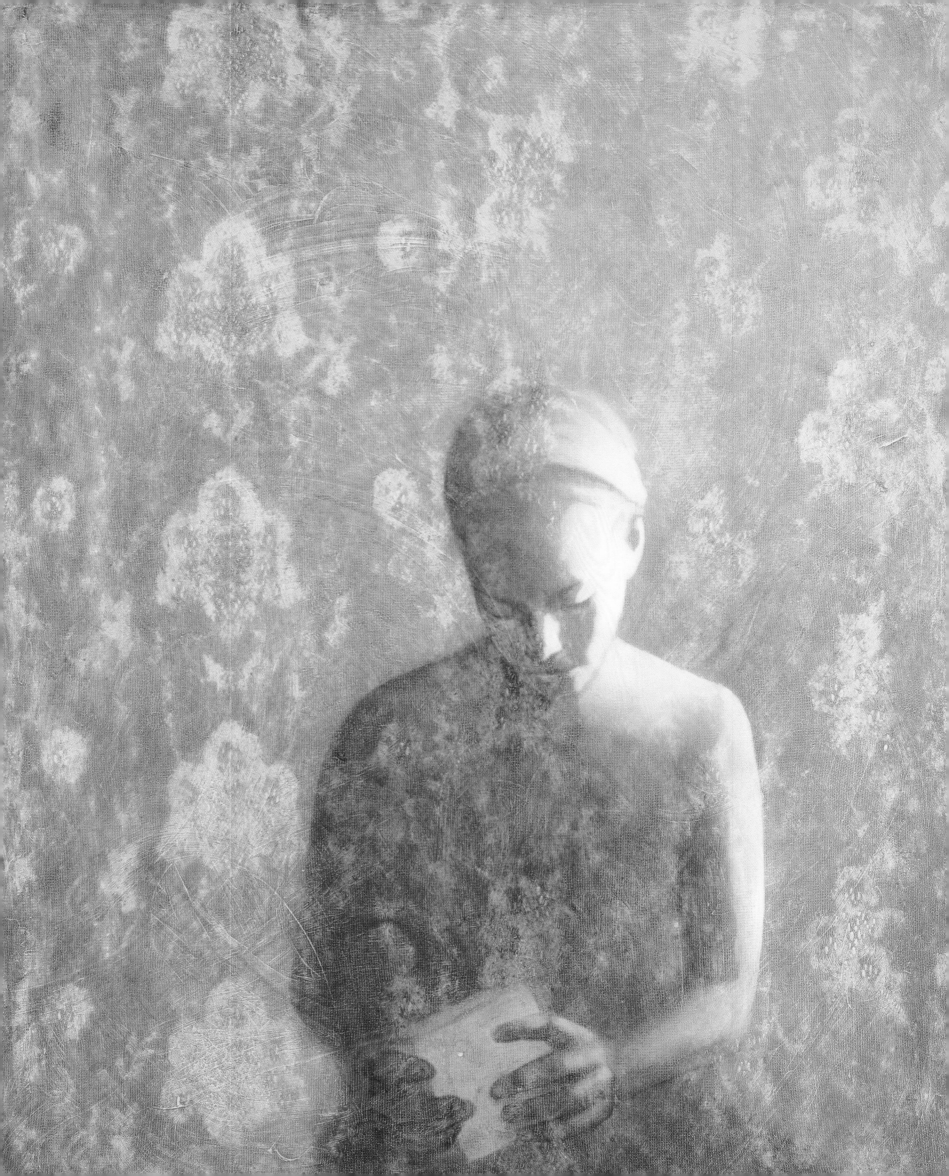

LIVING ARTISTS

Ivy Sundell

CROW WOODS PUBLISHING

Published by: Crow Woods Publishing
Post Office Box 7049
Evanston, IL 60204
crowwoods1@netscape.net
http://www.crowwoods.com

Printed in Singapore.

Publisher's — Cataloging-in-Publication Data
Sundell, Ivy.
 Living Artists (Includes 3D Images) / Ivy Sundell.
 p. cm.
 ISBN 0-9665871-3-8 (pbk.) ISBN 0-9665871-4-6 (hc.)
 1. Artists—Illinois. 2. Art, American—Illinois. 3. Art, Modern—21st Century—Illinois. I. Title.
 N6535 2004
 709'.2'2

Library of Congress Control Number: 2004095247

FRONTISPIECE:
Gift
Susan Hall, 2003, Oil on Panel, 50"h x 38"w
(also used in the background of the group montage on the front and back covers)

CONTENTS

3D-VIEWING SECTION

ACKNOWLEDGEMENTS

The conception of the 3D approach in this book is credited to Curt Frankenstein, an artist featured in *Art Scene: Chicago 2000*. He approached me with the stereoscopy of two of his works, and was delighted that the imagery 'enhanced his work'. I also met with his photographer, Gerry Hoos, who shared equal enthusiasm about anaglyph 3D work.

I am also indebted to the following people for the success of this book, plus many others not listed here:

Jurek Polanski, who reviewed the exhibitions of many artists from my prior art books, met with me to discuss jury selection.

Margarete Gross, formerly with the Harold Washington Library, and Bert Menco each provided me with an exhaustive list of artists they would recommend.

Colette Cooper of Wilmette Art Guild and Valerie Niskanen of North Shore Art League both lent me slide projectors.

Frank Crowley of Windy City Arts who made calls to artists on my behalf.

Artists, art leagues and art schools that passed out the Call for Artists, and artists and art galleries that responded.

Beth Caldwell who helped me with Photoshop and production issues.

Gail Drozd who gave me many of the design suggestions I implemented.

Bunny Zaruba for reviewing the design once again. She had reviewed the design of all my prior books.

Gerald Hoos of International Photo Corporation, Skokie, Illinois for 3D consultation. (Gerry has the capabilities to shoot high resolution digital files for limited edition reproductions of fine art, thus providing a true matching of the original image.)

CREDITS

(based on names of photographers submitted by the artists)

Photos of the Artists:
Trine Bumiller's by David Naylor
Barbara Cooper's by Eileen Ryan
Mr. Imagination's by Link Harper
Bruno Surdo's by Saverio Truglia
Charlie Thorne's by Robert Kameczura

Photos of the Artwork:
Barbara Cooper's by Eileen Ryan
Mr. Imagination's on the lead-in page to the Artists section by Robert A. Alter
Mr. Imagination's on the 2-page spread by William H. Bengtson

3D Work:
All 3D work except Chidester's, Culver's and Wiens' conversions was done by Gerald Hoos.
Sean Culver provided his own stereopairs.

INTRODUCTION

The impetus of this book is to excite the public about living visual artists who are here among us. Many of these artists are recognized by the art world. However, unlike artists in the music, theatre and movie professions, they are largely unknown to the public. When pressed to name a few artists, inevitably one would think of Picasso, Monet, Chagall, Gauguin, Sargent, etc., all of whom share one characteristics—they are long deceased. I even know a few older artists who feel that the only way they will become known is to leave a legacy after their death.

There are many advantages to recognizing artists while they are alive. Like other art professions, visual artists can be commissioned to produce work tailored to individual taste, needs and budget. Other than paintings and sculptures that are already completed, artists may be asked to paint portraits, create artwork for a particular space, paint murals on the walls and ceilings of residential homes and commercial properties, and create art for a myriad of other applications. For example, if you read the pages featuring Mr. Imagination, you will find that art collectors, Robert Alter and Sherry Siegel, work with the artist to arrive at the artwork they want. That is essentially the beauty of working with a living artist. The artwork, then, is not just what the artist creates, but what can be customized for us.

While this book features artists who exhibit in Illinois, I am increasingly aware that artists are not bound by geographic locations. They are more likely than the rest of the population to spend a length of time in all corners of the world in residencies and workshops. Even their vacations often include art creation time. As you go through the book, you will notice that some of the artwork featured were produced while away from home. This phenomenon allows us to stay at home yet partake in cultural exchanges that artists have internalized into their work.

To examine the fluidity of the selected artist group, I have included a column in the Directory listing where they grew up and where they may have moved to after their stay in Illinois. If you count the number of true native Illinois residents, you will find that only one third of the artists grew up in Illinois and are still here. That means two-thirds of those we call Illinois artists either came from out of state or have moved out of state since. A few of them even live in two states, or in a state and a foreign country for parts of the year.

Finally I want to demonstrate that visual art can also be a form of entertainment. The 3-dimensional viewing section is produced with the intention of making the viewer want to learn more about the artists. Please see these artists' work on their featured pages in the Artists section. The artist statements are also made succinct as if to engage the artist in a brief interview. The next best thing to reading this book, of course, is to get to know the artists yourself. To initiate the contact, you can use the Directory at the back of this book to call or email the artists or their galleries, or simply check out their web sites.

Enjoy!

JURORS

The jurying is based on rankings of submitting artists' originality, technique, composition and emotional appeal. Out of 262 entries, 59 (including 2 sets of collaborating artists) were selected for this book. While names of submitting artists and their biographies were withheld from the jurors, it should be noted that many artists' work were immediately recognized by one or more of the jurors, who frequent the art galleries.

John Brunetti is a Chicago-based critic, curator and educator. He has been writing on contemporary art since 1989. Presently he contributes reviews to *dialogue* magazine and is the author of the book, *Baldwin Kingrey: Midcentury Modern in Chicago.* In addition to writing on art, Brunetti is the curator for the Evanston Art Center, Illinois and teaches art history and studio art at Columbia College in Chicago and Northeastern Illinois University.

Exhibitions at the Evanston Art Center Brunetti curated include *Alterations: The Body/Identity Revealed* (2003), with custom-made clothing that reflect the desires and insecurities of both the wearer and the observer; *Remembrance* (2003) featuring four artists who record and reveal the deeply embedded cultural beliefs that shape our identities; *In the Material World* (2002), which questions boundaries between internal and external spaces, and between art and life; *Lost and Found: Collage and Assemblage* (2001); and *The Memory of Place* (2001), a landscape exhibit that investigates the complexities of recording the true physical world.

Dominic Molon is Associate Curator at the Museum of Contemporary Art, Chicago, where he has curated numerous projects including major exhibitions of Paul Pfeiffer (2003), Gillian Wearing (2002), Sharon Lockhart (2001) and Mariko Mori (1998); solo projects with Tobias Rehberger (2000), Eija-Liisa Ahtila (1999), Steve McQueen (1996), Pipilotti Rist (1996), and Jack Pierson (1995); and the group exhibition, *Out of Place: Contemporary Art and the Architectural Uncanny* (2002). He recently co-organized a major rehang of the MCA Collection titled *Strange Days* with MCA Associate Curator, Staci Boris. Molon is currently working on a major retrospective of the American artist, Richard Prince for 2006.

Molon has contributed to numerous publications including *Art on Paper, Trans, Flash Art Italia, Tate: the Art Magazine,* and the *New Art Examiner.*

Marianne Richter has been the curator at the Union League Club of Chicago since 1995. She is responsible for the care, research, presentation, and development of the Club's art collection, which includes over 770 works. She was the curator of *Chicago Artists in the New Millennium,* an exhibition held at the Club that featured work by 23 Chicago artists. She was the co-curator of *Here and Now,* an exhibition co-organized by the Club and the Chicago Cultural Center in 2002, and *Out of Line: Drawings by Illinois Artists,* also co-organized by the Club and the Chicago Cultural Center. In 2003 the Union League Club of Chicago published a catalog of its art collection, *Union League Club of Chicago Art Collection,* which she co-authored.

Richter is a doctoral candidate at the University of Illinois at Chicago. Before moving to Chicago, she was the curator of American art at the Dayton Art Institute in Ohio. Her Master's degree in art history is from the University of Delaware.

3-DIMENSIONAL VIEWING

The readers are invited to put on the 3D glasses provided at the back of this book to enjoy this section. All the images shown are the works of artists featured in this book.

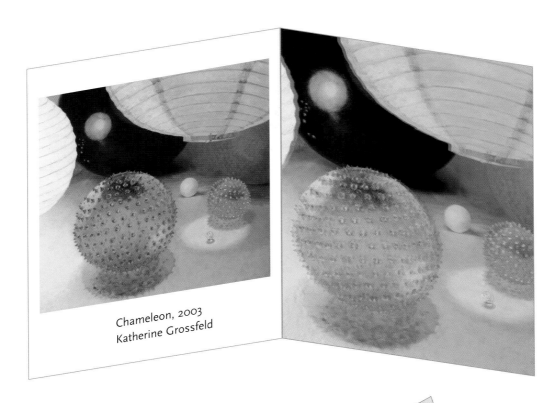

Chameleon, 2003
Katherine Grossfeld

The left side of the spread shows the original work of the artist.

The right side of the spread shows a detail of the same image that has been manipulated to allow 3-dimensional viewing with 3D glasses.

Tips: Make sure you are seeing through the cyan lens with your right eye and the red lens with your left eye. Take your time looking through the glasses. Some aspects of the 3D that may not 'pop' immediately will become evident upon inspection.

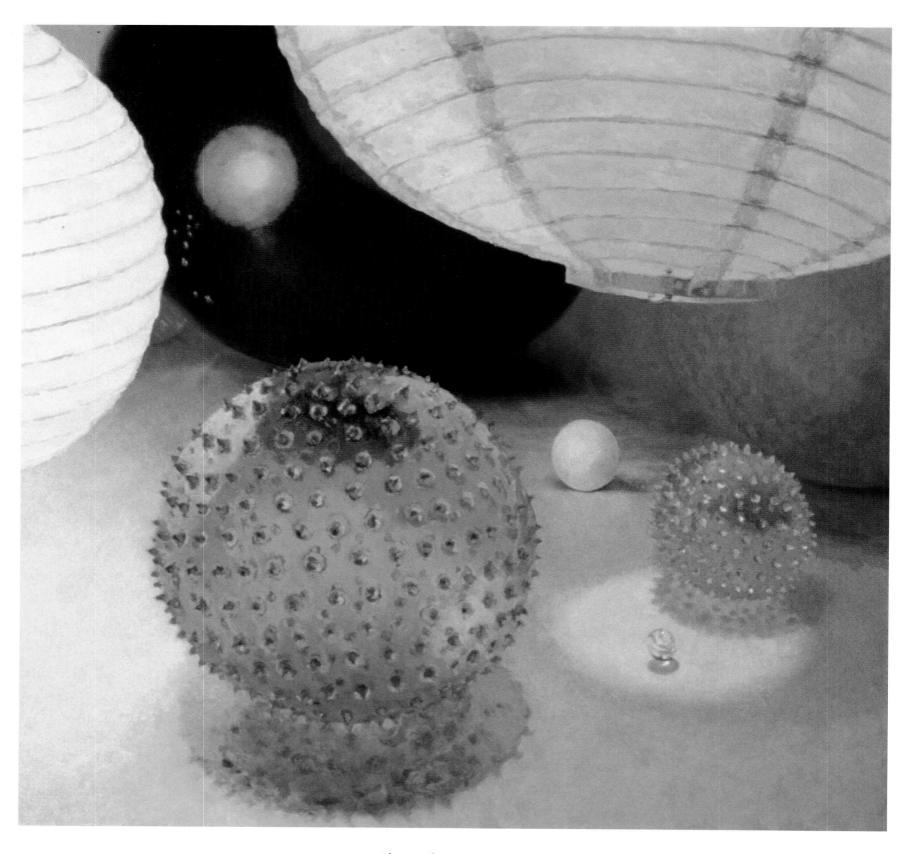

Chameleon, 2003
Katherine Grossfeld
Oil on Panel
18"h x 19"w

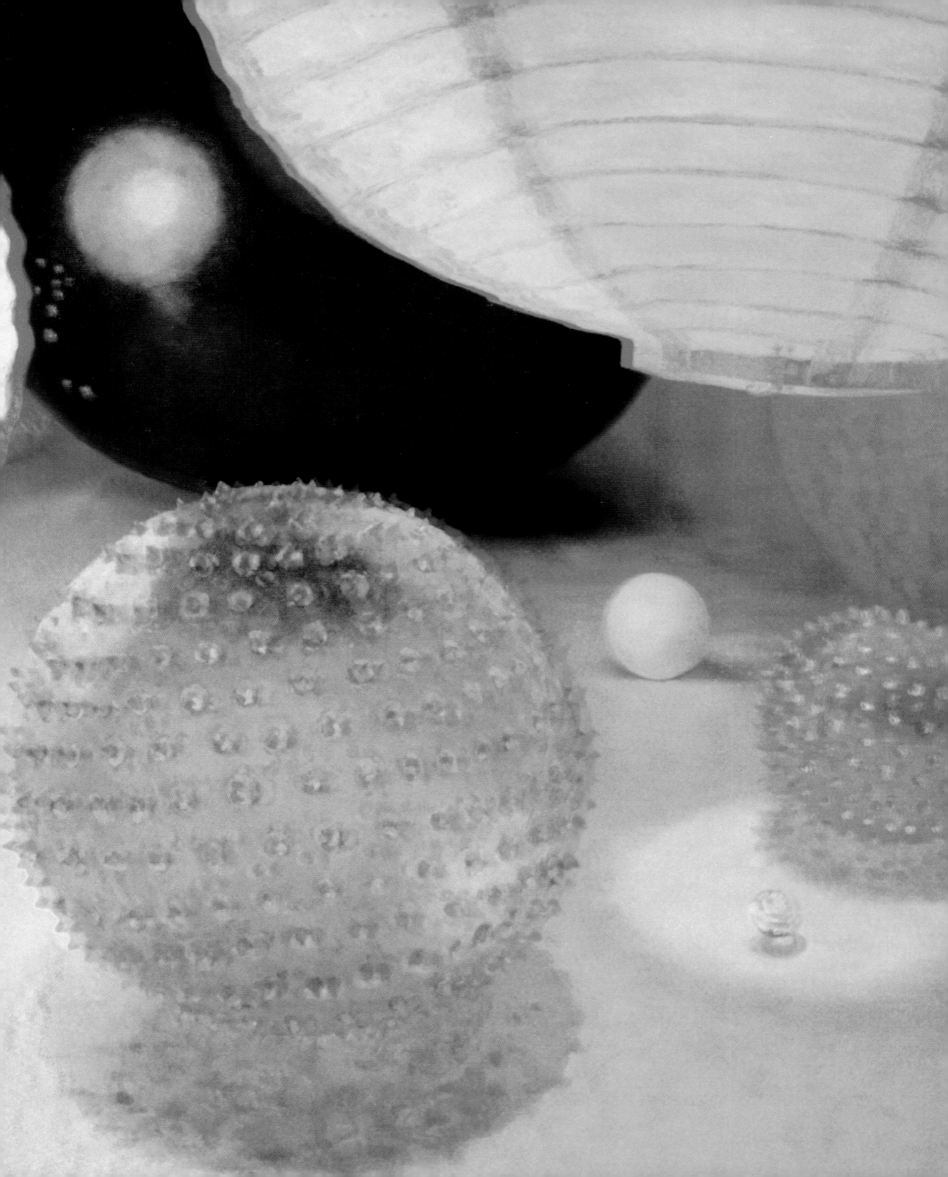

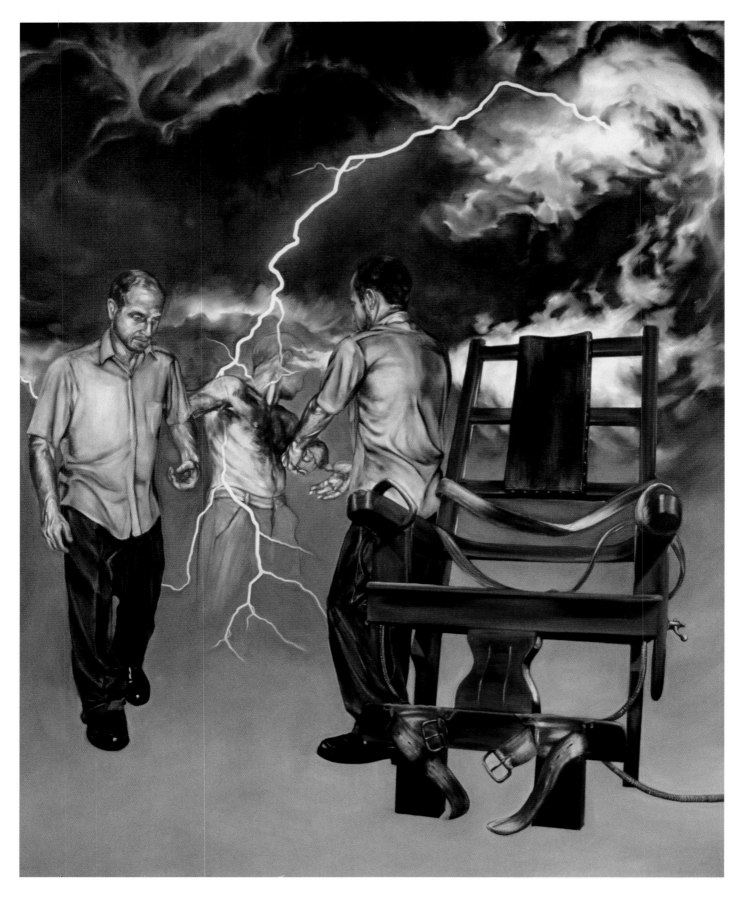

Conviction, 2003
Julie Comnick
Oil on Canvas
87"h x 72"w

"This piece examines how a victim of capital punishment is perceived in anticipation of his execution."

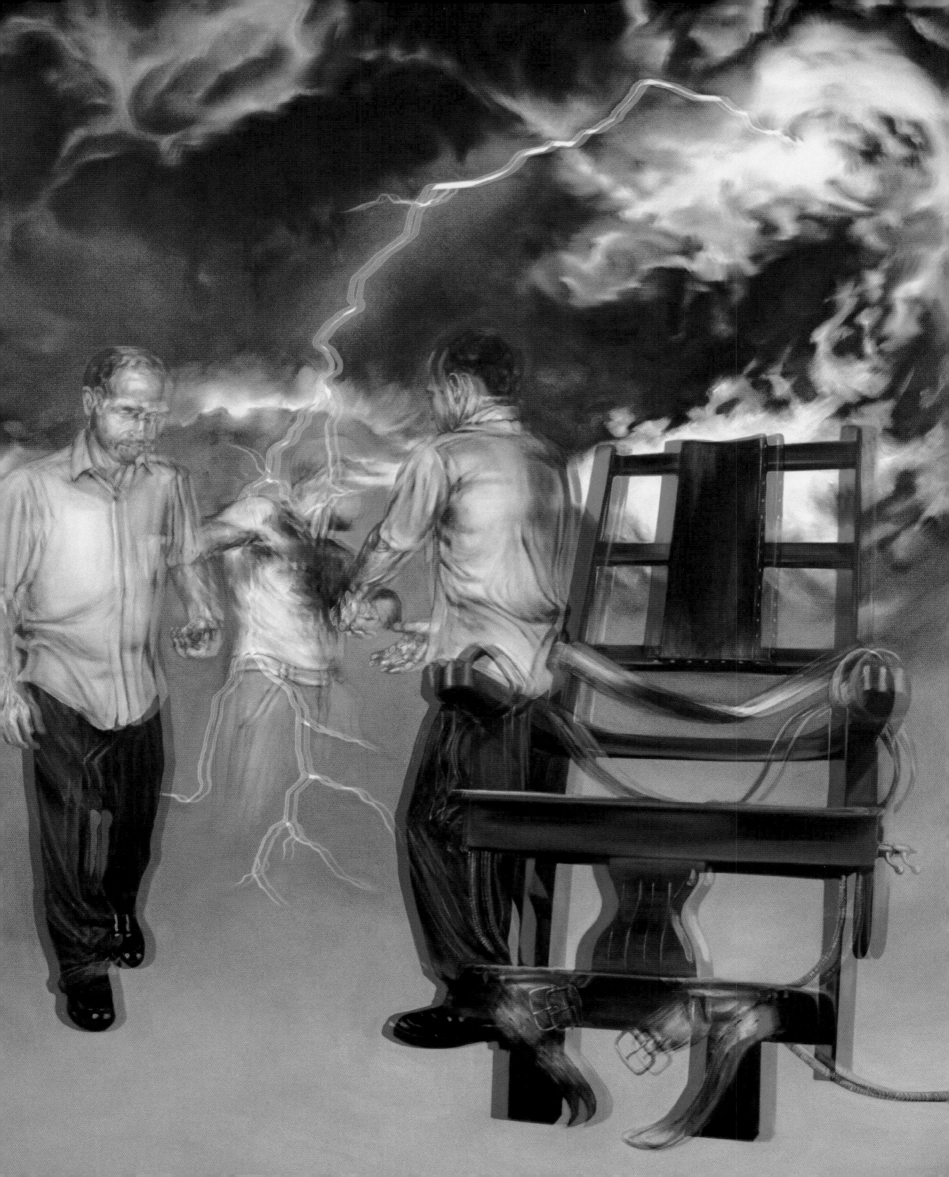

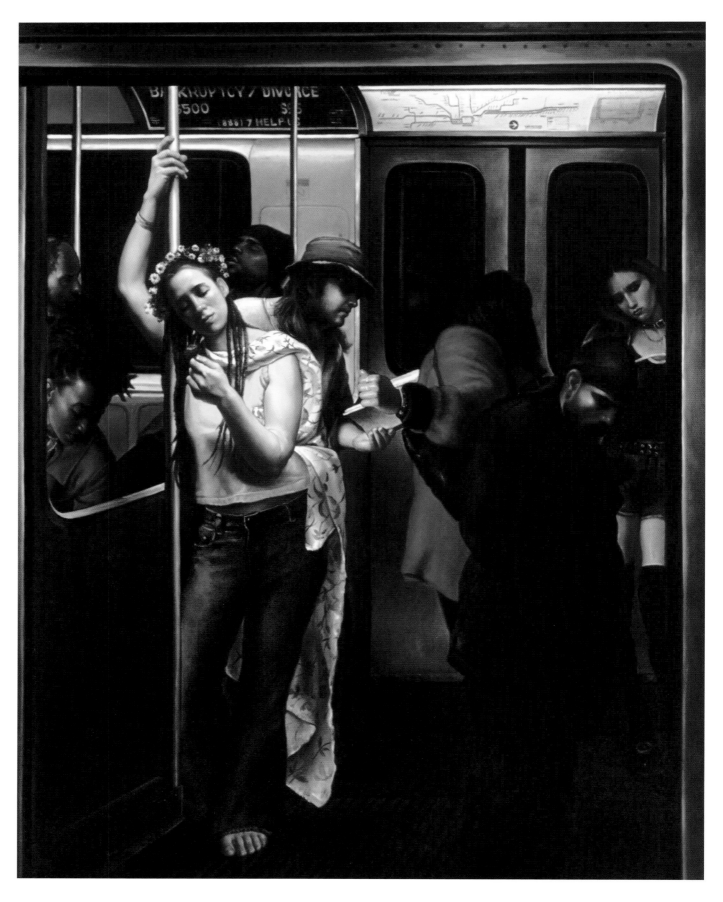

Flora of the Subway, 2000
Bruno Surdo
Oil on Canvas
72"h x 60"w

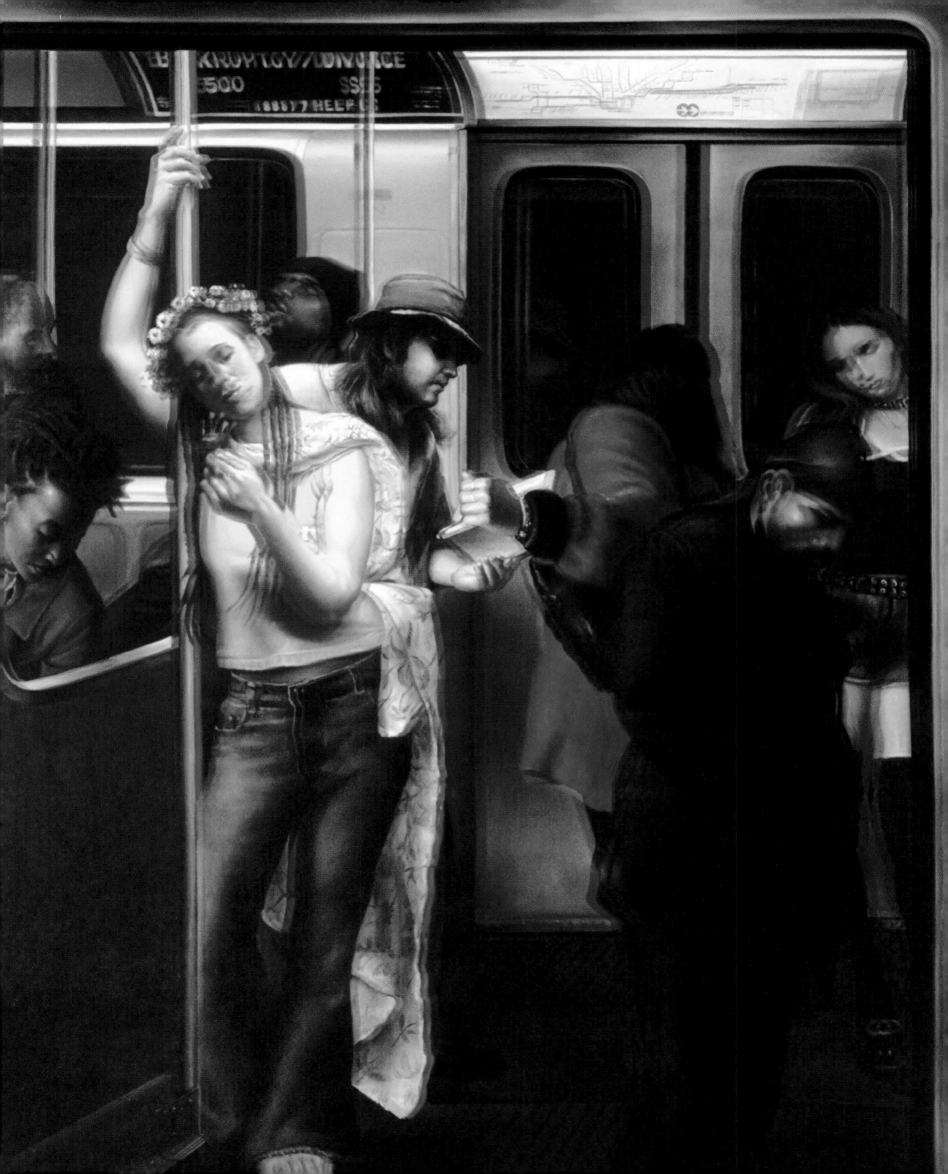

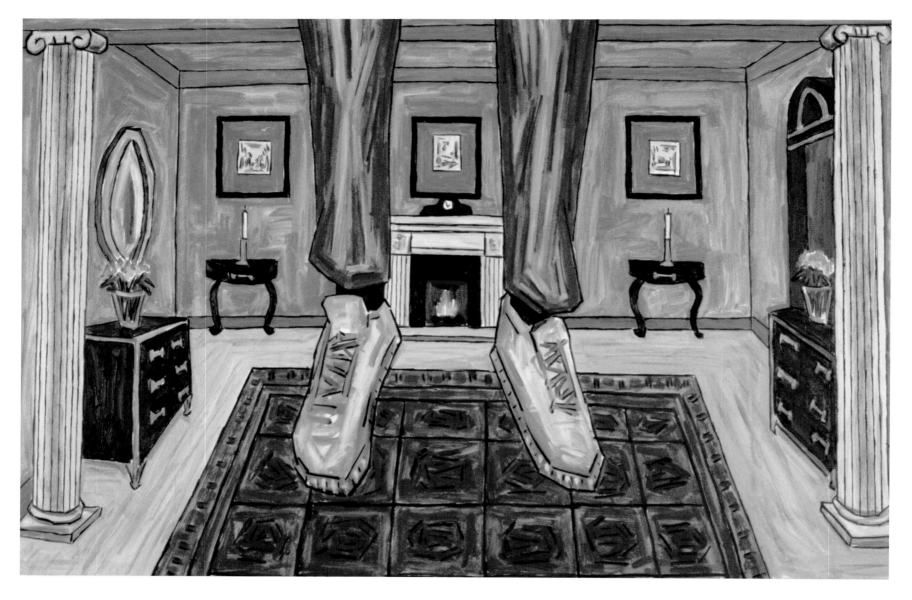

Hell, 2002
Geoffrey Bent
Oil on Canvas, 24"h x 36"w

"Contrary to tradition, hell is viewed here not as a torture chamber but as a luxurious mansion. The dangling feet in the foreground imply a hanged figure. His sneakers and jeans are at variance with the formal surroundings. The oppressive symmetry of the décor seems all the more ominous. Hell is most inescapable when it is a state of mind."

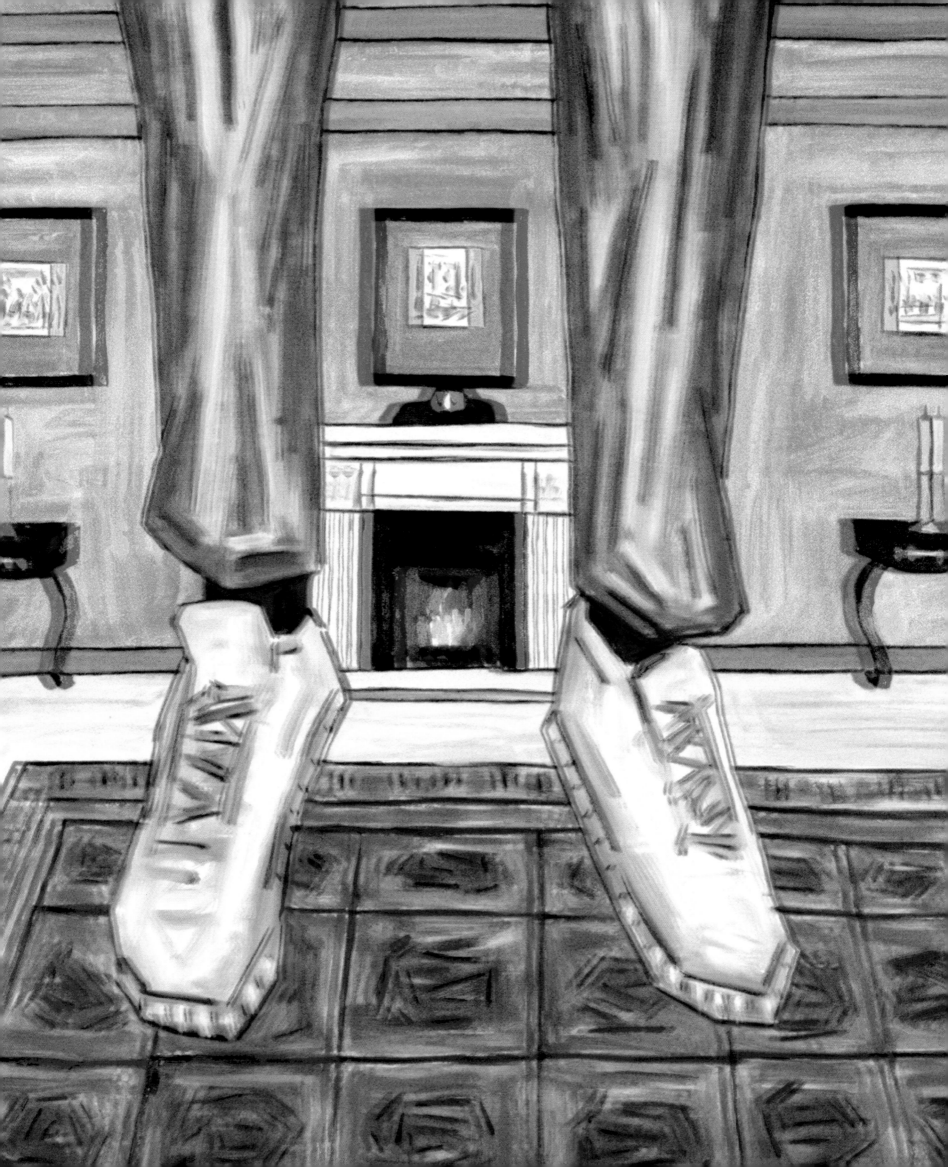

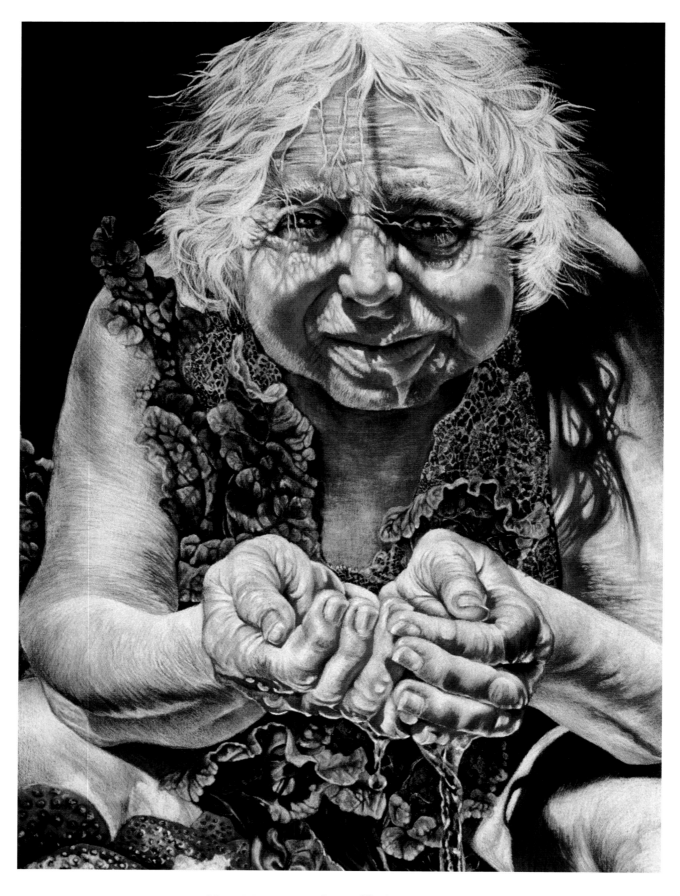

Hot Mama I, The Offering, 2002
Cynthia Hellyer Heinz
Colored Pencil on Black Paper,
30"h x 22"w

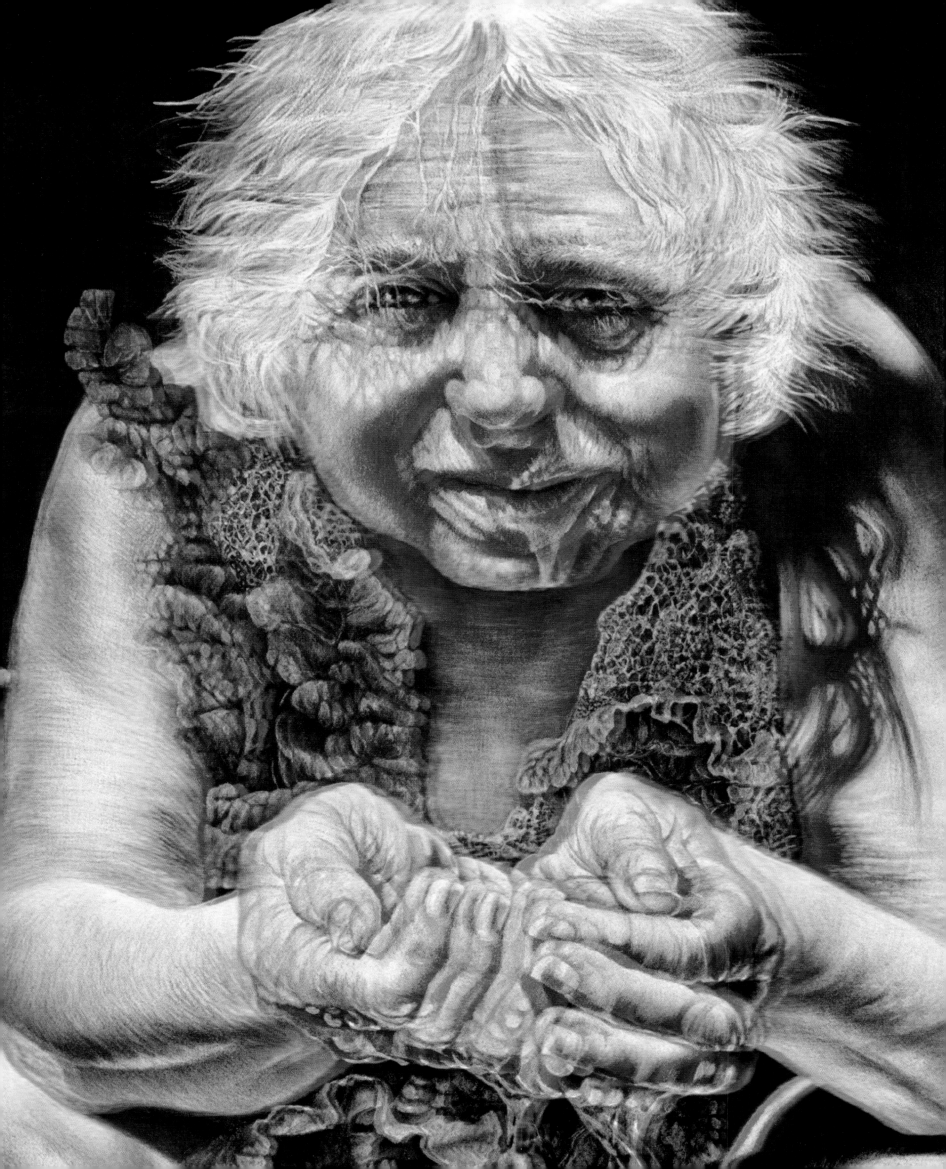

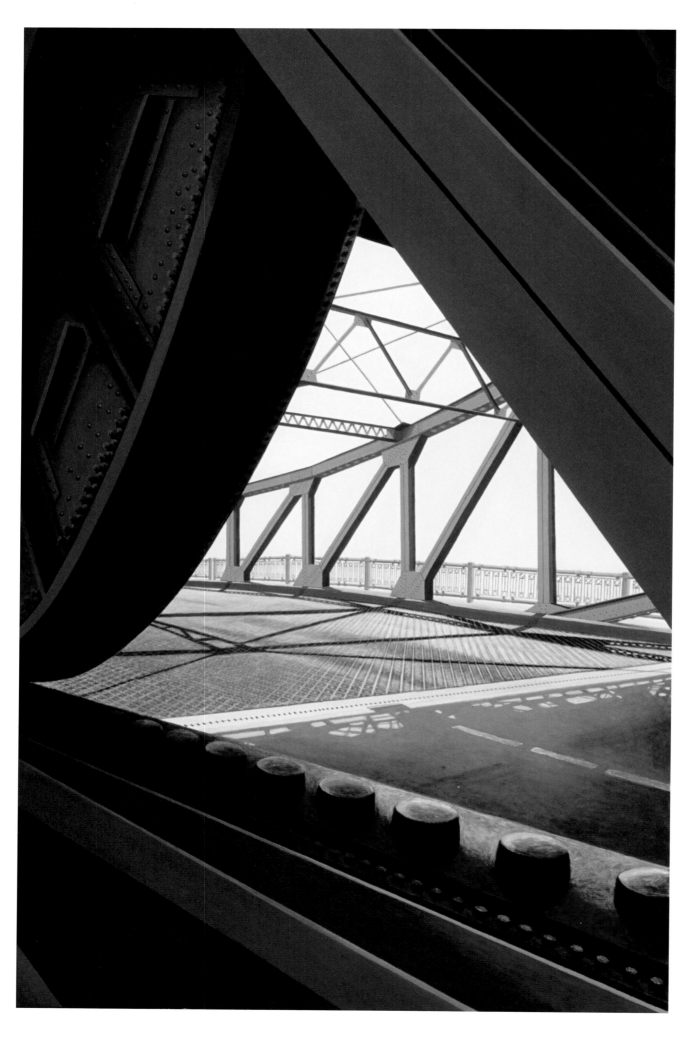

Joliet II, 2003
from the *Nuts and Bolts*
series
Roland Kulla
Acrylic on Canvas
60"h x 40"w

"This is one of the Des
Plaines River bridges in
downtown Joliet."

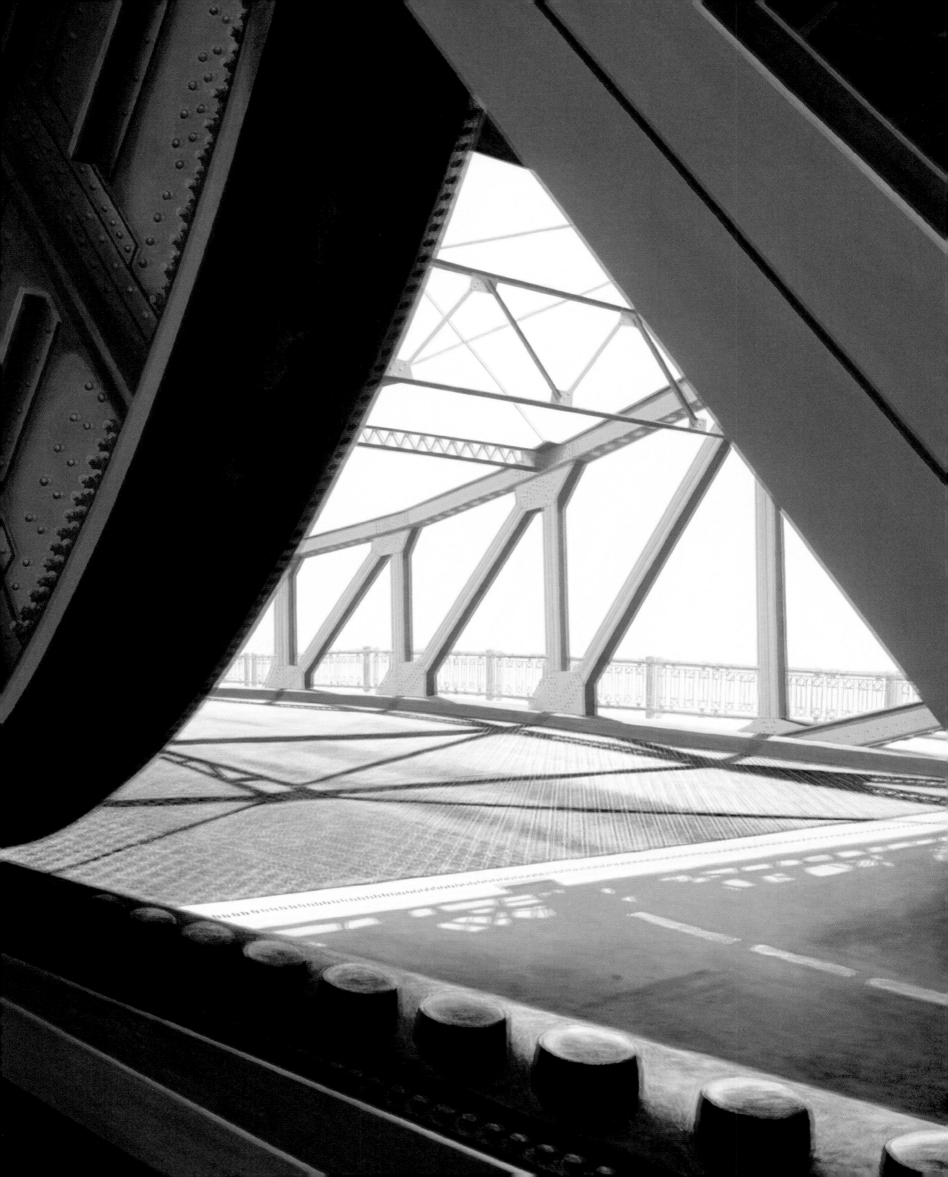

Landscape with Spinocerebellar Degeneration, 2002
Sean Culver
Wood, Found Objects, Glass, Transparencies, Plexiglas, Light Fixtures, Twigs, Styrofoam, Paint
78"h x 33"w x 43"d

"This work is essentially about my maternal grandfather who died of Parkinson's disease. He hand-built his own home. He formed it outwardly from a boxcar he had hauled from his work as a railroad maintenance worker. The finished house sat on top of a steep hill in a clearing of timber near Galesburg, Illinois.

This work represents the mind as inseparable from home and as the cradle of manufactured things and cultivated environments. Its individual environments represent the relationship between constructed things and the deterioration of both the mind and its resulting creation."

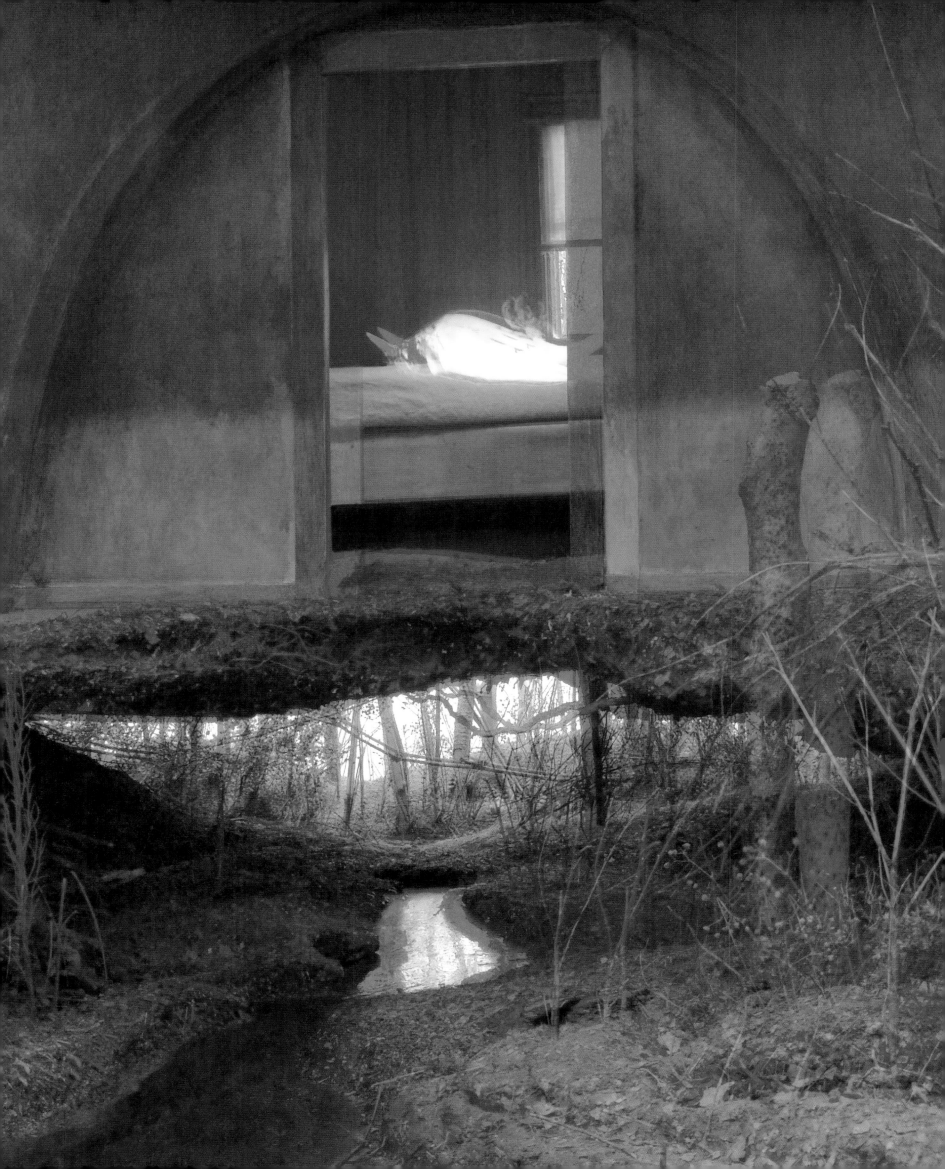

Trails, 1997
Paul Chidester
Egg Tempera on Panel
11$\frac{1}{2}$"h x 29$\frac{1}{2}$"w

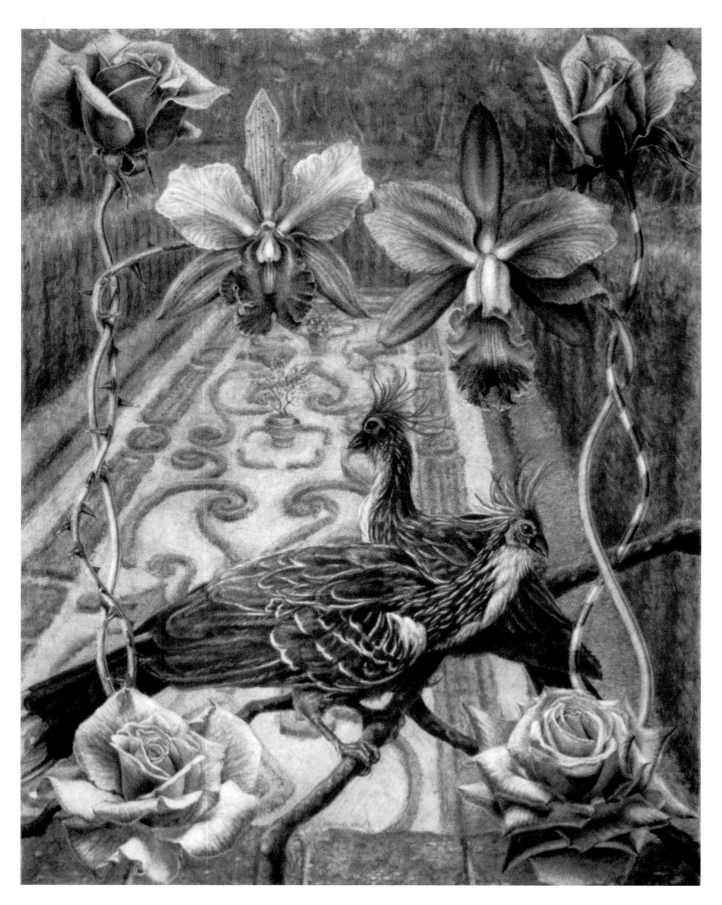

Vista, 2002
Curtis Bartone
Graphite on Paper
20"h x 16"w

"In this composition, South American Hoatzins, wild and prehistoric in nature, occupy the foreground while a cultivated version of nature—a walled Italian garden, occupies the background. A common thread in much of my work is how even what once would be considered the 'natural' world is now controlled by human beings. Wildlife refuges have, in essence, become large gardens. Nowadays we frequently see land being 'reclaimed'."

Zebra, 2001
Ann Wiens
Oil on Panel, 14$\frac{1}{2}$"h x 14"w

(opposite)

Standing Tall

2002

Mr. Imagination

Tree Limbs, Copper, Plaster, Wood
Putty, Bottle Caps, Broom
79"h x 34"w x 13"d

"The legs are made from a real tree.
What is so special about this piece is
that it was made here in the backyard
of my new home in Pennsylvania."

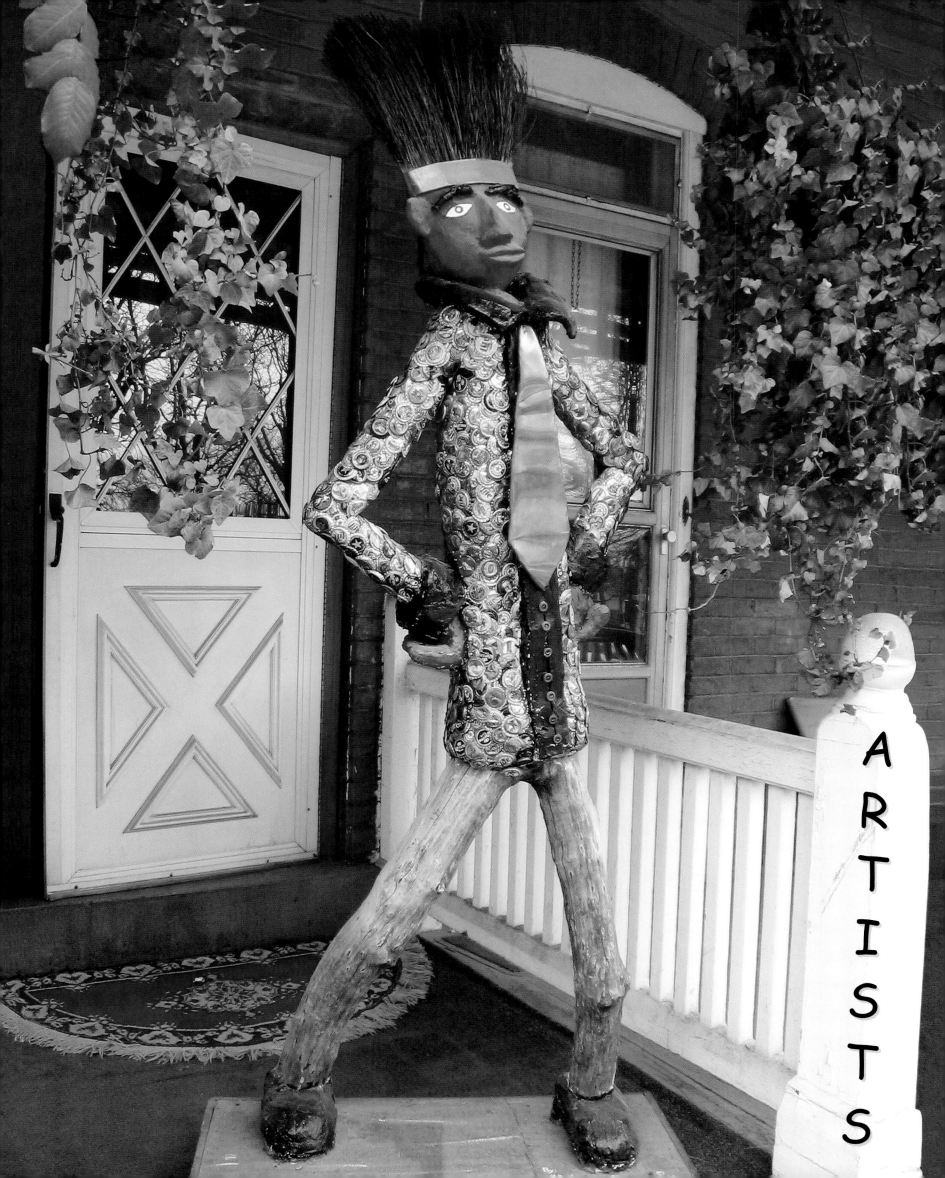

ARTISTS

 MAUREEN O. BARDUSK

Lagoon, 2002
Sheer Paper, Painted, Multiple Layers Stitched
Free Motion with Machine, Embroidered by Hand
18"h x 18"w

"One of a series of works focused on what lives above and below the surface, how each affects the other, and how our response determines the value of the ecological terms."

(above) **Sea View,** 2002
21"h x 40"w, 4 panels
Sheer Paper, Painted, Multiple Layers Stitched
Free Motion with Machine, Embroidered by Hand
(below) **Sea Map 1,** 2003, 9"h x 9"w

"A meditation on the constantly and quickly changing sea, a mesmerizing experience viewed from my studio window in Newfoundland. Shaping daily life for generations, the collapse of the cod industry has forever changed the dynamics of this powerful force."

Maureen Bardusk grew up in Chicago, and has been teaching since 1997. She has taught at Northwest Cultural Council's *Kids Meet Art* program, Harper College, Evanston Art Center, Hinsdale Center for the Arts, Elmhurst Art Museum, and State of Illinois Museum. She was the Co-Director of *Natural Wonders 2002 and 2003* in Jo Daviess County, Illinois and the Instructor/Presenter of the *Wild by Design Symposium* at the International Quilt Study Center in Lincoln, Nebraska in 2003. She has received 5 fellowships for Visual Arts Residency from the Ragdale Foundation; a recent residency was at Pouch Cove, Newfoundland, Canada. Maureen has written articles for the Studio Art Quilt Associates, and the *Art/Quilt Magazine* since 1997. She is represented by Vale Craft Gallery and Illinois Artisans Shop in Chicago; City Woods in Highland Park, Illinois; Studio Works in Elizabeth, Illinois; Green Lantern Studios in Mineral Point, Wisconsin; and Gallery 323 in Madison, Wisconsin.

BARLOW

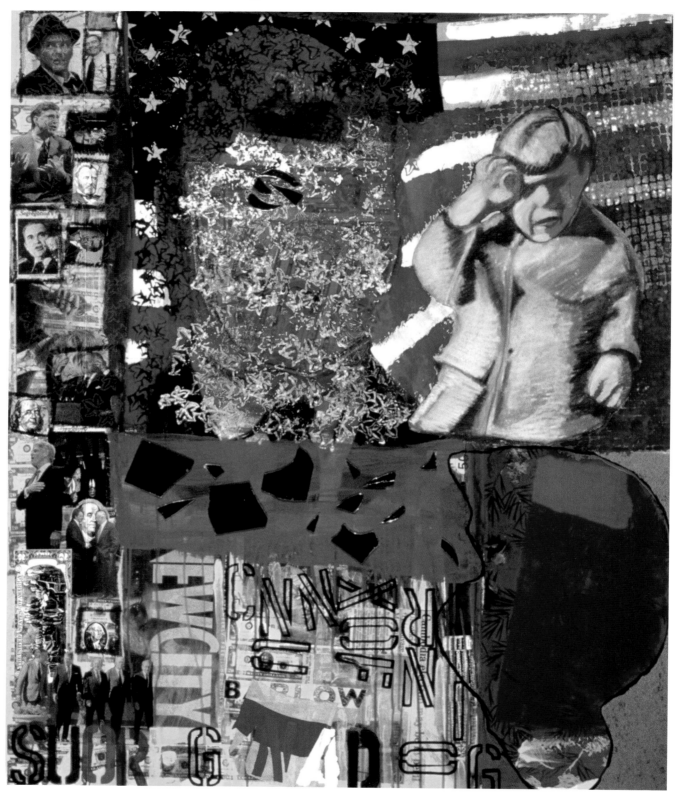

Dangerous Decisions: Y2K, 1999
Collage Painting with Mirror
42"h x 36"w

"This collage painting reflects the state of affairs we find ourselves in at the onset of a new century: the chaos of world affairs, disbelief in our cultural and political leaders and the uncertainty of tomorrow."

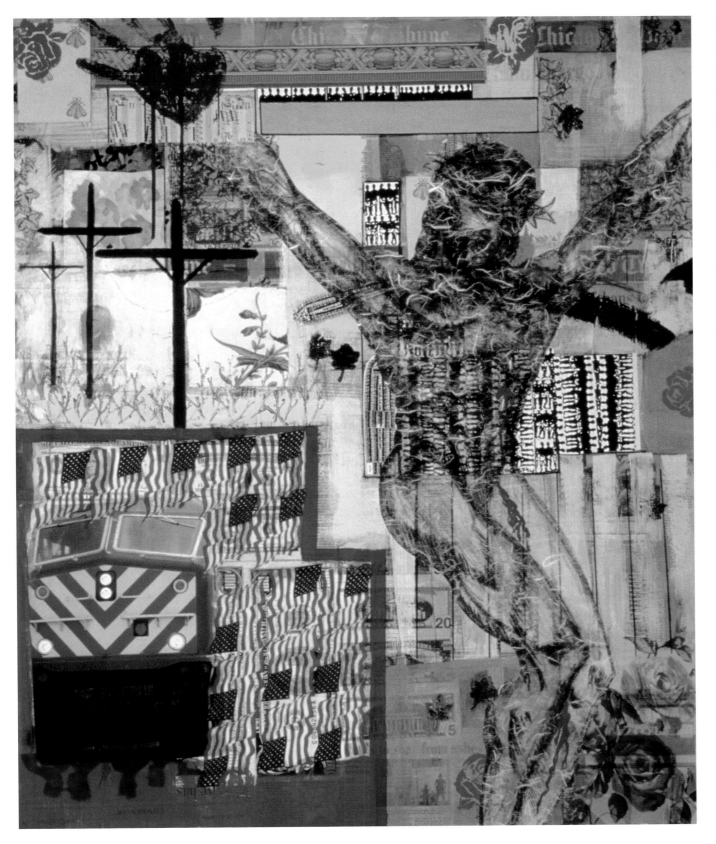

You Continue to Shed Blood for Me, 2002
Collage Painting
42"h x 36½"w

"This addresses power issues: the power of the Spirit, the power of money, the power of a mighty nation, and the power of the belief I have in Christ."

Michael Barlow goes simply by Barlow. He received his Bachelor of Fine Arts from Indiana University, and his Master's degree from The School of the Art Institute of Chicago. He has studied overseas in Florence, Italy and Port-Au-Prince, Haiti.

Barlow has been teaching at The School of the Art Institute of Chicago since 1988. He also teaches at Depaul University, Harper College, Marween Arts Foundation, Columbia College, and the Museum of Contemporary Arts in Chicago.

Barlow has volunteered at various programs for children and for the needy. For several years, he volunteered at the Children's Memorial Hospital and the Cook County Children's Hospital in Chicago. Recently he volunteered for the *Feed the Needy* program in Gary, Indiana. He is represented by Nicole Gallery in Chicago.

 CURTIS BARTONE

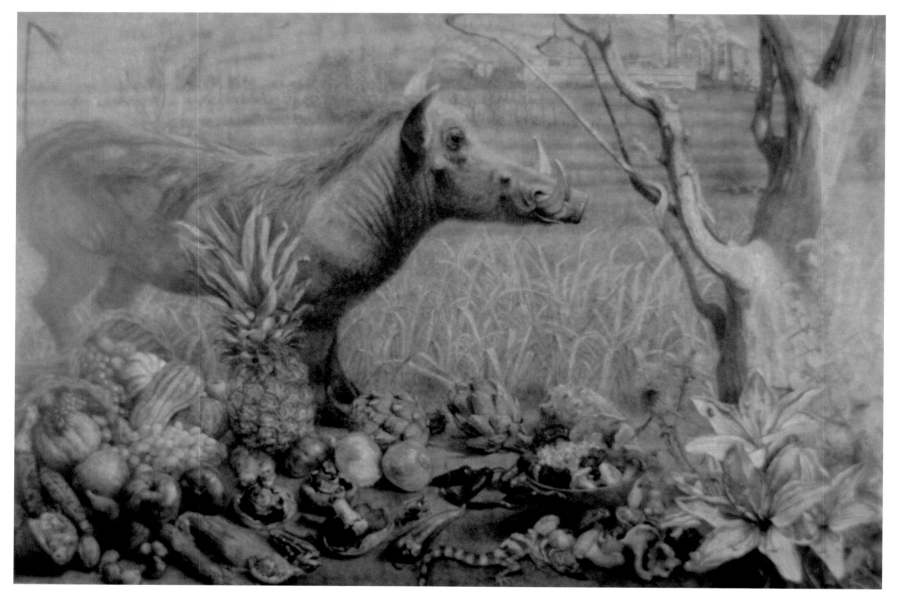

Earth from the *Elements* series
2002
Graphite on Paper
40"h x 60"w

"This is the first in a series of large drawings about the four elements: earth, water, air, and fire. In this drawing, the objects depicted are closely related to the earth: a cornucopia of harvested produce, a warthog that digs into the earth, factories that turn trees into paper. I place objects in the same composition that shouldn't be together—animals and plants with man-made objects from different parts of the world. Much of the background here, including the paper mill, exists in Savannah, Georgia."

Iktomi, 2002
Graphite on Paper
20"h x 16"w

"The dangling spider is Iktomi, the trickster spider in the Sioux Native American folklore. The background image is a recently-burnt, still-smoldering section of a South American rainforest into which cattle are already being placed. The lush foreground growth represents, in contrast, the hope that eventually the destruction will be remedied by nature reasserting itself."

After receiving his Bachelor of Fine Arts degree from Columbus College of Art and Design in Columbus, Ohio, Curtis Bartone moved to Chicago. In the 12 years in Chicago he graduated from Northwestern University in Evanston, Illinois, with a Master of Fine Arts degree and established himself in the area as well as nationally. He moved to Savannah, Georgia in 2001. Bartone has had solo exhibitions in galleries, such as Byron Roche Gallery and Anchor Graphics Gallery, both in Chicago and Gallery KiQi in Brunate, Italy (2004); art centers such as the Evanston Art Center; universities such as the University of Illinois at Chicago, the Millikin University in Decatur, Illinois, University of Minnesota at Morris, and San Joachin Delta College in Stockton, California; and art museums such as the Erie Museum of Art in Pennsylvania and the Elmhurst Art Museum in Illinois. The Elmhurst Art Museum exhibit in 2000 was a retrospective covering 10 years of his work. He is represented by Byron Roche Gallery in Chicago.

CHRISTINE J. BASICK

"My work explores the parallel between life and games. It has become difficult to determine whether society created games or games are controlling society. I explore these issues through an abstract language."

Proball

2001

Oil, Wax on Canvas

60"h x 36"w x 2"d

"This painting was developed with a game format using the idea of pinballs as a basis. Choices in paths are offered and images of men running refer to life's current trend."

Forward One/Back Two, 2003
Oil on Canvas
36"h x 36"w x 2"d

"We learned to play in our youth. We started with simple, solitary games. Forward one, two, then finally 'home'. Time was abundant. Now society is obsessed with accomplishments that can be made in a short time. We no longer have the luxury of our youth."

Christine Basick is a freelance muralist. She studied at the American Academy of Art and received her Bachelor of Fine Arts from The School of the Art Institute of Chicago in 1991 and her Master of Fine Arts from University of Chicago in 1993. She has exhibited solo at Duke University in 2002, and has been in various group exhibits over the years. In 2001 and 2003 she was part of *Bare Walls,* an annual fundraiser at The School of the Art Institute of Chicago during which alumni create artwork to be auctioned at the end of the eight-hour day. In 2003 she had a residency at the Vermont Studios. That same year she exhibited at the *38th Annual Open National Exhibition* at the San Bernardino County Museum, the *Chicago Art Open* sponsored by the Chicago Artists' Coalition, and at State Gallery in Massapequa, New York. Her studio is in the Fine Arts Building in Chicago.

 GEOFFREY BENT

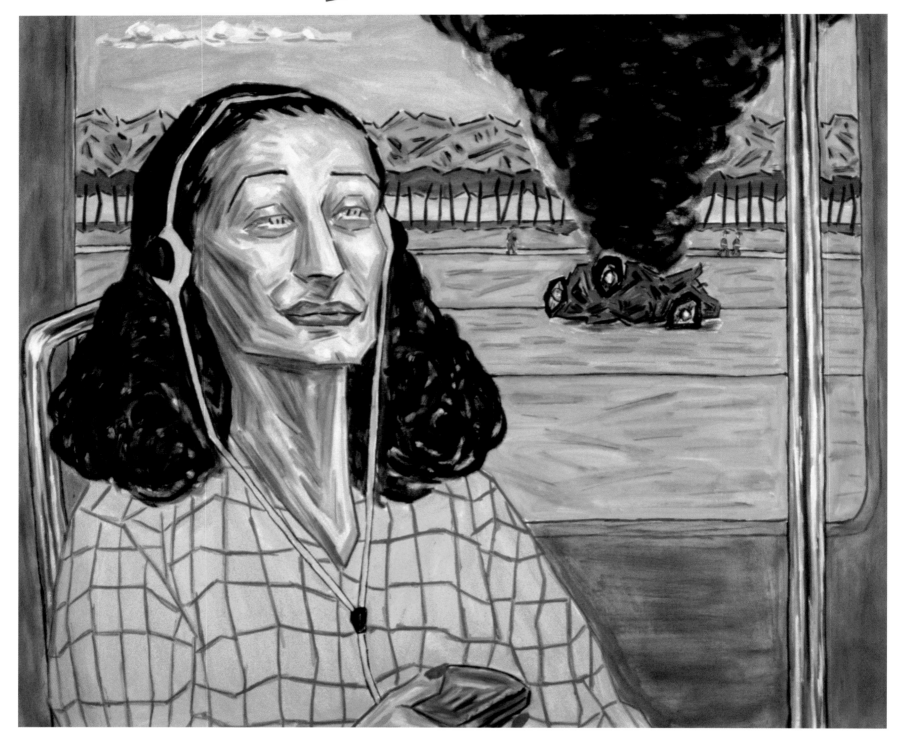

Detachment

2002

Oil on Canvas

30"h x 36"w

"The figure on the bus seems anything but detached as tears stream down her face in response to the music from her headset. But the car wreck she passes doesn't rate a glance. Like the joggers in the distance, she can ignore the disaster. Passionate absorption can be the most ruthless form of detachment."

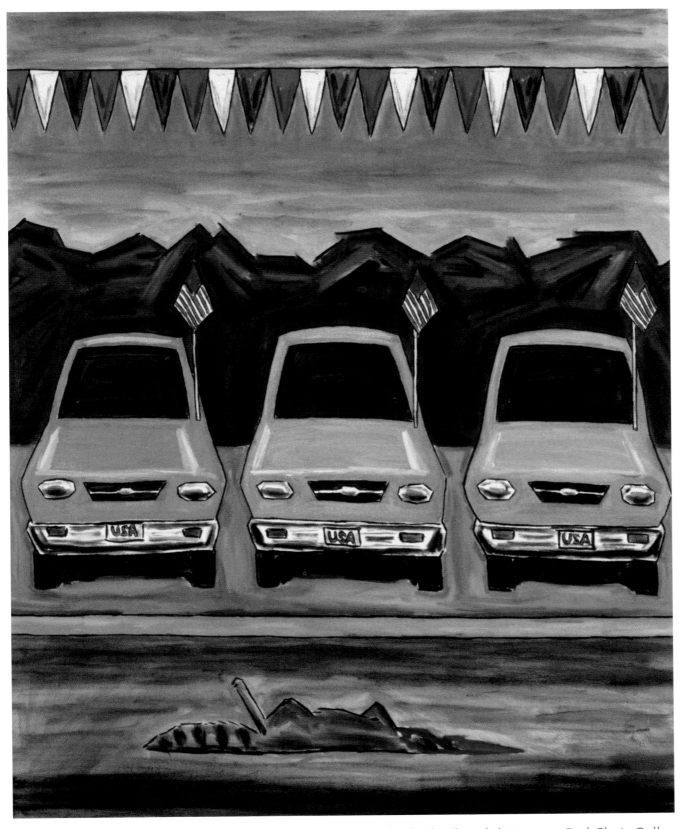

Patriotism, 2001
Oil on Canvas
36"h x 30"w

"The pattern here implies unanimity. All the flags and signs enhance the connection between this country and the greatest expression of its lifestyle: the automobile. But in the street lies some of the collateral damage of that lifestyle, the contrast tempering the enthusiasm with a broader perspective."

Geoffrey Bent has participated in many national competitions in the 1990s. In recent years he had solo exhibitions at Red Chair Gallery in Kansas City, Missouri, University of Illinois at Chicago, and Bloomingdale Art Museum. He also exhibited at SUNY at Buffalo and 3rd Street Gallery in Philadelphia, among others.

Bent has written many articles on Shakespeare and on art criticism. His articles were published in *Pleiades, North American Review* and *The Chicago Reader.* His first novel, *Silent Partners,* was published in 2003.

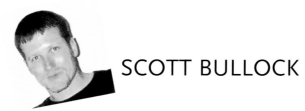 SCOTT BULLOCK

"The *Contours* series depicts human forms assembled from meticulously rendered fragments of materials and parts arranged in groups. This causes the viewer to recognize the individual parts before the whole assembled form becomes apparent to the eye. The way the viewer sees the images is comparable to the process of self-discovery. Each event in an individual's life shapes the character."

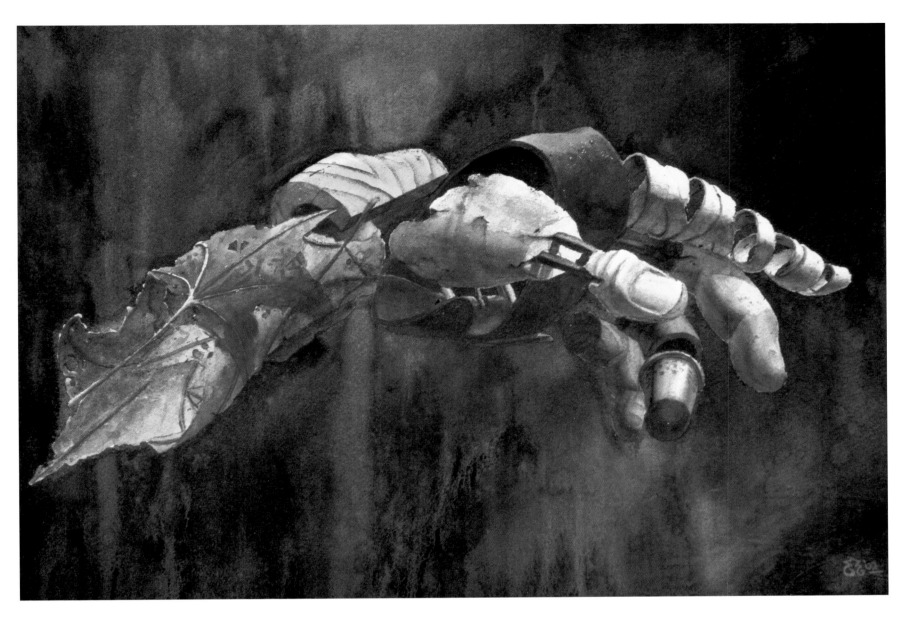

Anatomy of a Dream, 2003
Oil
51"h x 48"w

(above)
Touching Grace, 2002
Watercolor, 30"h x 22"w
"This is one of the few deviations from using
the human torso in the *Contours* series."

Scott Bullock is a native of South Carolina. He began his art studies with commercial design at Charleston, South Carolina's Trident Technical Institute. He is a graduate of the American Academy of Art in Chicago and runs a mural and decorative painting studio, Penumbra Studios, with his wife, Ronit Mitchell in Chicago.

Bullock is represented by Byron Roche Gallery in Chicago. He has had solo and group shows there since 1994. In 2001 he had a solo exhibition at the University Club of Chicago. Locally he has also exhibited at Around the Coyote, Absolut Vision, and the Chicago Printmaker's Collaborative. Elsewhere he has exhibited at the Kershaw County Fine Arts Center in Camden, South Carolina and at Dog Days, a public art event in Racine, Wisconsin.

 TRINE BUMILLER

"My paintings reference the natural world. My interest is in the rhythms of order and disorder in nature, through rivers, the wilderness, the microscopic and space. From a simple twig, a stand of trees, a thicket of branches to fractal mathematics and universal theories, I draw attention to the variety of pattern and form that surrounds us."

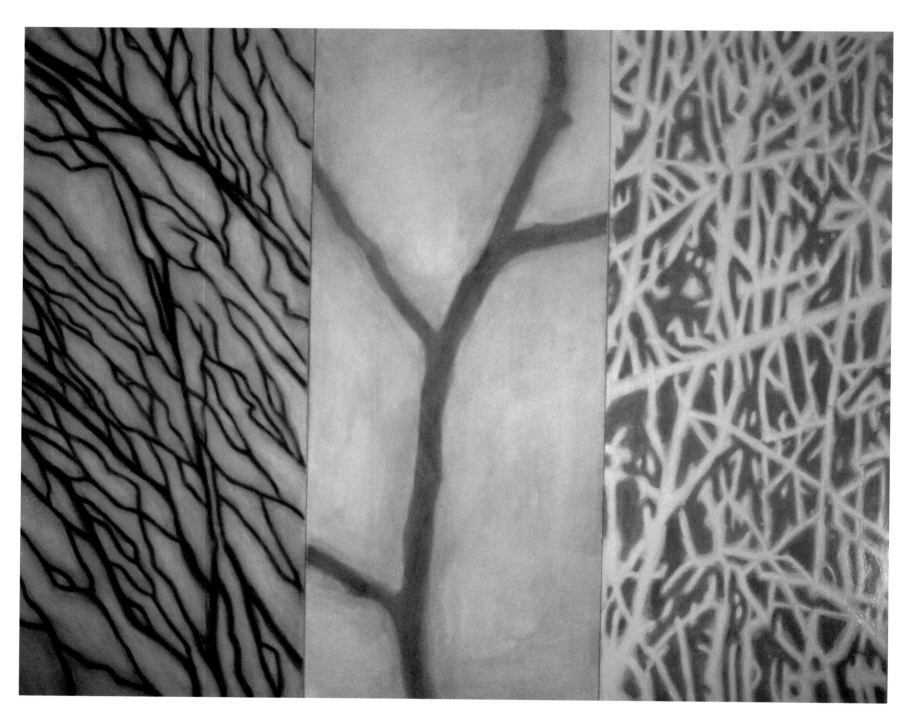

Fearful Symmetry, 1999
Oil on 3 panels
56"h x 72"w

Pyre, 2002
Oil on Canvas
20"h x 32"w
2 panels

"This past summer was marked by wildfire and drought. The combined images explore connections between cause and effect, growth and decay."

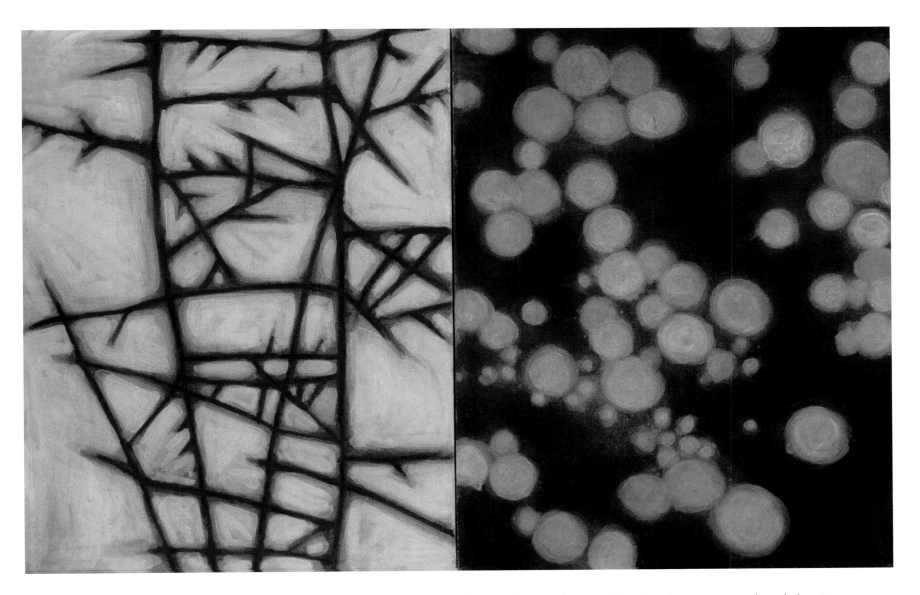

Trine Bumiller is a graduate of the Rhode Island School of Design, having completed the European Honors program in Rome, Italy. She had her first solo show at the Exit Art Gallery, and has since exhibited at Grace Borgenicht Gallery, Jack Tilton Gallery, and Martina Hamilton Gallery, all in New York City. She has also exhibited her work nationally at Cervini Haas Gallery in Scottsdale, Robischon Gallery in Denver, The Museum of Contemporary Art in Fort Collins, Colorado, University of California in San Diego, and the University of Wyoming Art Museum.

Bumiller is the recipient of several awards from the Colorado Council on the Arts, and the Colorado Federation of the Arts. Public art commissions include pieces for the City and County of Denver, and the University of Colorado. She is represented by Zg Gallery in Chicago and Robischon Gallery in Denver, Colorado.

BEN BUTLER

"My interests revolve around questions of how human creations relate to the non-human world. I create objects and situations that present the nuances of this coexistence. They reveal how we are influenced and inspired by the non-human world, and how our creations at once pay homage to it and contradict it."

Species III, 2003
Poplar Wood
32$\frac{1}{2}$"h x 40"w x 40"d

Invention
Site-specific Installation, 2003
Poplar Wood
52"h x 144"w x 144"d

Ben Butler received his Bachelor's degree in Visual Arts from Bowdoin College in Maine, and his Master of Fine Arts in Sculpture from The School of the Art Institute of Chicago in 2003.

Butler is part of the Plane Space Artist Residency program in New York City in 2003, and had a residency at the Vermont Studio Center in Johnson, Vermont in 2004. Apart from having exhibits at Zg Gallery, which represents him and at various galleries in Chicago, Butler had a 2-year outdoor sculpture exhibition, *Glacial Erratics,* at University of Western Alabama; a joint exhibit with Rena Leinberger, *Waiting,* at the Evanston Art Center in 2003; and a group show, *Perfect,* at the Chicago Cultural Center in 2004.

CARIANACARIANNE

"CarianaCarianne are working towards the reinvention of the individual into a collaborative team. We have collaborated on performance, installation and digital projects since 1999. Our spaces are large scale assemblage-installations that morph over time. Each day we bring materials. We enter our spaces. We move things around and we grow with them. We are spending time together, listening to one another and hearing one another. Together she and I become collaborators."

Inside the Skin/Negotiations and Resolutions
Installation at Studio Space, Chicago
3 hours per day for 17 days, 2002
Cardboard, Tape, Tree, Plastic, Books, Nails,
Dirt, Water, Tubing, Lights, Bowl, LCD Screens

"We responded to the question, 'How do you observe me?' while engaging in debate, contradictions, and the unyielding social nature of symbology. We negotiated our shared environment and shared our insights."

What Is It that We Want?, 2001
Composite installation views of time
lapsed - 13 hours (1 day)
Cardboard, Tape, Oranges, Cloth,
String, Lights, Scissors, Paper

"The installation condensed 13 hours of improvisational performance into a visual dialogue. Moments before the performance, we overheard a question, 'What is it that you want?' We used the question as a departure to display our conversation and to elaborate on the posed question."

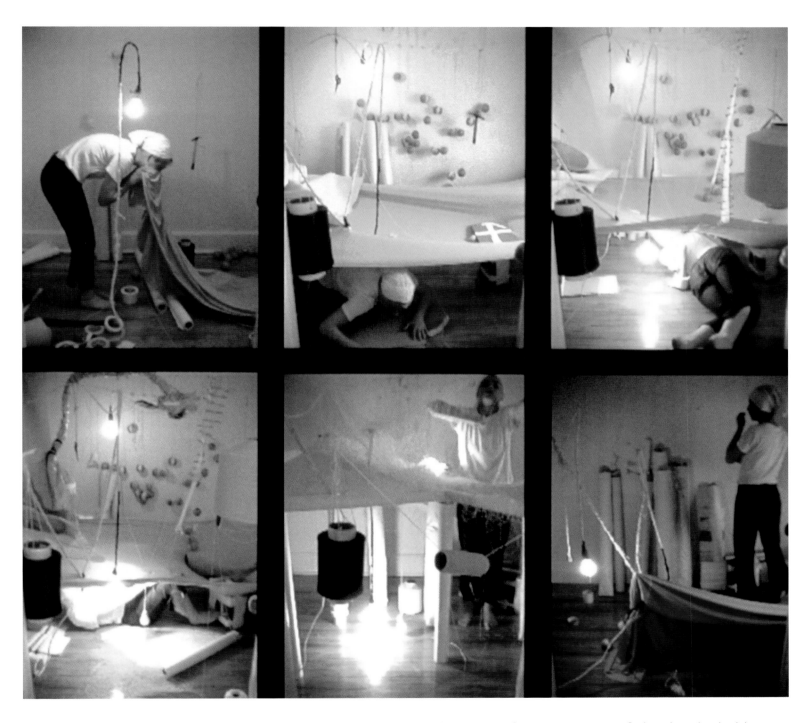

CarianaCarianne received her Bachelor of Fine Arts from University of Florida. She holds two Master of Fine Arts degrees, one in sculpture from University of North Carolina in 2001 and the other in fiber and material studies from The School of the Art Institute of Chicago in 2003. The installation and video, *What is it That We Want?—The Fugue* had been screened in Chicago, San Francisco, Croatia, and Hungary. In 2003, her videos and installations were held in Turkey, Germany, Belgium, and Canada.

PAUL CHIDESTER

"During the last 15 years, I have produced a body of work that tries to raise questions about the representation of nature from a variety of institutional points of view. The series began with an allegorical prairie grass museum housed in an abandoned 19th century fire station on the west side of Chicago. Soon after I produced an illustrated Martian travel guide, an architectural bestiary and an illustrated lunar calendar. After relocating to Pennsylvania, I continued with a deer-hunting labyrinth based on the myth of the Minotaur."

(above)
Traveler's Loot, 2002
Egg Tempera on Panel
29$\frac{1}{2}$"h x 40$\frac{1}{2}$"w

(opposite, top)
Station's Remains, 1998
Casein and Acrylic on Paper
15"h x 22"w

Paul Chidester received his Bachelor of Fine Arts from the University of Colorado, and his Master of Fine Arts from The School of the Art Institute of Chicago. He has exhibited widely in Chicago, Pennsylvania, New York, Florida, North Carolina, Louisiana, Italy, and rather extensively in galleries and art centers in Ireland. *Whitewalls,* a journal of his work on 'The Jay Pee Chaff Museum of Prairie Grasses' was published in 1990. *Mars and Lunar Calendar* were published in 1991. Most recently, he collaborated with Helen O'Leary on *Silage* which was published in Ireland. Chidester is represented by Zg Gallery in Chicago.

Big Germs
1998
Acrylic on
Panel
26"h x 80"w

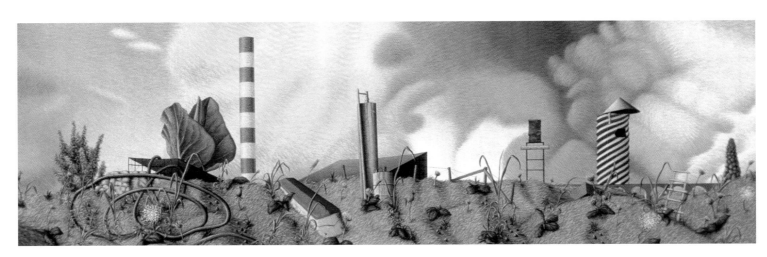

 GRACE COLE

"My large body of works depicting figures, landscapes, and fruits are meant to provoke an awareness of mankind's need to contemplate our evolution into the 21st Century."

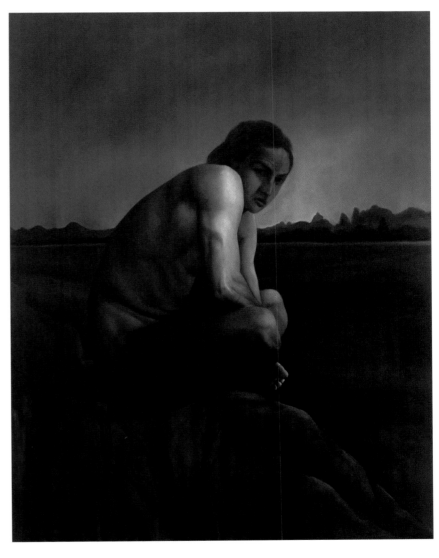

(left)
The Awakening, 2000
Oil on Linen
48"h x 36"w
"*The Awakening* examines time."

(opposite)
The Truth Teller
2000, Oil on Linen
48"h x 38"w
"This work focuses
on wisdom."

(right)
The Prophet, 2001
Oil on Linen
48"h x 36"w
"This work contemplates
reflection."

Grace Cole studied at The School of the Art Institute of Chicago, the University of Chicago, and at the École Albert du Fois in France. She has taught at various organizations in Illinois such as the Old Town Triangle Association, Prairie State College, and Suburban Fine Arts Center. In 2000 and 2002, she taught at Ateliers Sans Frontières in France. She has been teaching drawing and painting at her studio since 1979. Cole has had solo exhibitions at the Union League Club in Chicago and The Arts Club in Washington, D.C. Her recent exhibitions were at the Fine Arts Building Gallery and the Old Town Triangle Gallery in Chicago; Chicago Athenaeum in Schaumburg, Illinois; College of Lake County in Grayslake, Illinois and Cahoon Museum of American Art in Cape Cod, Massachusetts. Cole is a Board Member of Friends of the Chicago Cultural Center, and the Illinois Committee of the National Museum of Women in the Arts. She is represented by The Fine Arts Building Gallery and Malovat Gallery in Chicago, and Anne Loucks Gallery in Glencoe, Illinois.

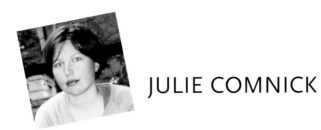

JULIE COMNICK

"My imagery pertains to the nature of precariousness. The narratives portray the brink of an event or the wake of its aftermath. The people are socially commonplace, the animals are unexotic, and the material objects are unsentimental. The viewers are invited to re-sensitize to the commonplace. By recognizing the symbolism embedded in our everyday lives, we can then prepare for the unanticipated and embrace impending change."

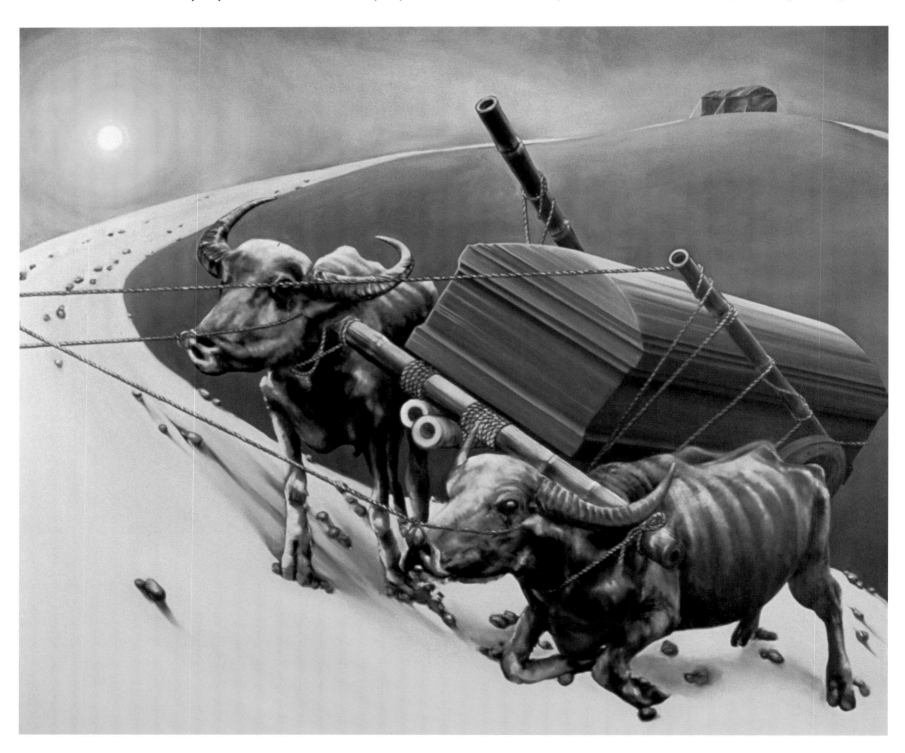

Procession, 2003
Oil on Canvas, 75"h x 90"w

"*Procession* suggests the burden of responsibility to uphold traditions."

Method of Luring

2002, Oil on Canvas

76"h x 84$\frac{1}{2}$"w

"What commonplace devices do you use, unconventionally, to summon what we have lost?"

Julie Comnick graduated from The Evergreen State College in Washington with a Studio Art and Humanities degree in 1995, then went on to Montana State University for her Master in Fine Arts. She has been teaching at the Hyde Park Art Center since 2002, and in 2003 she taught at the Gallery 37 Downtown Summer Program in Chicago. Comnick has had solo exhibitions at Zg Gallery, which represents her, Northeastern Illinois University and the Hyde Park Art Center in Chicago; The Evergreen State College and University of Puget Sound in Washington; and Emerson Cultural Center and The Exit Gallery in Montana. She also participates in group exhibits from Florida and Connecticut, to North Dakota, Utah and New Mexico.

ANTONIA CONTRO

"My work is ultimately about observation of the physical world and how experiences trigger ideas and the artistic process."

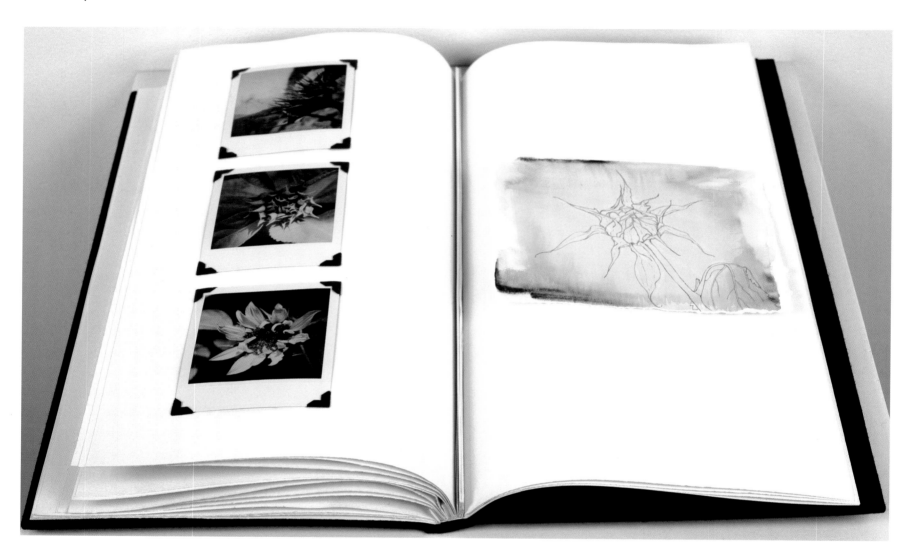

L'Odor del Bosc, 2002
Artist Book with Polaroids, Graphite
and Watercolor
17"h x 11"w

"This book presents studies done during my fellowship. Each page features two sets of entries—Polaroid photographs and a graphite line drawing of a single plant specimen. Employing a plant as the subject of intense observation, the studies focus on comparisons between art made by the camera and that made by the hand. The book contains a page for each day of the fellowship."

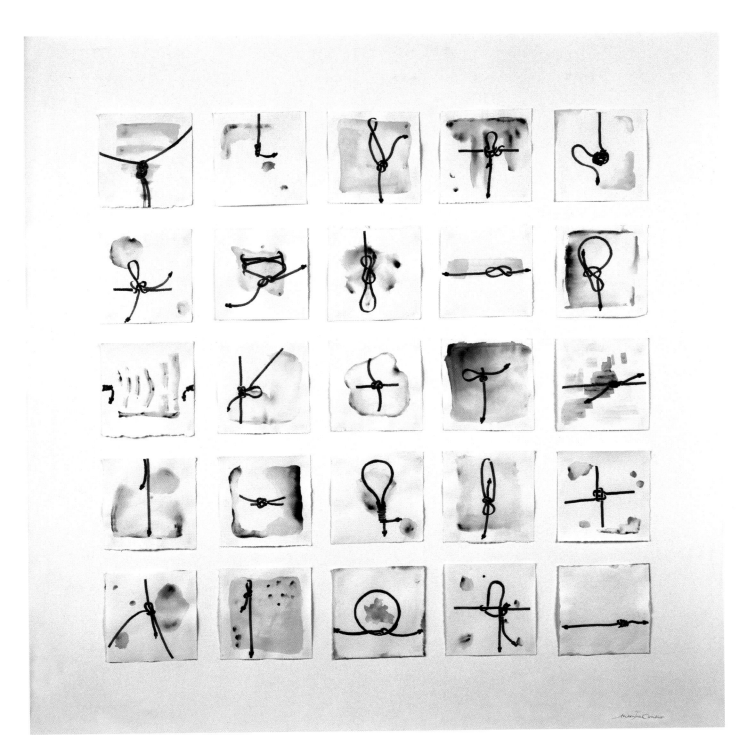

Working: Seeing

2002
Watercolor
33"h x 33"w

"The title refers both to working towards an idea and the term that sailors use to describe the tying of a knot. I originally started drawing knots as a meditative practice at the beginning of each day I enter my studio. Each knot was made with one dip of the pen into ink and completed in one continuous stroke; each knot was made in a 4" x 4" square."

Antonia Contro first studied art history, studio art and Italian at L'Universita per Gli Stranieri and L'Academia Pietro Vannucci in Perugia, Italy. She continued her studies at Northwestern University, which culminated in a Bachelor's degree. In 1987 she received her Master of Fine Arts from University of Illinois in Chicago.

Over the years Contro has had many solo and group exhibitions. Her recent solo exhibitions were at Carrie Secrist Gallery in Chicago, which represents her, Fort Wayne Museum of Art in Indiana, the Museum of Contemporary Photography and the Union League Club in Chicago. In 2002 she was awarded the Rockefeller Foundation fellowship.

BARBARA COOPER

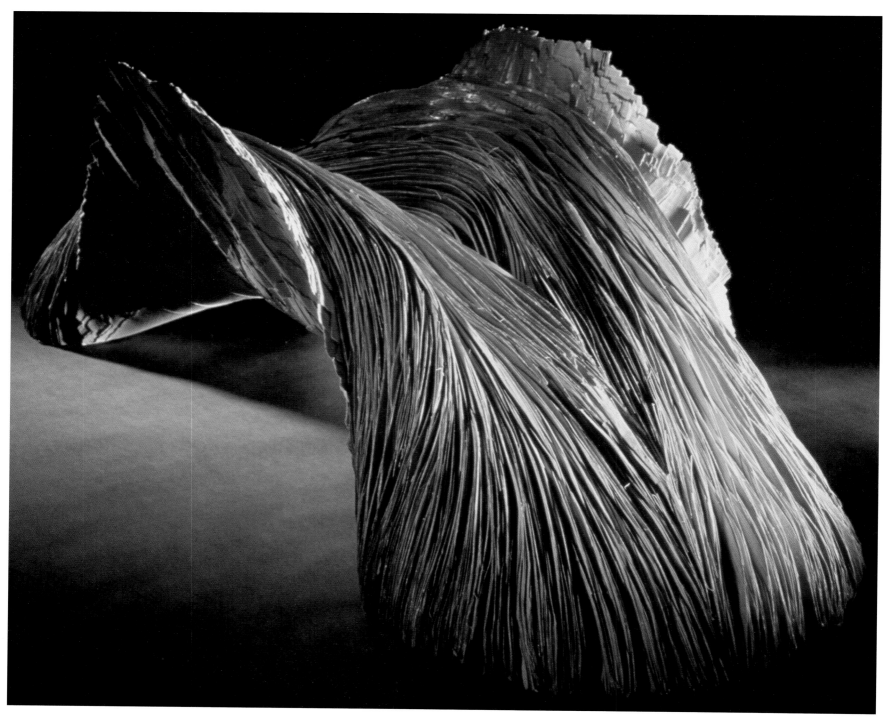

Surge, 2002
Wood and Glue
21"h x 24"w x 66"d

"I always begin with nature. I am drawn to how forms respond to stresses they withstand and the obstacles they confront. Starting with observations of specific phenomena, I abstract the parallels I find in processes as diverse as the surge of lava, the creep of a glacier, the flow of water, and the growth of a tree."

Processes of Change:

Agitate

2003
Charcoal on Paper
60"h x 120"w

"Constructing a drawing parallels the process of building a sculpture, but without the complications of gravity and the specifics of sculpture."

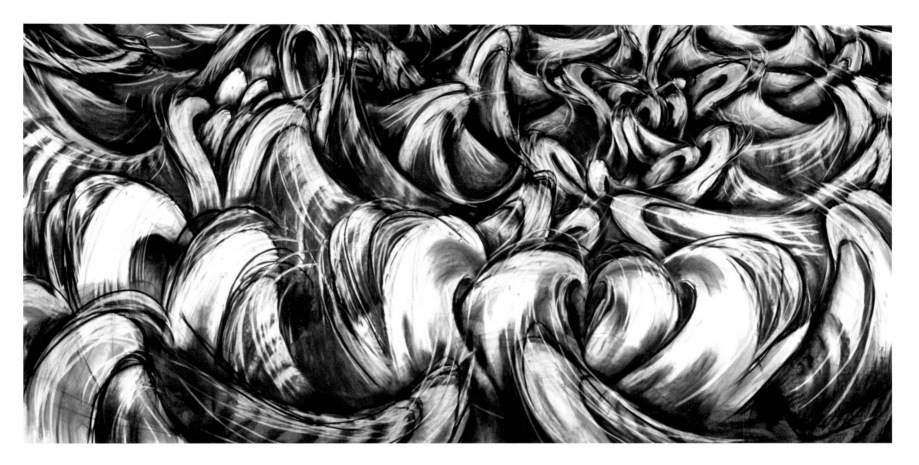

Barbara Cooper received her Bachelor of Fine Arts from Cleveland Institute of Art and her Master of Fine Arts from Cranbrook Academy of Art in Michigan. She has been teaching sculpture and drawing as Continuing Studies at The School of the Art Institute of Chicago since 1987. She also taught at Harper College in Palatine, Illinois for 13 years. Cooper has held many workshops, lectures and visiting artist positions across the country.

Over the years Cooper has had residency fellowships in many states from Massachusetts and New York to Kansas and Montana, to Oregon and California. In recent years, she was at Hafnarfjordur and Akureyri, Iceland, Newfoundland, and Costa Rica. She has had many solo exhibitions at schools and galleries nationally, including those at Fassbender Gallery in Chicago, which recently closed, Southeast Missouri State University Museum, Sybaris Gallery in Royal Oak, Michigan, Indiana University NW Gallery for Contemporary Art in Gary, and the Southwest School of Art and Craft in San Antonio, Texas.

Her work is in the collection of the Smithsonian National Museum of American Art.

CHRIS COSNOWSKI

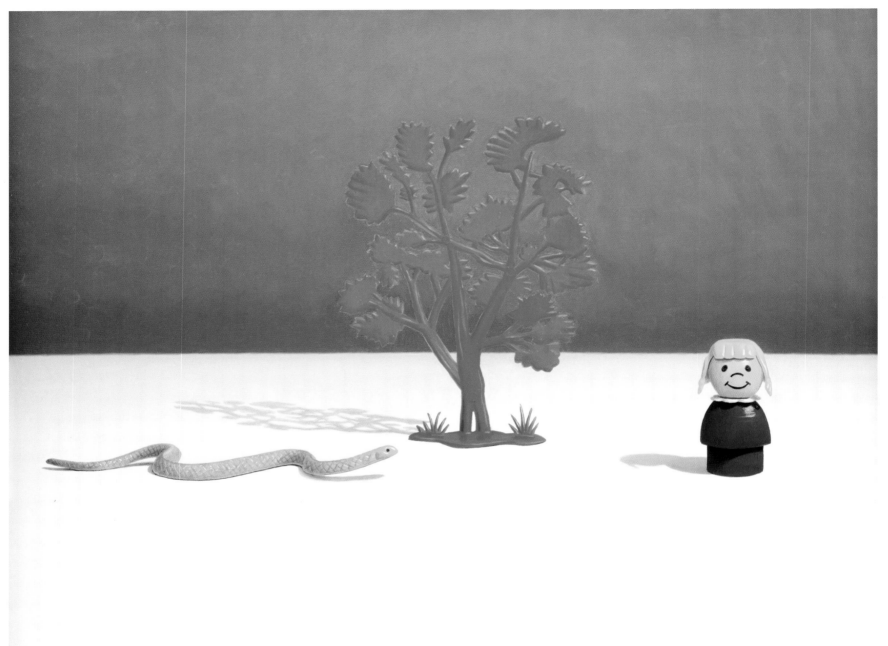

Eve, 2002
Oil on Panel
12"h x 16"w

"This painting is an update of one of the great stories in human history. Its perfectly spherical head and ubiquitous geometric smiley face allow the figurine to function as a contemporary 'ideal' figure. Its use in a religious painting draws a parallel between these figures and the 'ideal' figures of Italian Renaissance frescoes."

Madame, 2003
Oil on Panel
16"h x 12"w

"Opera is considered one of the highest forms of expression and certainly, one of the most haughty. This painting is a reference to Pucini's famous opera, *Madame Butterfly*. The use of toys in the image blurs the line between high and low culture. The highly decorative sensibility of the image, however, creates a beauty similar to that of the opera. The image pokes fun at this highest form of art while aspiring to its loftiness."

Chris Cosnowski was originally from Charleston, South Carolina. He was awarded his Bachelor of Fine Arts at Ohio's Columbus College of Art and Design in 1992. He received his Master of Fine Arts from Northwestern University in 2000. He has taught at Triton College in River Grove, Illinois, and is now a faculty member of the American Academy of Art in Chicago. Cosnowski has had solo exhibitions at the galleries that represent him: gescheidle in Chicago, Lyonswier Gallery in New York City, and Dolby Chadwick Gallery in San Francisco. He has also exhibited at the Hyde Park Art Center and the Chicago Cultural Center. In 2001 his work was featured on the cover of *New American Paintings*.

SEAN CULVER

"All of the pieces have to do with the line between the conscious and the unconscious. The imagery is intended to be reliquary-like statements expressed in the language of a dream."

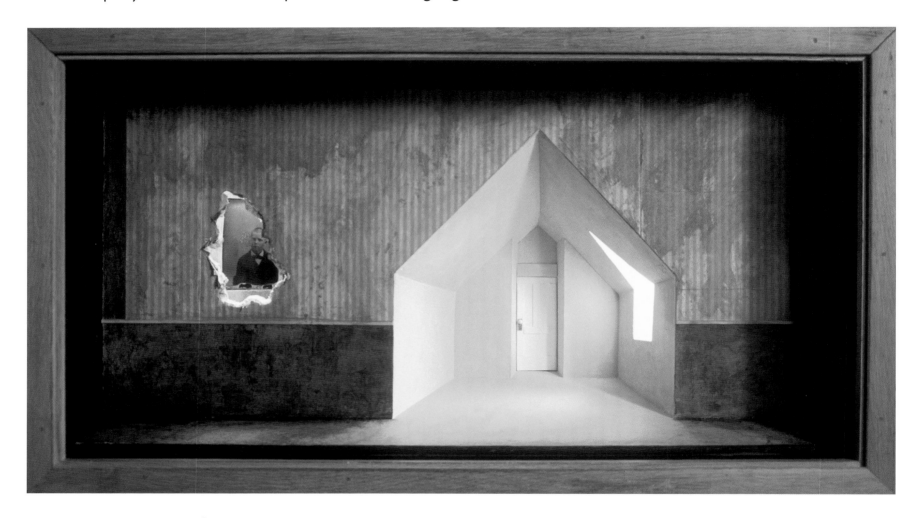

(above)
Relic of the Venomous Obstacles, 1995
Box Construction, Wood, Glass, Museum
Board, Paint, Paper, Found Tintype
14"h x 30"w x 9"d
Collection of Joseph Ramirez

"Buried secrets, disease, walled-up and hidden. The room where stories are told are whitewashed and flooded with light. This piece was inspired by the set design in Charles Laughton's *Night of the Hunter*."

(opposite)
Center of Gravity, 2002
Wood, wide-angle lens, earth, cremation urn in 23 k gold,
Daguerreotype., drill bit, 24"h x 11"w x 5³/₄"d

"This work is about my maternal grandfather. The front features an intricate marquetry in cherry, white oak and bocote. Through the top viewing port, one sees a miniature diorama of a landscape. The cross-section shows a grave filled in with earth. In the grave is a wooden box containing a cremation urn gilt in 23 k gold. Lying in a central channel, a large rusted drill bit runs from the bottom of the grave to a large cavernous area.

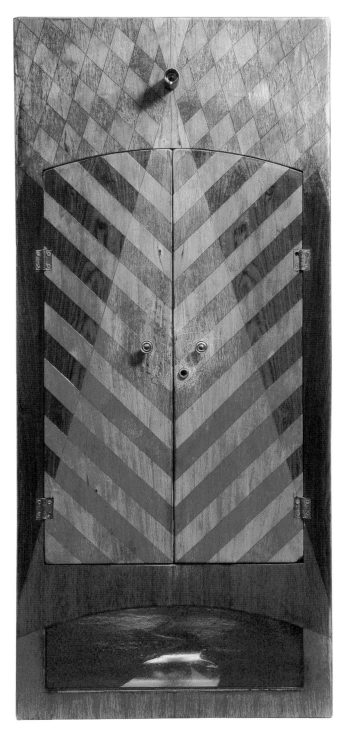

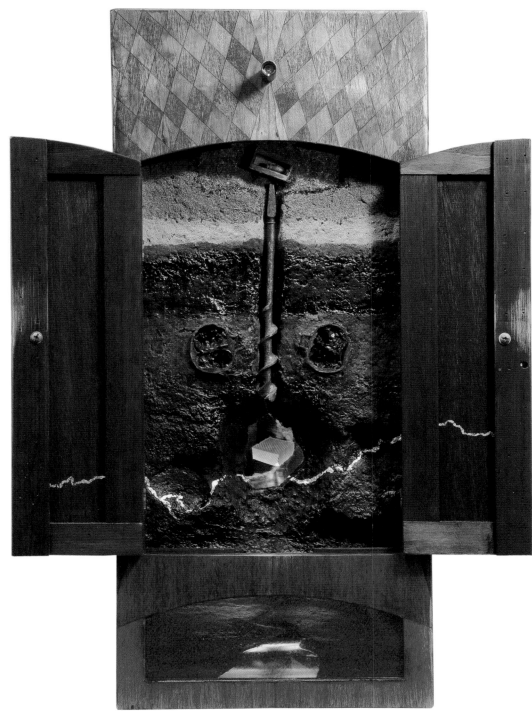

(below) **Center of Gravity** (detail seen through the top viewing port)

A circular aperture is carved in the rock through which can be seen a gold gilded Daguerreotype of a gift package of self that is also seen in the river below."

Sean Culver grew up in rural Galesburg, Illinois. He discovered his calling as an image-maker while at the hospital with a bout of mononucleosis at age 10. He studied black and white photography at The School of the Art Institute of Chicago. Later he studied painting conservation and collaborated on two major independent films, on which he served as cinematographer, sound designer and co-editor. In 1993 he began sculptural works based on his photographic images. In each piece of these box constructions, some form of photographic image is either central to, or is otherwise informing the sculptural work.

RACHEL DAVIS

Rachel Davis received her Master of Fine Arts in Printmaking from the University of Wisconsin in Madison and her Bachelor of Arts from the State University of New York at Plattsburgh. She is the recipient of a number of awards, grants, scholarships and residencies, including a 1999 residency fellowship at the Vermont Studio Center and a 2002 residency at the Montana Artist's Refuge in Basin. In 2003 she was commissioned to make children's sensory boxes for *Barnstorm Wisconsin*.

Davis has exhibited nationally. In 2001 she was part of a traveling exhibit from Bluseed Gallery in Saranac Lake, New York to The Mist Grill Gallery in Waterbury, Vermont, to 113 Ludlow in New York City, to Arts Center/South Florida in Miami Beach and The Pro Gallery in Nassau, Bahamas. In 2002 she was part of another traveling exhibit from the Center of Contemporary Art in St. Louis, Missouri to the University of New Hampshire in Durham, to St. Mary's College in South Bend, Indiana, and the College of Visual Arts in St. Paul, Minnesota. Davis is represented by Zg Gallery in Chicago.

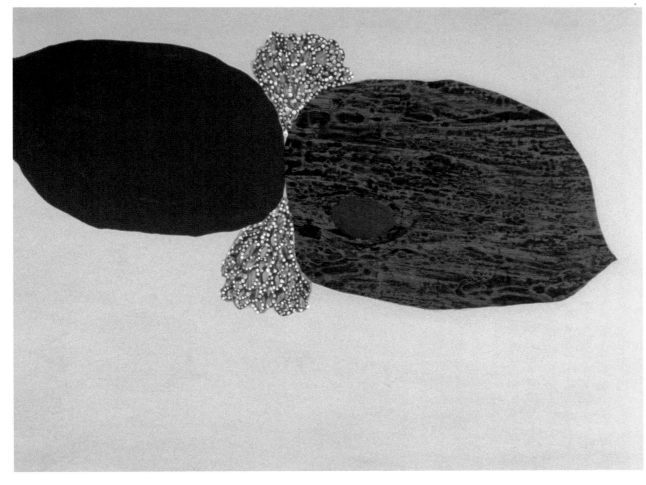

Parting, 2002
Acrylic on Panel
9"h x 12"w

"This painting is about when someone departs from this world. There's not a void where they were. Something grows either from the parting or from the effect of having that particular person no longer there."

(opposite)
Wingbeat, 2001
Acrylic on Wood
9"h x 12"w

"In many of my paintings I use organic shapes, such as seed pods or shells."

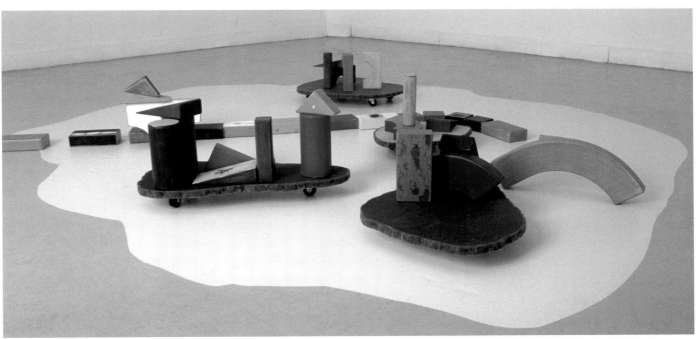

Push Toys, 2001, Acrylic on Wood, Casters, Felt, 8'h x 10'w installation

"I am interested in having children engaged in art while exploring the world. The push toys are paintings turned into person-powered scooters, with wool bumpers around the edge. Accompanying each scooter are building blocks of the sort familiar to most preschoolers."

SANDRA DAWSON

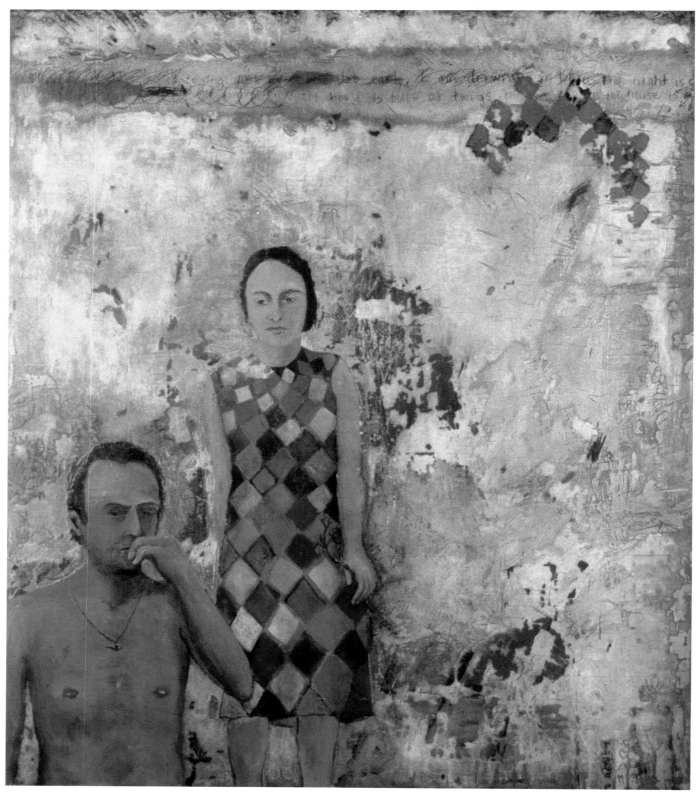

The House of Twigs, 2001
Acrylic, Graphite, Colored Pencil,
Joint Compound, India Ink on Panel
50"h x 48"w

"I thought of the title for this piece while camping with family and friends. We found a house entirely built from twigs. I was struck by the fragile relationship between nature and man, man and woman. However fragile, this is the foundation of stability in all life forms."

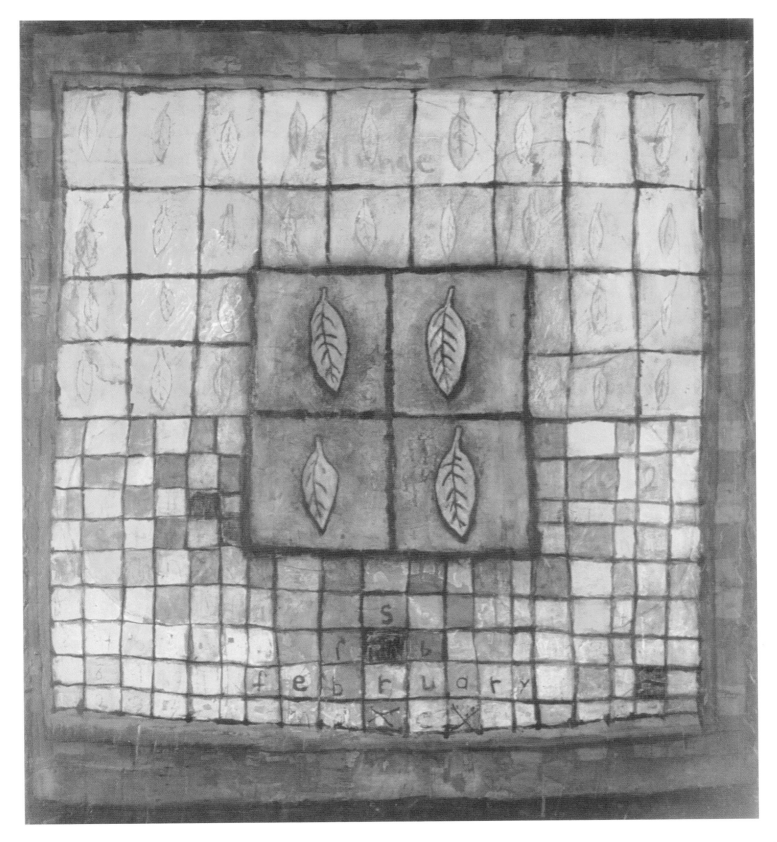

February

2002
Acrylic,
Graphite,
Colored
Pencil, Joint
Compound,
India Ink on
Panel
22"h x 20"w

"I painted
this piece in
February. I
wanted to
convey the
grandeur of
the leaf—so
simple and
abundant
that we take
for granted
its enormity.
Like a lot of
things, so
missed when
gone."

Sandra Dawson graduated from University of Illinois in Chicago with a Bachelor of Fine Arts in 1989. Over the years, she has had solo exhibitions at Gallery A, IDAO Gallery and Byron Roche Gallery, all of which are in Chicago. She has been participating in *Art Chicago*, the international art exposition at Navy Pier since 1997, and has also participated in the *San Francisco International Art Exposition* and the *Seattle International Art Exposition*. She is represented by Byron Roche Gallery in Chicago.

MELANIE DEAL

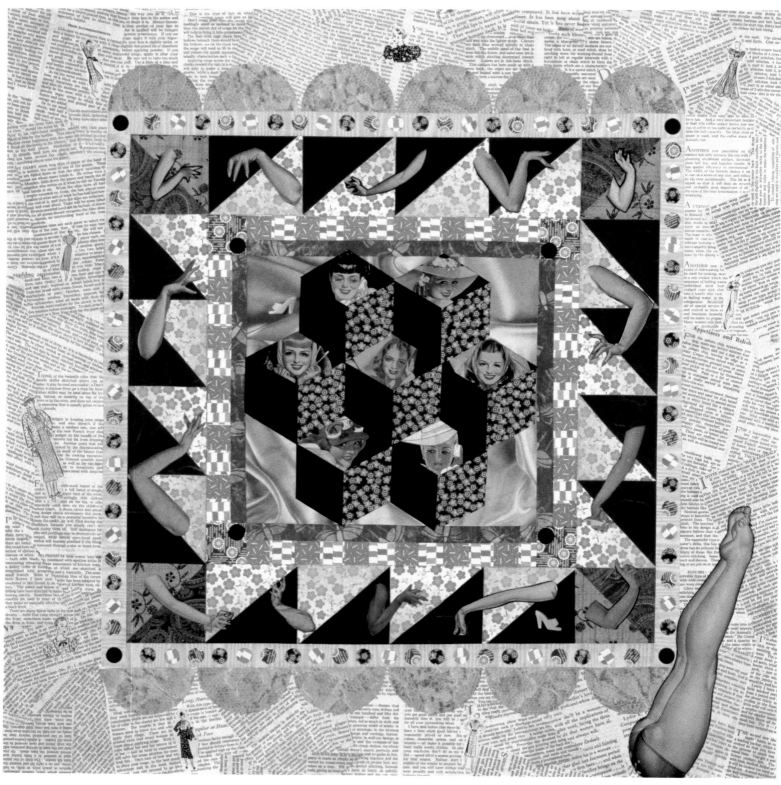

Pinups, 2002
Magazine Cutouts, Paper, Plastic Shoes
24"h x 24"w

"My father, who died in 1953, made a scrapbook of pinup illustrations from the 1940s. I decided to dismember these idealized women and let their limbs float freely in a lacy pink landscape."

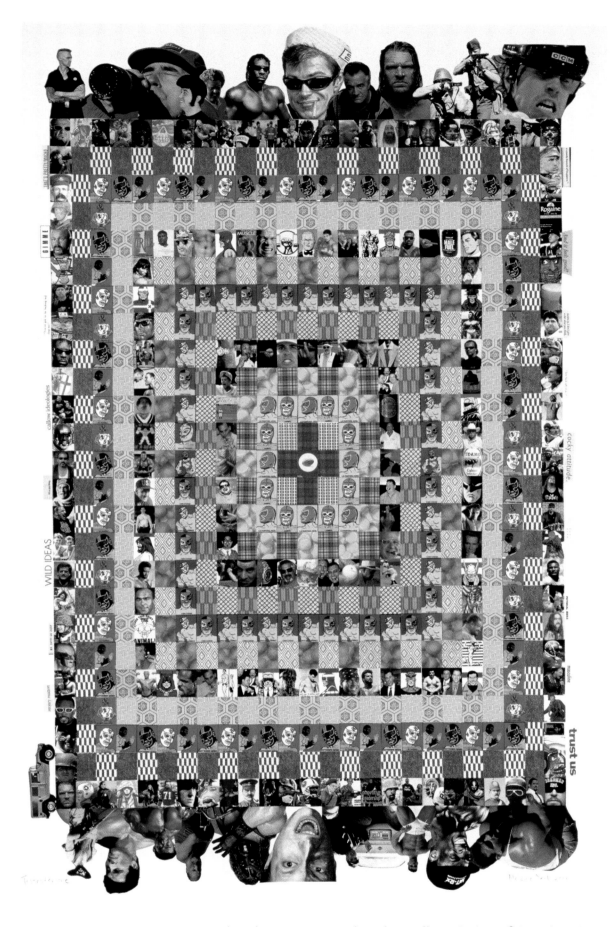

Testosterone, 2001
Origami Paper, Magazine
Cutouts, Wrapping Paper
40"h x 30"w

"Testosterone is a good thing in moderation. But an excess of it leads to all sorts of silly and strange behaviors, including pro wrestling, cigar smoking, body painting at sporting events, and war."

Melanie Deal holds a Bachelor's degree in English and a Master's degree in English Language and Literature. In 2002 and 2003 she exhibited at several Evanston, Illinois venues: Gillock Gallery, McDougal Littell, and Gallery Mornea. In 2003 she also participated in the *Collage Artists of America Open* at Brand Gallery in Glendale, California, and a juried show, *Women in the New Millennium—The Artist's Perspective,* at Seton Hall University in South Orange, New Jersey. She has had group exhibitions at Woman Made Gallery, Chicago in prior years; in 2004, she had a solo exhibition there funded by an Illinois Arts Council grant.

BRIAN DETTMAR

"I excavate and edit an existing communicative object or system to expose its possibilities and limits. Much of my work deals with altering books and audio recordings."

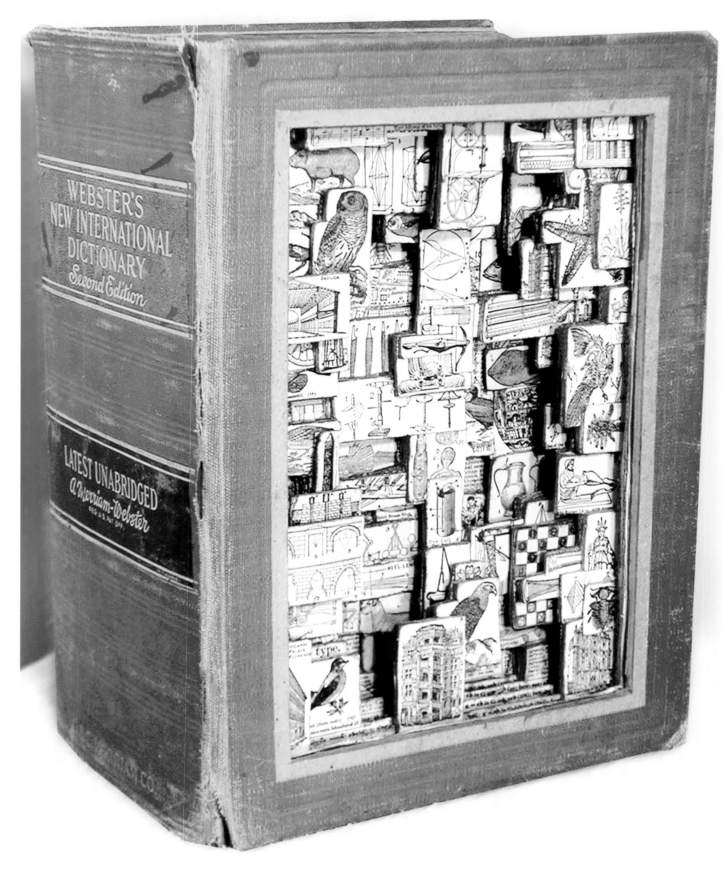

New International Dictionary

2003
Altered Dictionary
12"h x 9"w x 7"d

"This piece is an original 1947 Unabridged Dictionary that I have altered. I sealed the edges, then carved into both the front and the back to allow the small images to emerge. Every exposed image remains in its exact previous location."

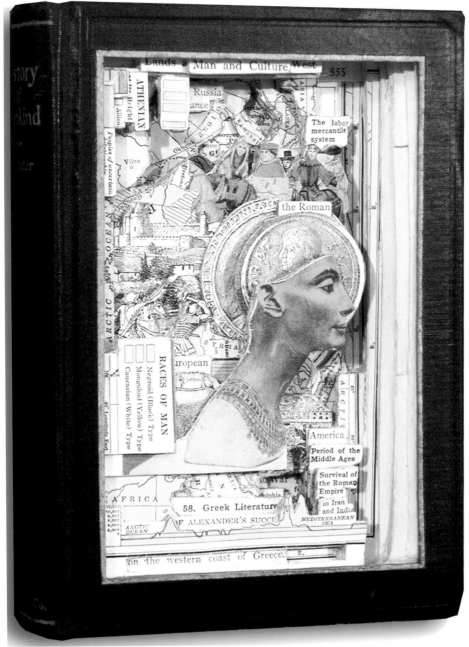

The History of Mankind, 2003
Altered Book
8½"h x 5½"w x 1½"d

"This piece is an attempt to re-investigate the way history can be told. When excavating the book I try to recontexturalize the book's content without adding too much interference of my own ideas on content or composition."

Brian Dettmar received his Bachelor's degree in Art and Design, and Art History from Columbia College, Chicago in 1997. His work has been exhibited in galleries such as Gallery on Lake, Glass Curtain Gallery, A & D Gallery and Aron Packer Gallery in Chicago; and Judith Racht Gallery in Michigan. In 2002 and 2003 he exhibited his work at the Hyde Park Art Center in Chicago. His work also appeared at the South Bend Regional Museum of Art in Indiana, Rockford Art Museum in Illinois, and the Long Island Beach Foundation of the Arts in Loveladies, New Jersey. He is represented by Aron Packer Gallery in Chicago.

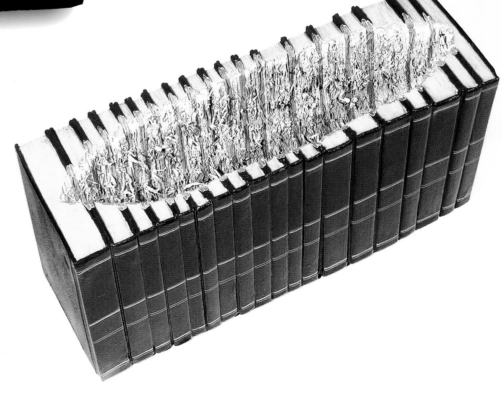

Scoop, 2003
Encyclopedia Set and Acrylic
11"h x 24"w x 8"d

"This piece began as a full set of encyclopedias. The intellectual content has been extracted and we are left with the physical results of laborious determination open to new implications."

BOB EMSER

"From the beginning my work has dealt with the internal structure and how that structure supported or becomes visible on the exterior. My current body of work is derived from and is a reference to the pioneering spirit of aviation and nautical history."

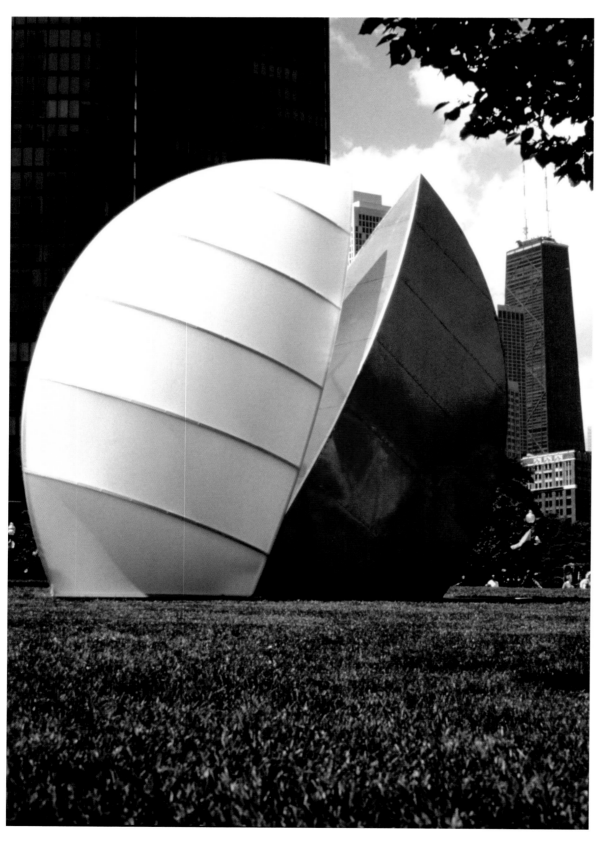

Sistine Touch, 2000
Copper, Aluminum, Canvas
11'h x 13'w x 4'd

"Photographed on Chicago's lakefront, Gateway Park, this sculpture's final home is the Elmhurst Art Museum where it has been purchased for its permanent collection."

(opposite)
"*Bob's path* is a good example of the small works that I create. It has been exhibited in Michigan's *4th Biennial Krasel Sculpture Invitational,* in the *Soho20 2003 Spring Juried Exhibit* in New York City, and *Grounds for Sculpture,* a juried exhibit at the International Sculpture Center in New Jersey."

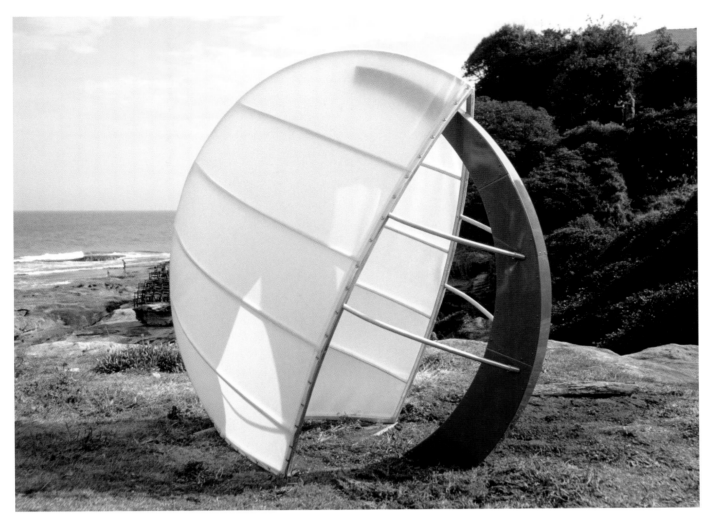

Down the Runway,
2002
Aluminum, Vinyl/
Nylon Fabric
7'h x 7'w x 3'd

"This was created for the Australian sculpture exhibit, *Sculpture by the Sea,* which is the world's largest international outdoor sculpture exhibit. It is photographed on Sydney's Bondi Coastline."

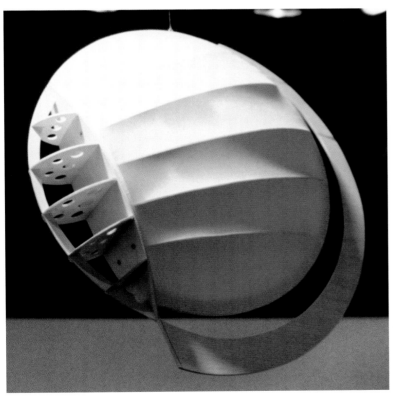

Bob's Path, 2000
Wood, Nylon
24"h x 20"w x 6"d

Bob Emser was born in Illinois in 1954. Influenced by the constant house construction of the era and his father, a mechanical engineer, he spent most of his early years building and playing with machines. In 1978 he completed his Master of Fine Arts in sculpture at Bradley University in Illinois. He was the youngest sculptor to have his work selected for the Illinois Arts Council's Sculpture Exhibition, which traveled throughout the state.

In the past 25 years Emser has served as a visiting artist, and has taught at several universities. He has held a tenured professorship for 14 years. He is the founder of the Contemporary Art Center of Peoria, and has served for 2 years as the Executive Director of Chicago's international sculpture exhibit, *Pier Walk* before forming Modern Sculpture Services, a consulting, curatorial and installation organization.

BEATRICE FISHER

"My camouflage series uses pattern and imagery to explore the mysteries of vulnerability and strength, as well as ideas about war, terrain, concealment and deception. Like my other work, it's painted with smooth, flat forms. I generally use a small format so as to provide a sense of intimacy with the viewer and encourage psychological contemplation."

Homeland Security, 2002
Acrylic, Stickers on Canvas, 12"h x 16"w

"The best offense may be a good defense."

74

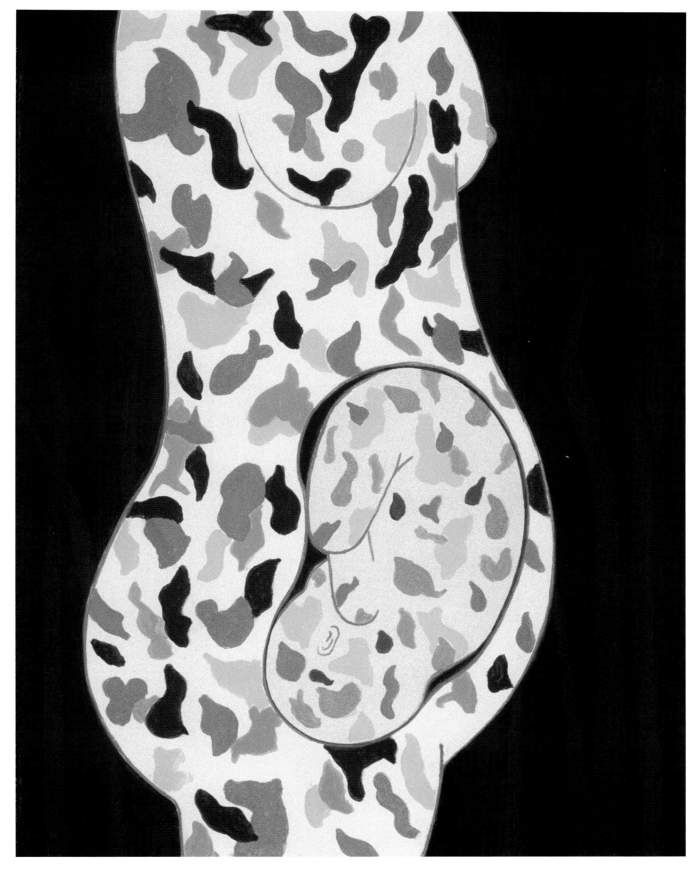

Safe Keeping

2002

Acrylic on
Masonite
10"h x 8"w

"Maternity in
difficult times."

Barbara Fisher was born in Michigan. She graduated from Wayne State University in Detroit with a Bachelor's degree in English and Theater. When she moved to Chicago in the early 1960s, she studied art with Don Baum, a Chicago artist and teacher. Her work has been in many local and national juried shows. She has exhibited at Aron Packer Gallery and Judy Saslow Gallery in Chicago, and is currently represented by Gillock Gallery in Evanston, Illinois.

 KATHERINE GROSSFELD

"In my oil paintings, I examine the humble objects that occupy much of domestic life and are so often discounted as insignificant."

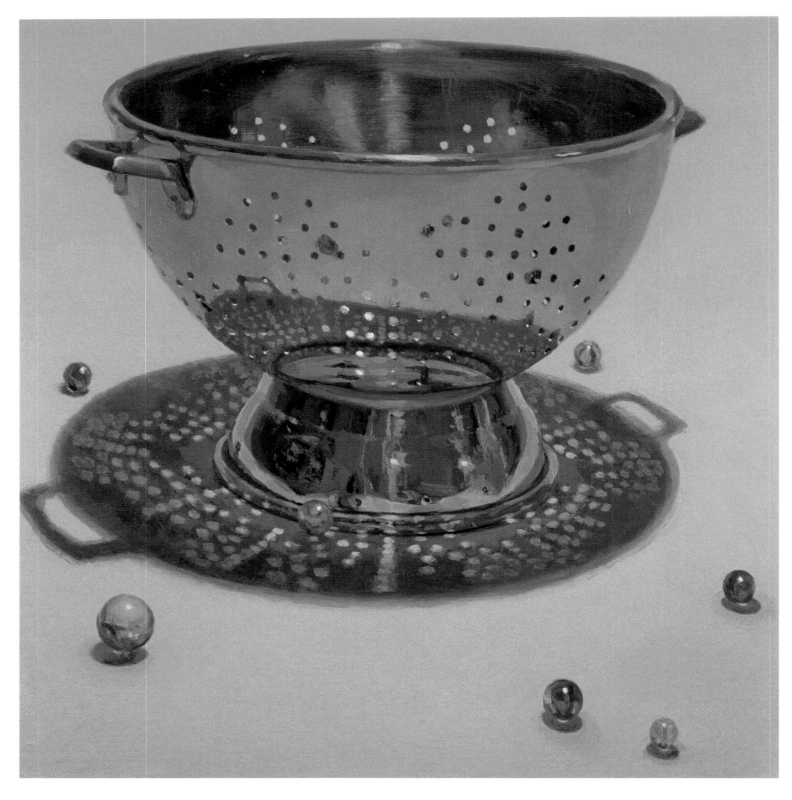

Everyday Whirl, 2002
Oil on Panel, 12"h x 12"w

"The desire to contain and control the mayhem of everyday life. Inevitably, things slip by."

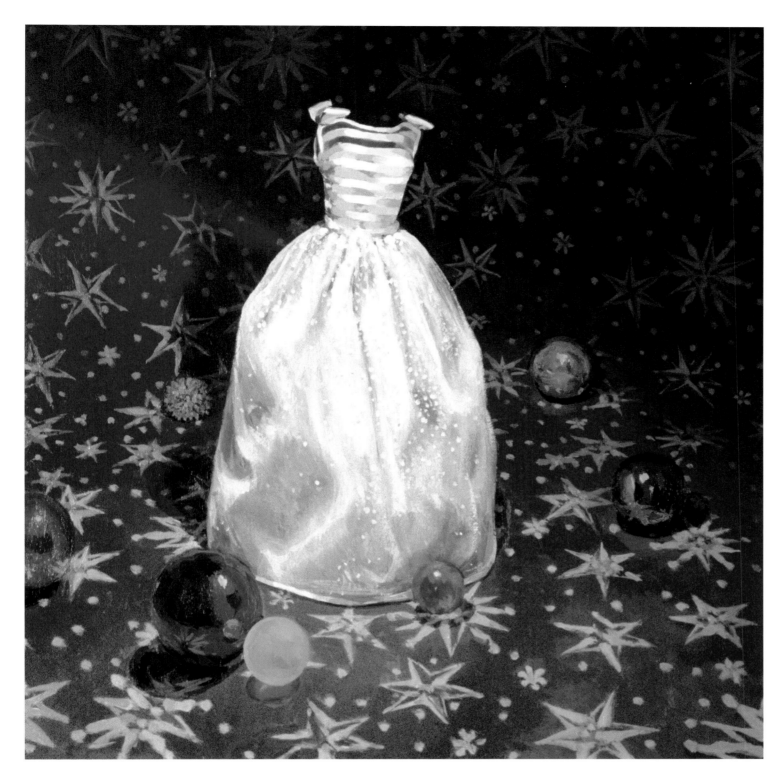

"In our culture, the glamour of the wedding is often emphasized over the reality of marriage. Wearing a beautiful gown and being the focus of admiration continues to be a dream in generation after generations of girls. Although the dress is modernized, the idea isn't."

Sparkle, 2002
Oil on Panel
12"h x 12"w

Katherine Grossfeld received both her Post-Baccalaureate Certificate and her Master in Fine Art from The School of the Art Institute of Chicago. Upon graduation in 1998, she was chosen to participate in Artemisia Gallery's one year mentorship program for emerging artists.

Grossfeld has had solo shows at Byron Roche Gallery, which represents her, and at Duke University in North Carolina. Her paintings were included in a touring exhibition, *The Object Considered,* which was a survey of contemporary still life in the Midwest. Her work was featured in *New American Paintings* in 2003.

SUSAN HALL

"My oil paintings are done on Stonehenge printmaking paper. Before I begin painting, I prime the paper with either acrylic gel medium or gesso. Because the gel medium is thick, it can create a textural surface, especially when I apply it with my hands rather than a brush. Gold composition leaf, which adds luminosity, is occasionally applied to the paper. After adding multiple layers of paint to the paper, I typically remove paint in certain areas by using chemical strippers or a sander. The result effect can connote the passage of time."

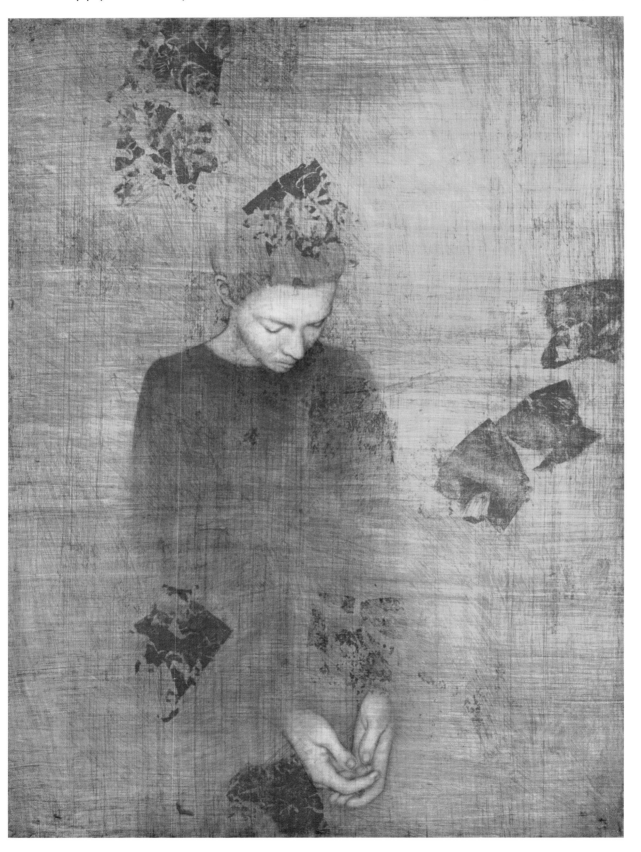

Autumn
2002
Oil and Gold Leaf on
Paper
50"h x 38"w
Private Collection

"Specific details about the figure, such as hair and clothing, are simplified in order to suggest a previous non-specific era. The figures I paint are intentionally vague or softened so that they may represent all people."

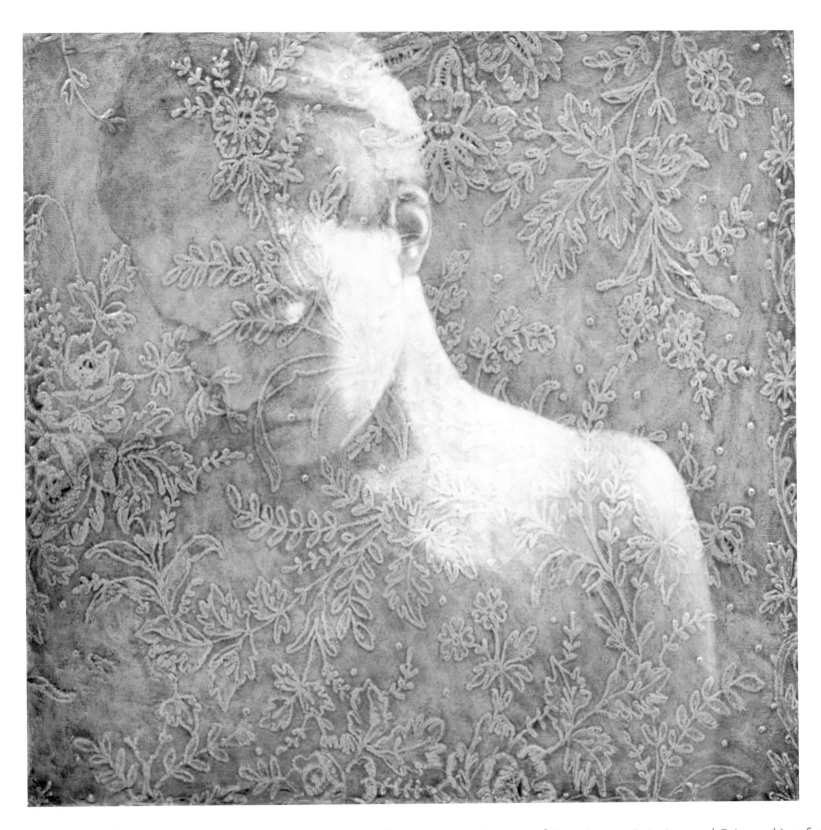

Garden

2003

Oil and Lace on
Panel

20"h x 20"w

Private Collection

Susan Hall received her Master of Fine Arts in Painting and Printmaking from University of Georgia. She has had many solo shows, including those at Lyons Wier Gallery in Chicago; Lyonswier Packer Gallery in New York City; Butters Gallery in Portland, Oregon; and Lydon House Art Center and Gallery MSL in Georgia. In 2003 her work was judged the Best in Show by Ed Paschke at the *Animal Images Art Exhibition* sponsored by the Chicago Anti-Cruelty Society. She is represented by Melanee Cooper Gallery in Chicago, as well as Butters Gallery and Lyonswier Packer Gallery.

CYNTHIA HELLYER HEINZ

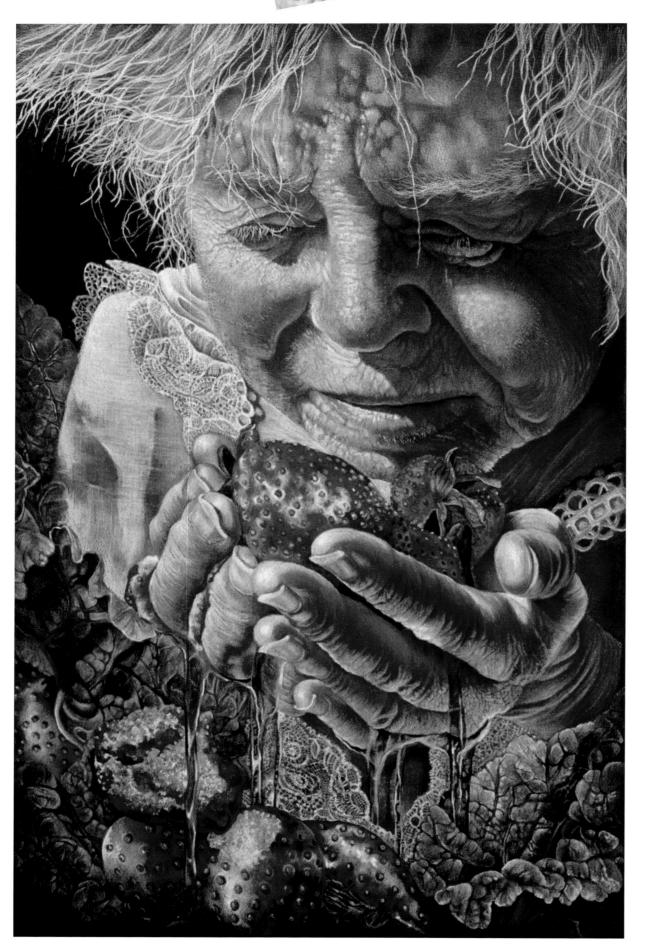

"My grandmother, at ninety, looked in the mirror and asked, 'Who is that old woman?'. We are more than the skin bag. At our core is genuine beauty and we wrap it up in artifice."

**Hot Mama II,
Breathless Fruits of Living**
2003
Colored Pencil on Black Paper
22"h x 15"w

"A woman of long experience and age is erotically immersing herself in ripe strawberries. She is wearing lace. She is oblivious to the viewer, unselfconscious in her sensuous pleasure. The attitude encouraged by a culture fascinated with youth is confronted by the beauty glistening off the aged countenance. Wrinkles are landmarks of life well lived and facial hair shimmers in luminous fuzz."

Edible Coercion Ritual of Decorative Birth

2002
Colored Pencil on Black
Paper
16"h x 20"w

Cynthia Hellyer Heinz received her Bachelor of Fine Arts in drawing from Pratt Institute in 1973. She returned to school recently for her Master of Fine Arts in drawing at Northern Illinois University and was granted a teaching fellowship. Heinz has been a full-time assistant professor at Northern Illinois University since 2000, teaching drawing, painting, illustration, and design. She is also the assistant supervisor of graduate teachers at Foundations Drawing, and an adjunct professor of health and wellness at North Central College.

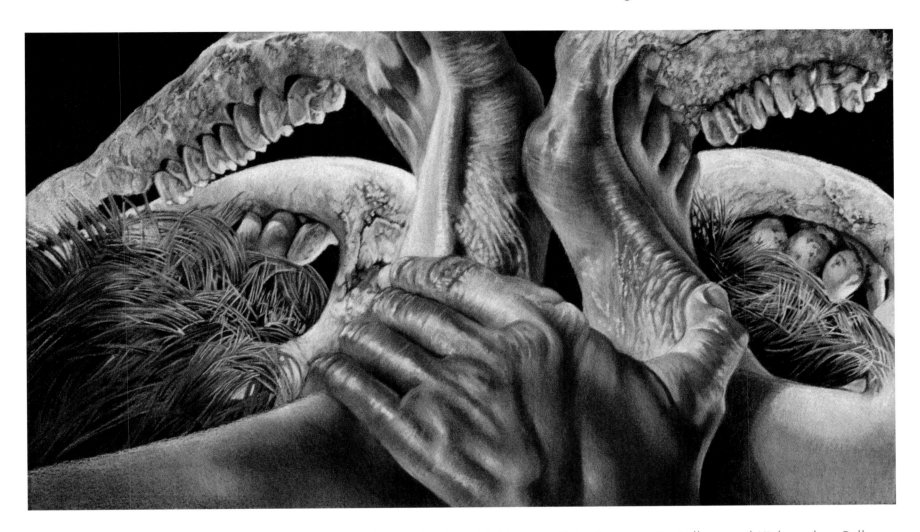

"Embellished with feathers, the adult feet are held in the birthing position, tense and reluctant to emerge into the ritual of expected maturity. The feet transformed into jaw bones, emblematic of the anticipated desiccating aging process."

Heinz has had solo exhibitions at Elgin Community College and Kishwaukee College in 2002. She has also exhibited in a large number of juried exhibitions across the country. For example, in 2003 she showed at the *46th Chautauqua National Exhibition of American Art* in New York City; the *46th Annual Invitation Award Exhibition* at the San Diego Art Institute; *The Chicago Solutions Show* at Gallery on Lake; St. Louis Artist Guild's *Face It: Portraits;* Columbia College's 24th national exhibit, *Paper in Particular; Dimensions 2003*, a National Juried Exhibition in Winston-Salem, North Carolina; and *20" x 20" x 20"*, a Compact Competition at Louisiana State University, among others. Heinz is a committed gardener and often watches as the tomatoes ripen, to rot, to seed, to regeneration. She and her husband, a potter, work out of their home studio in Warrenville, Illinois.

MARY HENDERSON

"The subject of these paintings is family photographs. The work is concerned both with individual memory and with archetypal experiences of American family. The paintings focus on the small or peripheral pieces of information, a gesture or facial expression or the pattern of a dress, that often trigger the strongest memory."

I Love You, 2003
Alkyd on Linen
11"h x 14"w

"The initial significance of a snapshot lies in who or what they capture, not in its artistic merits. What is central to the painting is the sense of concrete experience being evoked."

Drink, 2001
Gouache and
Flashe on Paper
$5\frac{1}{2}$"h x 7"w
Private Collection

Tomorrowland
2003
Alkyd on Linen
11"h x 14"w

Mary Henderson received her Post-Baccalaureate Certificate in Studio Art from Brandeis University in Massachusetts, and her Master of Fine Arts from University of Pennsylvania. Henderson has exhibited at Gross-McCleaf Gallery in Philadelphia; Zg Gallery and gescheidle gallery in Chicago; Kenise Barnes Fine Art in Larchmont, New York; Delaware Center for Contemporary Art in Wilmington; and Momenta Art and White Columns in Brooklyn and New York City. In 2003 she was granted an artist residency from the Jentel Foundation in Banner, Wyoming. Henderson is represented by Zg Gallery.

NANCY HILD

"I use animal imagery in most of my work in what I consider a still life context."

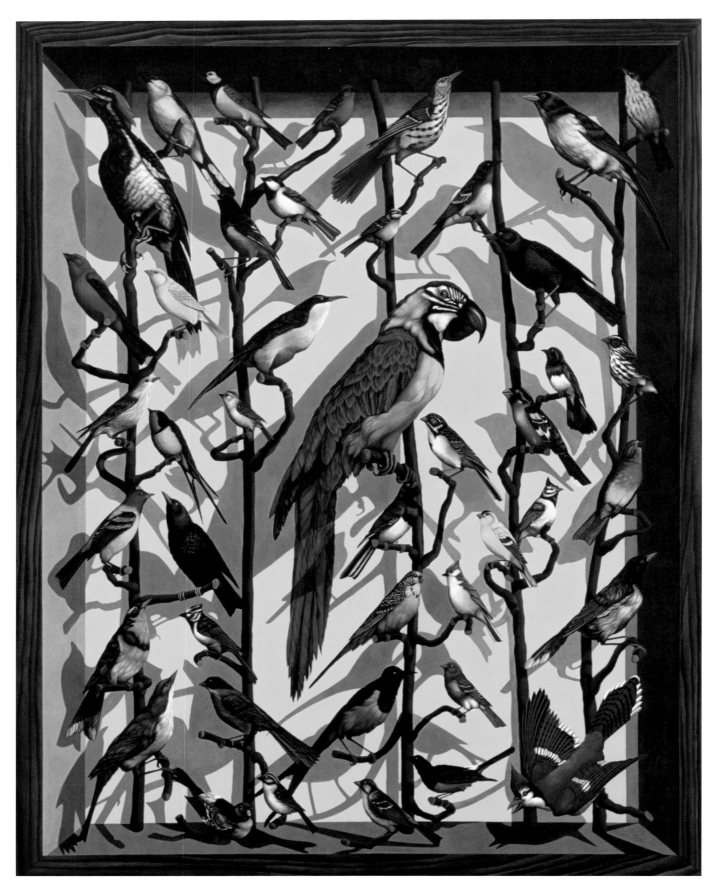

The VainGlorious Parrot, one of three in the *Bird Room* installation at the Chicago Cultural Center
2001
Acrylic on Canvas
60"h x 48"w x 1½"d

"*The Bird Room* project grew out of my simultaneous interests in natural history, early museums and the 17th century examples of 'nature morte'. The three paintings use a trompe l'oeil approach to a still life tableaux. Their titles reflect human attitudes towards the central birds: *The VainGlorious Parrot, The Approaching Magpie* and *The Dreadful Raven.*"

Untitled #9, 2002
Acrylic on Panel
10"h x 8"w

Nancy Hild received her Bachelor of Fine Arts and Master of Fine Arts degrees from Indiana University in Bloomington. She has been a lecturer and guest artist at University of Wisconsin in Madison; Evanston Art Center, The School of the Art Institute, and Columbia College in Illinois; Savannah College of Art and Design in Georgia; and National Women's Caucus for the Arts in Seattle.

Since 1983 Hild's work has been in dozens of solo and two-person exhibitions in Chicago; Wisconsin; Arizona; Belfast, Northern Ireland; Ouidah, Republic of Benin, West Africa; and Oaxaca City, Mexico. In 2001 she had a solo exhibition *The Bird Room* at the Chicago Cultural Center. In 2003 she had shows at the Leigh Yawkey Woodson Art Museum in Wausau, Wisconsin, and at the Charles A. Wustum Museum in Racine, Wisconsin. She has also shown her work at gescheidle, Las Manos and Artemisia Galleries in Chicago over the years.

Hild is the recipient of several grants and awards from The National Endowment for the Arts to an Illinois Arts Council Project Completion Grant. In 2003 she was the Chicago Sister Cities representative for *Shanghai in the Eyes of World Artists* held in Shanghai.

NIKKOLE HUSS

"Handwritten or threaded lines filling a surface are innately imperfect. Imperfections allow us to connect with others and recognize common patterns."

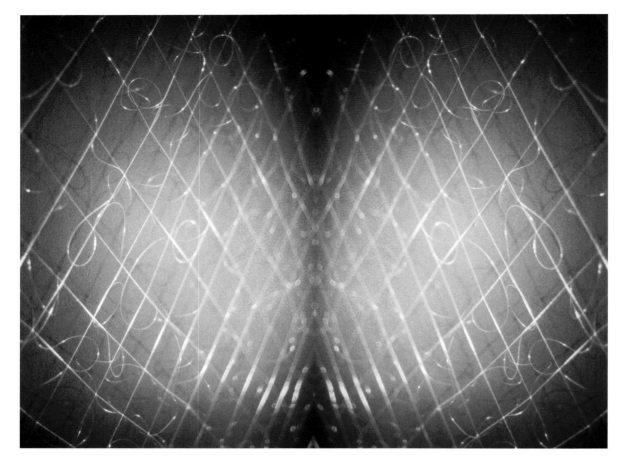

Monofilament Green-Gold

2003
Monofilament
30"h x 40"w x 2"d

"One in a series of threaded installations composed entirely of monofilament suspended two inches away from a wall painted yellow-green."

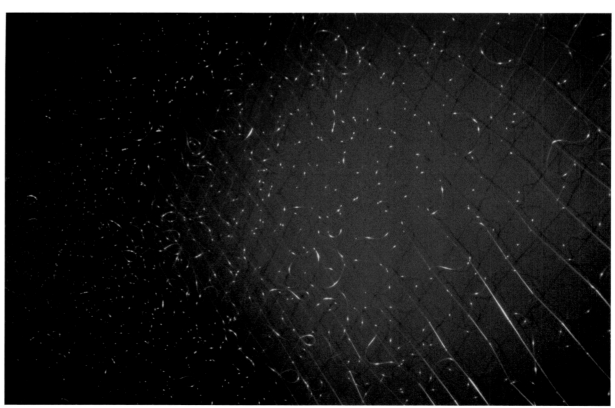

Monofilament Blue

2003
Monofilament
9'h x 15'w x 2"d

Phenomena Perceived II, 2003
Monofilament
30"h x 40"w x 2"d

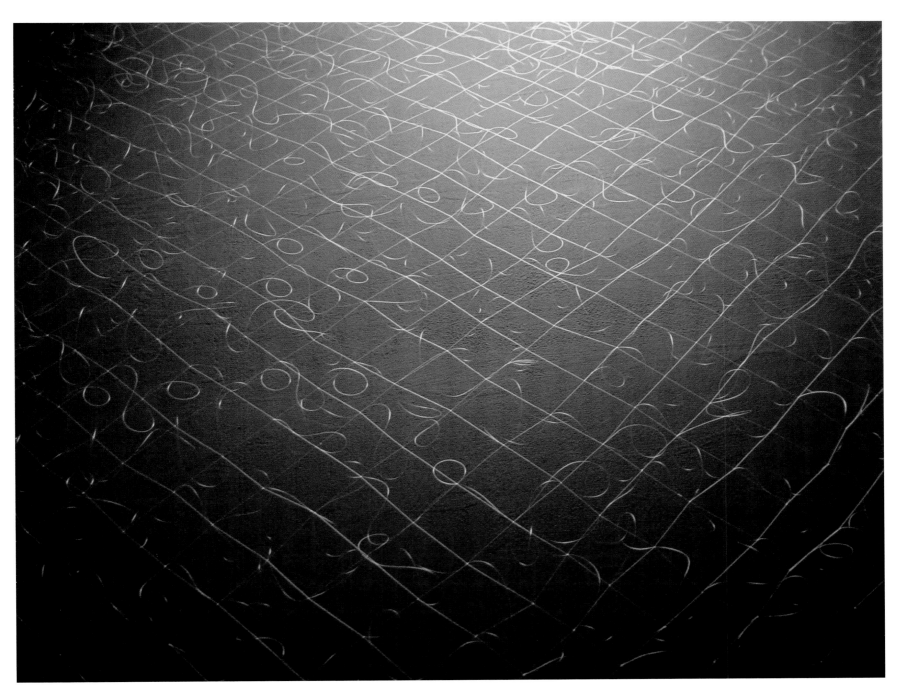

Nikkole Huss received her Associate of Arts degree from Moraine Valley Community College and her Bachelor of Science in Education from Northern Illinois University with additional studies at the American University of Rome in Italy. In 2004 she completed her Master of Fine Arts degree from The School of the Art Institute of Chicago.

Huss has exhibited work at the Betty Rymer Gallery, the 1926 Exhibition Studies Space, the DeCaprio Gallery, and the Zeke & Neen Space in Chicago. She also participated in *Art Hotel* at the Embassy Suites.

IGOR & MARINA
IGOR KOZLOVSKY & MARINA SHARAPOVA

"We are a married couple. Though we've worked together for twenty years, we spend most of our work time arguing. Between Igor's subtle sense of color, texture, and abstract images, and Marina's realistic drawings, we attempt to combine the Russian avant-garde with images based on Italian and Dutch Renaissance, while adding a surrealistic touch. The result is worth the pains of collaboration."

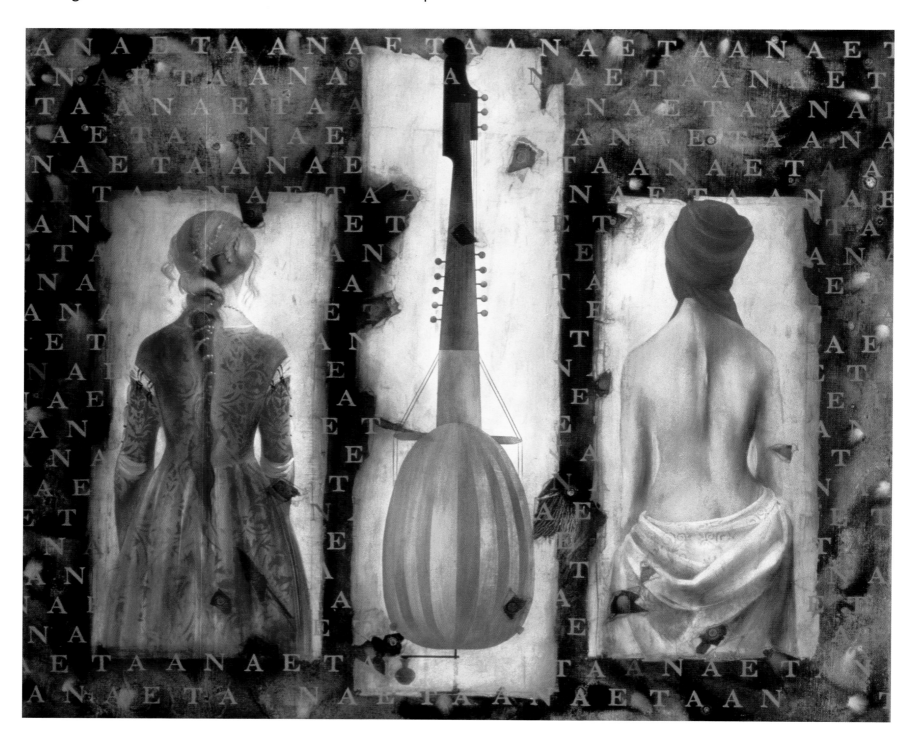

Behind the Scene from *A Renaissance That Never Was* series, 2002
Oil on Canvas, 48"h x 60"w

Diana

2003
Oil on Canvas
62"h x 48"w

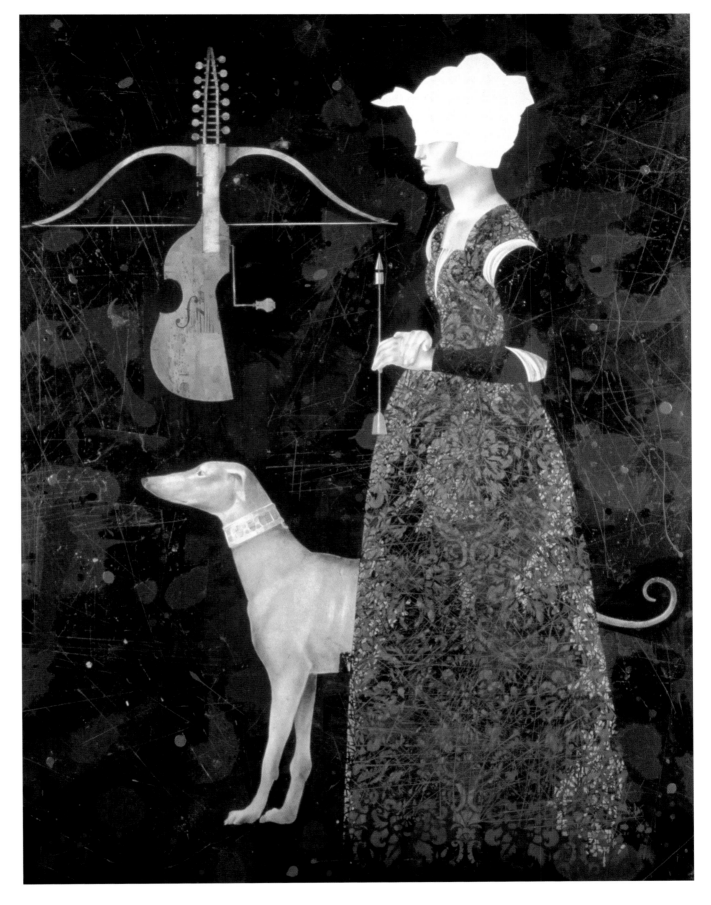

Igor Kozlovsky and Marina Sharapova were born in Russia. They both received their MFA from Mukhina Academy of Art and Design in St. Petersburg in 1985. They have done book illustrations and graphics design for Northwestern University in Evanston, Illinois since 1997.

Kozlovsky and Sharapova have had many exhibitions in Russia, Byelorussia, Latvia, France, Germany, Finland and the United States. They have had two-person shows at the Consulate of France in St. Petersburg; UNESCO International Federation of Artists, and Federation of Interior Architects in Russia; Centre Culturelle de St. Malo in France; Ravinia Festival in Highland Park, Illinois; Eastwick Gallery, and Thomas Masters Gallery in Chicago, which represents them. They are also represented by Lisa Kurts Gallery in Memphis, Tennessee, Fay Gold Gallery in Atlanta, Georgia, and Artemise Gallery in Dinard, France.

GREGORY JACOBSEN

"My work deals with grotesque characters and situations. Figures limp and hobble on and off the stage. Boils, pustules, bashed in noses, big beefy hairy bodies flap. It's pathetic. Everyone laughs."

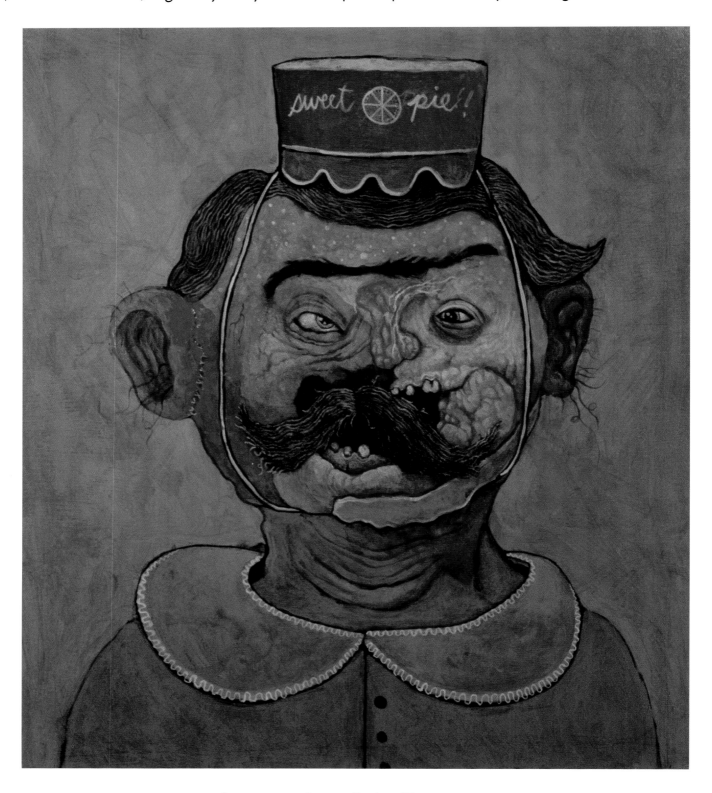

False Mustache Boiled Off Fat Face, 2002
Acrylic on Wood
12$^{1}/_{2}$"h x 10"w

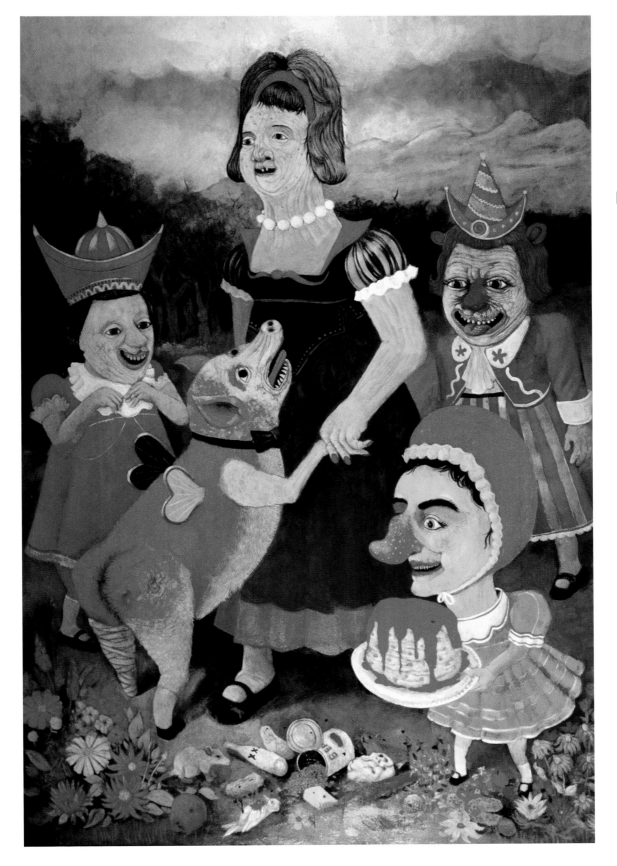

Regal Procession
2003
Acrylic on Wood
34¼"h x 24"w

Gregory Jacobsen received his Bachelor of Fine Arts from The School of the Art Institute of Chicago in 1998. He is also a performance artist with the local collective, Lovely Little Girls. He was awarded the artist in residence grant for the *Frump! Strumpet! Strife* radio show from Experimental Sound Studio in 2000.

Jacobsen has shown his work at many Chicago venues such as Hotel Kafka, Quimby's, The Butcher Shop, Dogmatic Gallery, Contemporary Art Workshop, Chop Shop, Zolla/Lieberman Gallery, Heaven Gallery, and at Zg Gallery, which represents him.

BEVERLY KEDZIOR

"Our society's biological and botanical advancements are both fascinating and repulsive. Human organs are transplanted, genes are manipulated, embryos are frozen and animals are cloned. Fruits and vegetables are manipulated to produce hybrids that never before existed and nature never conceived. Our ability to control is overshadowed by our inability to control the outcome. My work is based on images I've dissected from biological and botanical illustrations and images gleaned from animated movies, Sunday comic strips and Saturday morning cartoons."

Black Meander, 2003
Acrylic on Paper
22"h x 30"w

Prattling Brook, 2004
Acrylic on Panel
24"h x 24"w

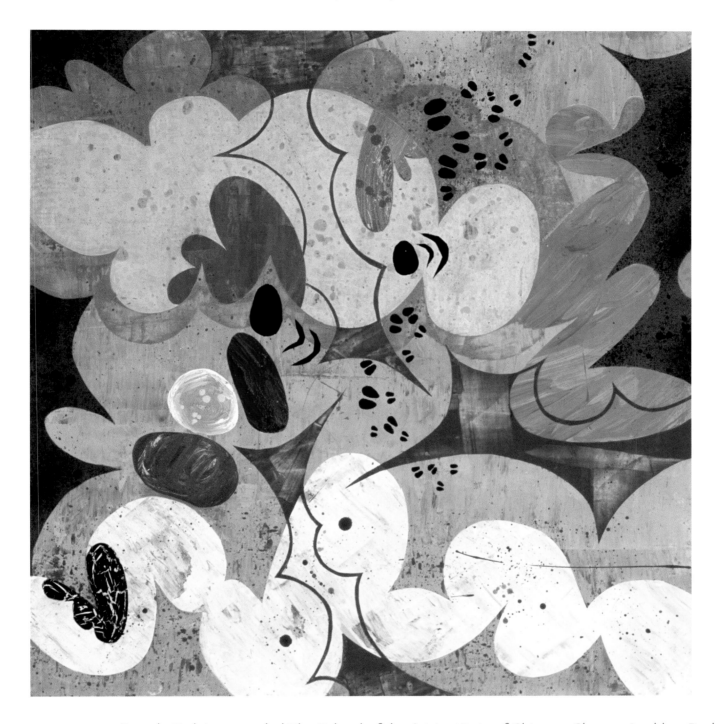

Beverly Kedzior attended The School of the Art Institute of Chicago. She received her Bachelor of Fine Arts from Barat College.

Kedzior has exhibited extensively since 1987. She has had solo exhibitions at South Bend Museum of Art in Indiana; Kishwaukee College Art Gallery, Dramaticus Gallery, Evanston Art Center, University of Illinois at Chicago, ARC Gallery and Artemisia Gallery in Illinois. In recent years her work has also been shown at Freeport Museum of Art and Rockford Art Museum in Illinois; and Davenport Museum of Art in Iowa. She is represented by Kraft Lieberman Gallery in Chicago.

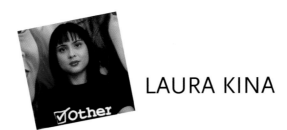

LAURA KINA

"The ongoing *Hapa Soap* series started in 2002 is based on mixed-race people I have photographed from around the United States. Hapa is a Hawaiian word referring to a person of mixed blood with partial roots in Asian or Pacific Islander ancestry. My work draws inspiration from Asian film posters and portrait genres. They play with the ideals of the American melting pot and the anxieties and hopes surrounding the 'browning of America'."

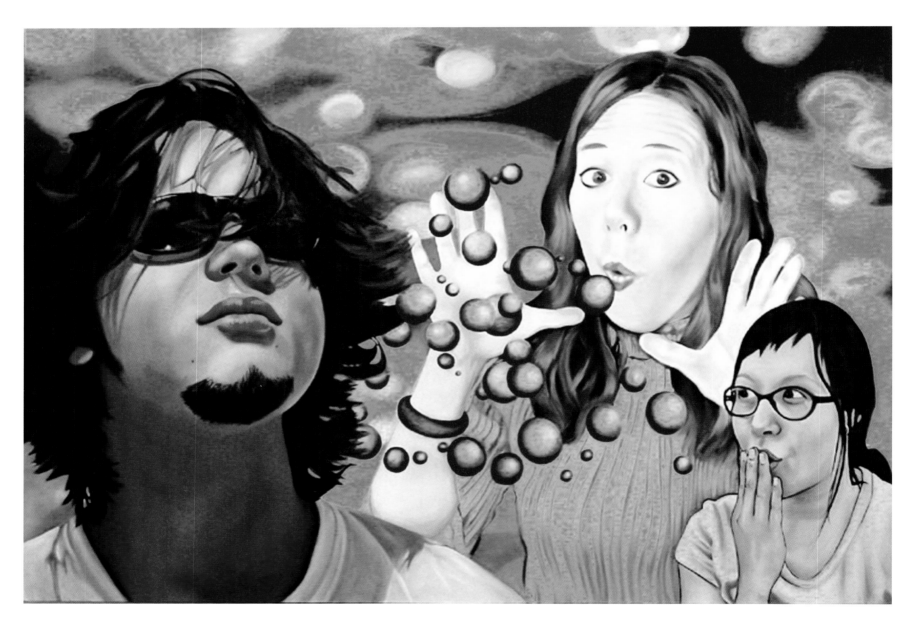

"I find hapas to work with me through word of mouth and by networking with organizations such as The Asian American Artists Collective in Chicago, Godzookie in New York, Asian Art Initiative in Philadelphia, Hapa Issues Forum in San Francisco and Mavin Magazine in Seattle."

Hapa Soap Opera #3, (Joe Kina, Isabel Cernada, Amanda Ross-Ho)
2003
Oil on Canvas
48"h x 72"w

**Hapa Soap Opera #5
(Joey Nakayama, Robert
Karimi, Jef French)**
2003
Oil on Canvas
72"h x 48"w

Born in California and raised in
Washington, Laura Kina's Hapa
status comes from her third
generation Okinawan father
from Hawaii and her Caucasian
mother. Kina moved to Chicago
in 1991. She received her
Bachelor of Fine Arts from The
School of the Art Institute of
Chicago in 1994 and her Master
of Fine Arts from the University
of Illinois at Chicago in 2001.

Kina has taught at The School
of the Art Institute of Chicago
and Evanston Art Center. She is
now teaching at DePaul
University. Kina has had solo
exhibits at Diana Lowenstein
Fine Arts in Miami, which
represents her, and at the
Union League Club and Casa de
Arte y Cultura in Chicago. In
recent years her work has been
exhibited widely in Philadelphia,
New York City, Miami and
Chicago. In 2003 her work was
shown in Tokyo, Japan.

KATHLEEN KING

"Producing obsessive and hypnotic surfaces is my way to engage the viewer in an ongoing visual dialogue with my artwork. The media employed are acrylic, acrylic transfers and oil on canvas."

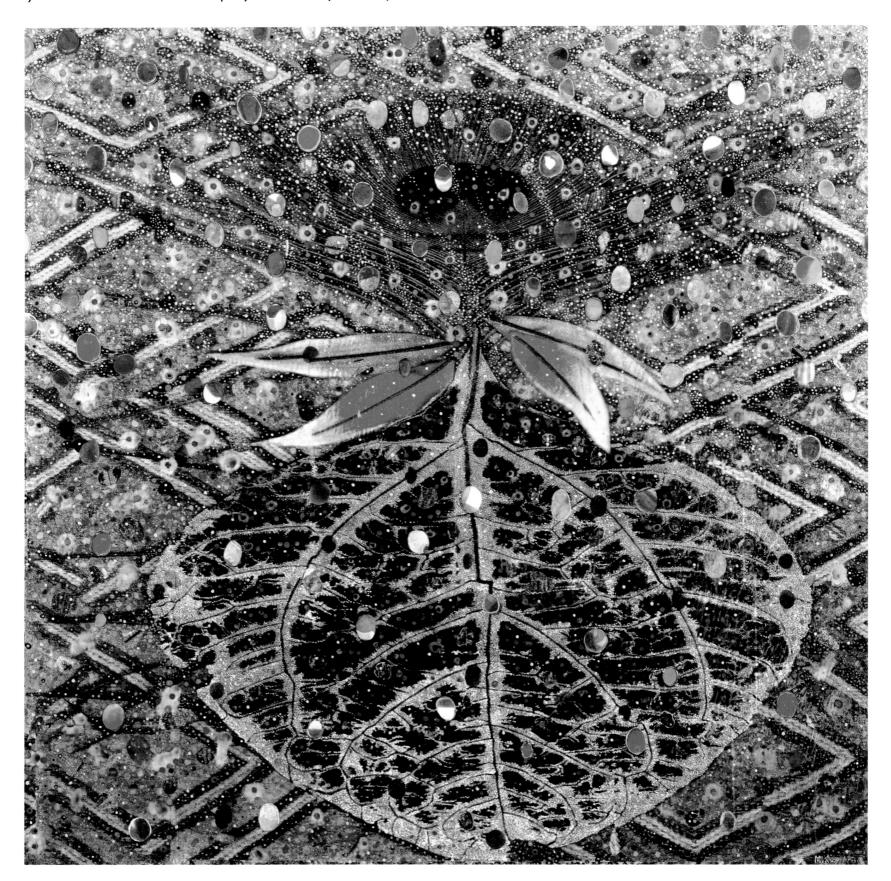

(opposite) **Ellipticity,** 2003
54"h x 54"w x 1½"d
"Is this attractive leaf-like aquatic creature resting contently or is it lurking, posed to attack a victim?"

(right) **Late Arrival,** 2003
36"h x 36"w x 1½"d
"The dark Icarus wing-like form is shown hovering over a sea-like surface. The image depicts a moment of perfection before his fall."

(below) **Natural Emblem,** 2003
36"h x 81"w x 1½"d (5 parts)
"A dark world loaded with swimming creatures opens to reveal a lighter filled realm within it."

Kathleen King received her BFA and MFA from The School of the Art Institute of Chicago. She teaches drawing, painting and printmaking at Loyola University in Chicago and is the Faculty Advisor for the Co-operative Education Program at The School of the Art Institute. Her recent solo exhibitions are at Drake University in Des Moines and Fine Arts Building Gallery in Chicago. She recently also exhibited at Viridian Gallery, Lobby Gallery and at the John Jay College of Criminal Justice, all in New York City. She is represented by Viridian Gallery, Fine Arts Building Gallery, and The Steeple Gallery in St. John, Indiana.

NIKI KRIESE

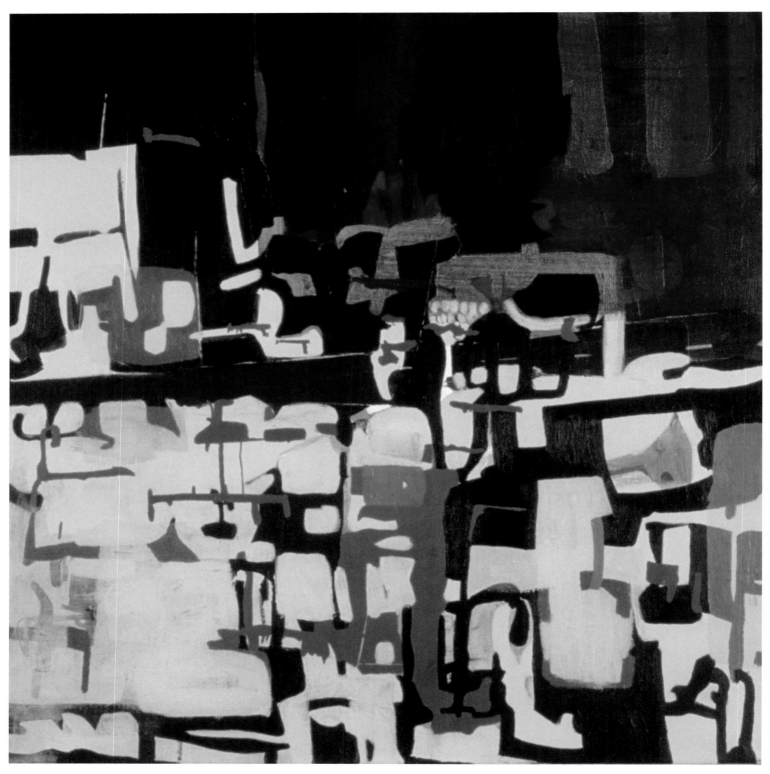

Sun-Vulnerable from the
Shadows series, 2003
Acrylic on Canvas
24"h x 24"w

"*SV* is a personal favorite because of the process involved. I began with layers of random marks. Then I applied repeated overall treatment, such as spraying with water or rubbing with sandpaper. Then I went back in to smooth edges, fill in shapes and change colors. The result is forms that are organic and abstract yet decisive."

New & Used

2003
Acrylic on
Canvas
32"h x 32"w

"This painting depicts one of the most ubiquitous elements of a Chicago neighborhood, the wooden back porch. Seen from any angle, the slats overlap, creating nuanced shadows and slivers of light. Color selection is crucial in the shadow paintings."

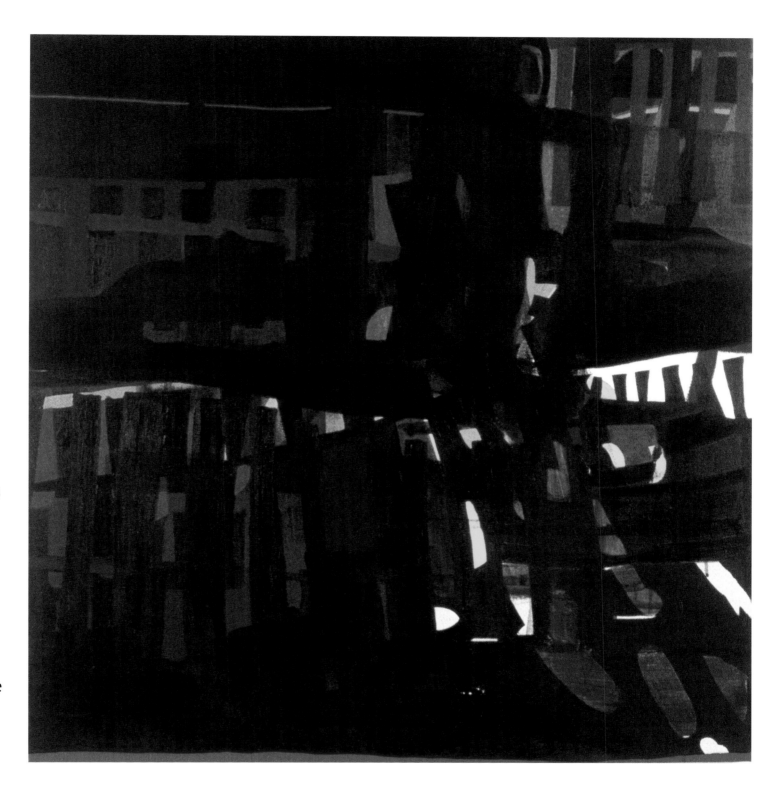

Niki Kriese studied at the Kansas City Art Institute in Missouri and received her Bachelor of Fine Arts from The School of the Art Institute of Chicago in 2000. She has had residencies at the Ox-Bow School of Art in Saugatuk, Michigan, and the Montana Artists' Refuge in Basin, Montana. In 2002 and 2003 she was awarded the Community Arts Assistance Program Grant from the Chicago Department of Cultural Affairs.

Kriese has had solo and two-person exhibitions at Bradley Gallery in Sheboygan, Wisconsin; Gallery 645, 18 Artists Gallery, Second Floor Gallery and Chicago Diner in Chicago; and at Guillemette Gallery in Butte, Montana. Her work will be at the Arthouse at The Jones Center in Austin, Texas through 2005.

ROLAND KULLA

"Nuts and Bolts are two common and mundane elements. Something we take for granted. And yet these most ordinary items coupled with human ingenuity and skill can be transformed into amazing structures. In this case, the structures that inspire the work are Chicago's many bridges. The creation of this series was greatly assisted by a residency at the Ragdale Foundation in Lake Forest, Illinois."

Cermak II from the *Nuts and Bolts* series, 2002
Acrylic on Canvas
45"h x 68"w

"Cermak II is the bridge near Chinatown over the South Branch of the Chicago River at Cermak Road."

Slow/Fast
2003
Oil and
Acrylic on
Canvas
36"h x 36"w

Roland Kulla received his Bachelor's degree from Bellamine College in Louisville, Kentucky, and his Master's degree from The School of Social Service Administration from the University of Chicago in 1976. He had spent ten years in the seminary before working as a caseworker, administrator, and researcher for 30 years. He was also a choral singer for a decade in symphony, opera and musical comedy, and designed sets and costumes. His interest in architecture led him to the award-winning restorations of an 1890 Victorian house and his 1907 apartment in Chicago's Hyde Park neighborhood.

Kulla has been sketching , drawing and watercoloring since college. Later he switched to oils, then to acrylics. In 2002 he started painting full-time. Aside from the galleries that represent him, Fine Arts Building Gallery in Chicago and The Steeple Gallery in St. John, Indiana, he has also had solo exhibitions at Bloomingdale Art Museum in Illinois, and at Union League Club, The University Club, Beverly Art Center, and Illinois Institute of Art in Chicago, to name a few. His work will be at the Rosewood Arts Center in Kettering, Ohio in 2005. He is also represented by George Billis Gallery in New York City and Aron Packer Gallery in Chicago.

RENA LEINBERGER

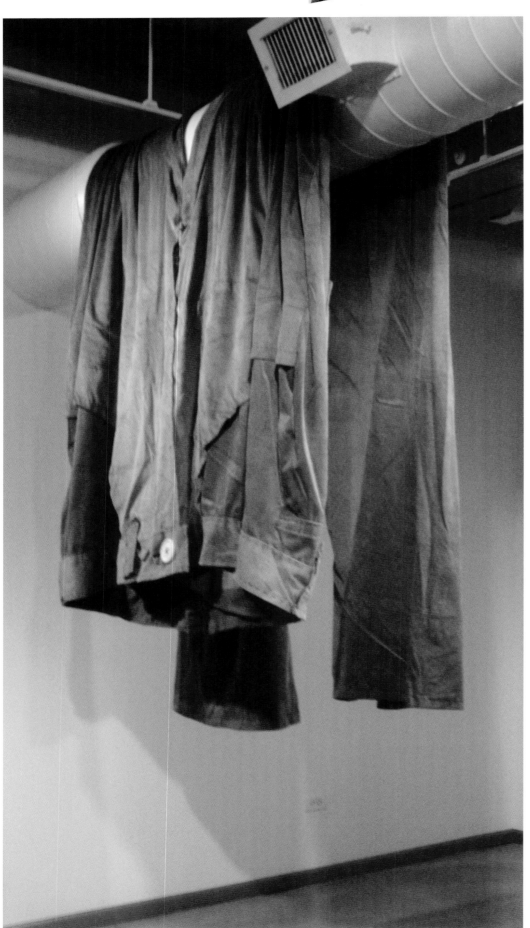

"My interests reside in taking aspects of familiar surroundings and somehow tweaking or altering them to make them slightly off, uncanny, and perhaps a bit disturbing and unfamiliar. This brings attentiveness and awareness to what often become the backdrops of our daily living, the spaces, architecture, surfaces and objects we looked beyond and moved past."

Lapse
Installation, 2003
Cotton Corduroy
156"h x 64"w

Drain
Installation, 2002
Wool Felt, 22$\frac{1}{2}$"h x 1$\frac{1}{2}$"w each

Rena Leinberger received her Bachelor's degree from Anderson University in Indiana in 1998 and her Master of Fine Arts from The School of the Art Institute of Chicago in 2002. In 2003 she was featured in the *12 x 12: New Artists, New Work* show at the Museum of Contemporary Art in Chicago. She has also had solo exhibitions at Gallery 400, Zg Gallery, and 1R Gallery, and group exhibitions at Klein Art Works, Northern Illinois University, and Evanston Art Center in the Chicago area as well as in Indiana, Texas and Germany.

Leinberger is a member of the collaborative team *Lint* with Ben Butler. Their outdoor exhibit, *Waiting,* was on the grounds of the Evanston Art Center from the Summer of 2003 through the Spring of 2004. Also a writer, Leinberger's interview of Helen Mirra appeared in the Winter/Spring, 2003 issue of Bridge Magazine. She is represented by Zg Gallery in Chicago.

SYDNEY LICHT

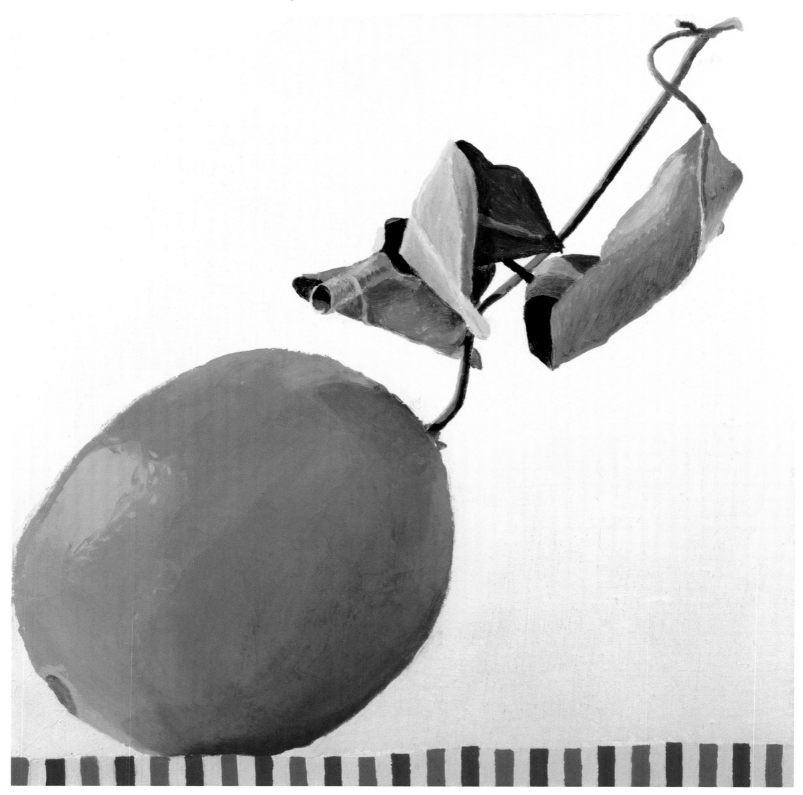

Still Life with Orange and Stem #1

2003

Oil on Linen

12"h x 12"w

"I am visually intrigued by the difference between the color and rounded shape of an orange and the assorted textures of its green leaves."

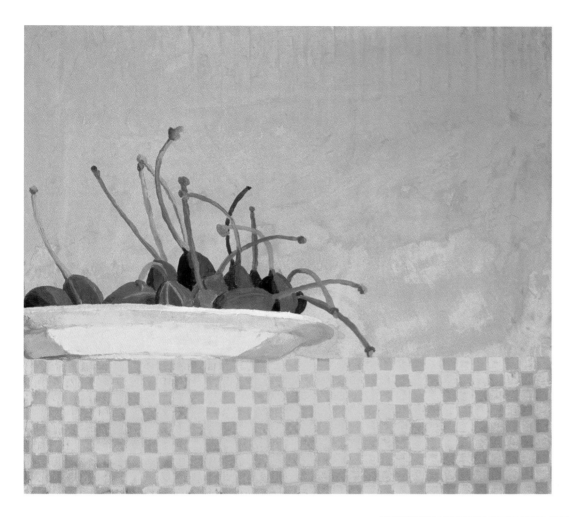

Sydney Licht received her Bachelor's degree from Smith College in Massachusetts. She also attended the Skowhegan School of Painting & Sculpture before studying at and graduating from The School of the Art Institute of Chicago with her Master of Fine Arts degree in 1983. She has taught at many schools, including Alfred University and the University of Rochester in New York, Ohio State University at Columbus, The School of the Art Institute of Chicago, and the Silvermine School of Art in New Canaan, Connecticut.

Licht has had solo exhibitions at gescheidle in Chicago, which represents her, as well as Lyonswier Packer Gallery in Chicago, SPACELab in Cleveland, Hobart & William Smith Colleges and 55 Mercer in New York.

Still Life with Caper Berries

2002

Oil on Canvas

16"h x 18"w

"In this piece I focused on the shapes of the caper berries with the many directions and the disorganization of their stems, as opposed to the regular pattern of the tablecloth."

Still Life with Cantaloupe

2002

Oil on Canvas

12"h x 12"w

SHONA MACDONALD

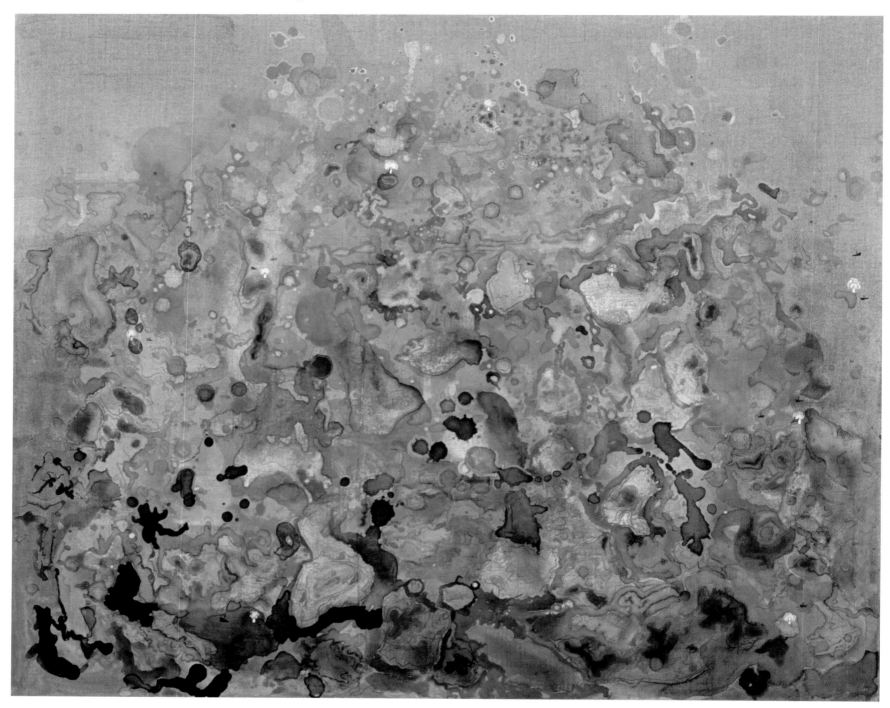

Invisible Isles #2, 2001
Gouache, Thread, Pencil,
Matte Medium on Linen
21"h x 25"w

"This piece is based on the Italo Calvino short story, *Invisible Isles.* Imaginary islands and other rocky landforms are brought to the surface by lobs, drops and spills of paint. The stacked composition builds the landmass as individual isles clustered together."

"This piece is comprised of hundreds of tiny horizontal strips of undulating, waving envelope innards. The innate earth-tone palette of the security envelopes and the coaxed waves of paper produce a heaving sea-like form. The waves of paper spilling onto raw linen suggest aerial views of the tide ebbing and flowing. This work was made after a six-month stay by the North Sea in North East Scotland."

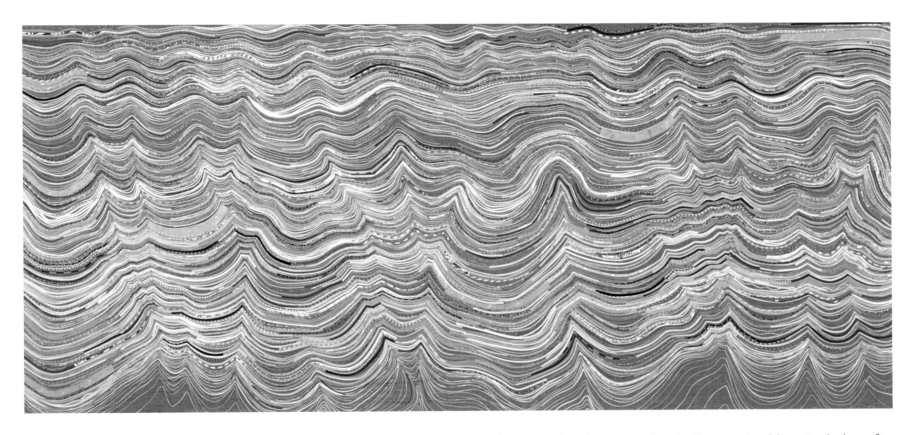

Sea of Envelopes

2000

Envelopes, Rice Glue,
MSA Varnish on Linen

31"h x 69"w

Shona Macdonald was born in Aberdeen, Scotland. She received her Bachelor of Fine Arts from the Glasgow School of Art in Scotland in 1991 and her Master of Fine Arts from the University of Illinois in Chicago in 1996.

Macdonald teaches art at the Illinois State University in Normal. She has been a visiting artist at The School of the Art Institute of Chicago, University of Illinois at Champaign-Urbana, University of Alberta, and University of Calgary, and has presented at Wimbledon College of Art in London.

Macdonald has had solo exhibitions at Fassbender Gallery, which represented her until it closed in 2003. She also had one-person exhibitions at Julie Baker Fine Art in Grass Valley, California, and Suffolk County Community College in Long Island, New York. Her work was shown at Galerie refugium in Berlin, Germany in 2002, and was shown at Dogmatic Gallery and at gescheidle in Chicago in 2004.

RENEE MCGINNIS

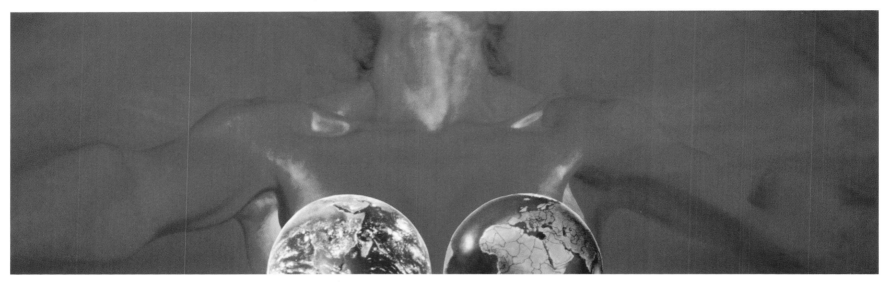

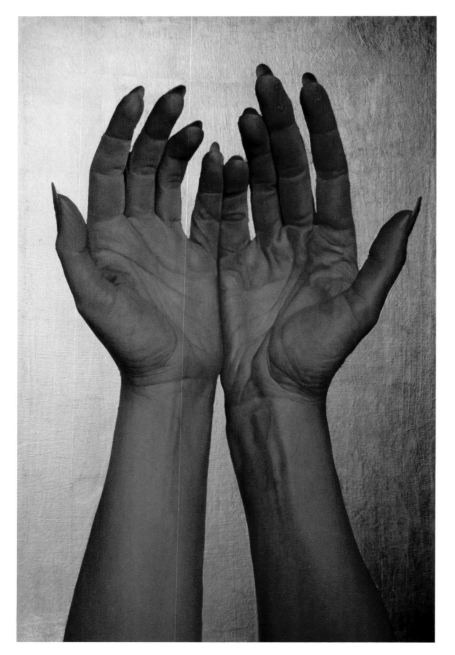

Mars, 2000
Oil on Canvas, 21"h x 71"w

"The red planet is a reminder of how
uninhabitable the universe is for all forms of
life. One glorious little planet not only
sustains us, Earth also is an infinite source of
wonder and beauty."

Open Prayer
2002
Oil, 23K Gold Leaf
30"h x 22"w

"Our hands are used in ritual.
The position and gesture of our
hands can communicate an
abundance of information."

Saviour Savings

2001

Oil, 23K Gold Leaf on Canvas

36"h x 52"w

"A crucifix is an object of worship. Here the sacrificed has turned to face and worship gold. Before the economic downturn of 2001, our citizens were unable to save a portion of their earnings for lean times."

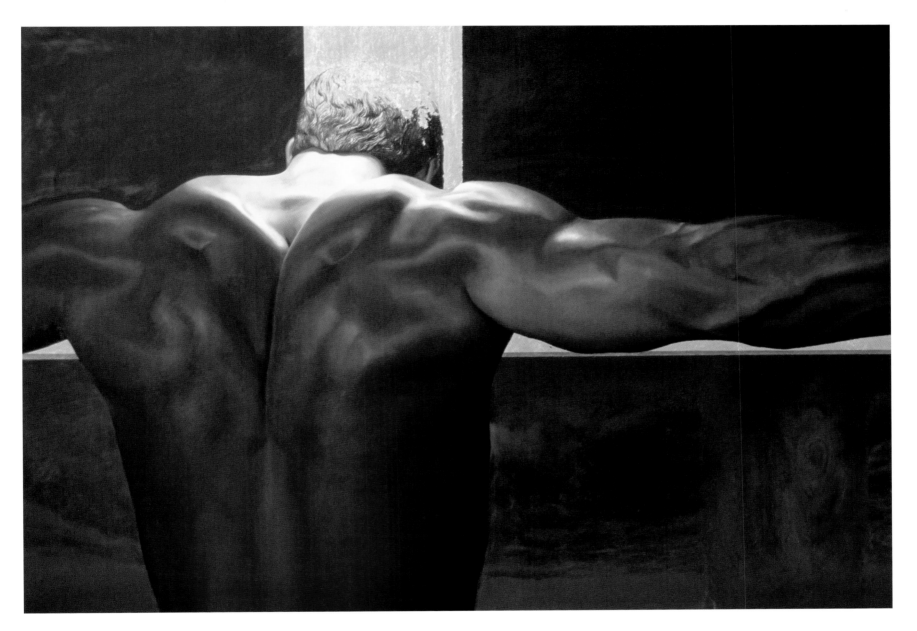

Renee McGinnis received her Bachelor of Fine Arts from Illinois Wesleyan University in 1984. She was the curator of the *Teen Living Exhibition* at ARC Gallery in 2000 and the *Chicago Solution Show* at Schopf Gallery on Lake in 2003. McGinnis has received many awards and honors over the years. Recently she's been juried into *Blues, Jazz, Dance—That's Chicago* at Gallery 415, *I See London I See France* at the ARC Gallery, the *Chicago Solution Show, Works on Paper* at the Eastern Illinois University and *Animal Images* at The Anti-Cruelty Society in Chicago. Her work has also been juried into international shows in New York City. She was a delegate to China with the Women's Caucus for Art in 1999. Her recent solo exhibitions were held at ARC Gallery in Chicago, University of Illinois at Chicago, and Fraser Gallery in Maryland.

NANCY MLADENOFF

"For the past several years the focus of my work has been to explore the natural world in greater depth. My work continues to revolve around transient things that exist on a small scale, in particular, fungi and insects. I am fascinated by our love-hate relationship with these small oddities that are rarely even noticed."

Spiders, Fungi, Etc., 2003
Latex, Spray Paint on Canvas, 32"h x 38"w

"hush, you mushrooms...", 2003
Wall Painting/Digital Photography
Installation at Wendy Cooper Gallery

"My work has expanded to include digital photography and installation. Props such as mirrors and colored modeling clay has also found their way into the work recently."

Nancy Mladenoff received her Master of Fine Arts from The School of the Art Institute of Chicago. She has had solo exhibitions at Wendy Cooper Gallery in Madison, Wisconsin and Aron Packer Gallery in Chicago, both of which represent her, as well as at Dean Jensen Gallery in Milwaukee, and Wake Forest University in Winston-Salem, North Carolina. In recent years, she has been invited to exhibit at Forest Art Path and Theater Gallery in Darmstadt, Germany; Museu de Arte de Brazil in Brasilia; The Beaker Gallery in Florida, Ten in One Gallery and the Wall Street Viewing Room in New York City, Davidson Galleries in Seattle, and the Milwaukee Art Museum.

MR. IMAGINATION
GREGORY WARMACK

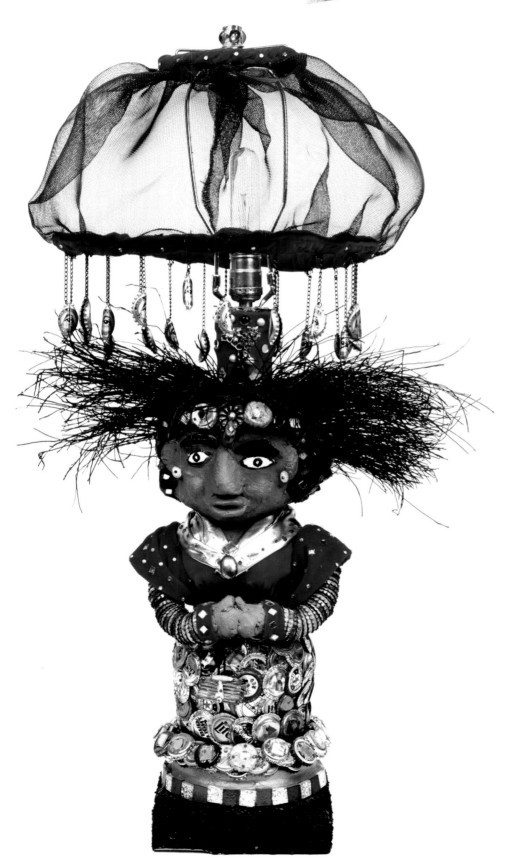

"This piece was named after Mr. I's grandmother. When Mr. I agreed to sell this lamp, it needed a shade. My husband, knowing that Mr. I had toyed with the idea of working with screen, suggested that screen would make an interesting shade. Mr. I liked the idea. After he made this shade, he made one or two more." — Sherry Siegel

Anna, 1998, Lamp, Broombristles, Velvet, Bottlecaps, Wood Putty, Paint, Fabric, Chain, Screen, Metal, Crystal, Buttons, Rhinestones, Mirror Bits, $32^{3/4}$"h x 18"w
Collection of Robert Alter and Sherry Siegel

Gregory Warmack is a Chicago self-taught artist who recently moved to Bethlehem, Pennsylvania. He had such frequent epileptic seizures as a child that his mother took him out of school at ninth grade. In the early years he often worked with scavenged materials on his porch and made art with neighborhood kids who sought him out. His near-death experience in 1978 solidified his calling as an artist. Soon after that, he took on the name, Mr. Imagination. In 1982 his apartment burned down and his burnt sandstone sculptures caught the attention of Carl Hammer, a gallery owner. He has since had numerous exhibits at galleries and art museums in Chicago, Boston, New York, Dallas and Philadelphia. At least seven of his works are at the Smithsonian Institution. He is represented by Koelsch Gallery in Houston, Primitive Kool in San Diego, Grey Carter in McLean, Virginia, and Home and Planet in Bethlehem, Pennsylvania.

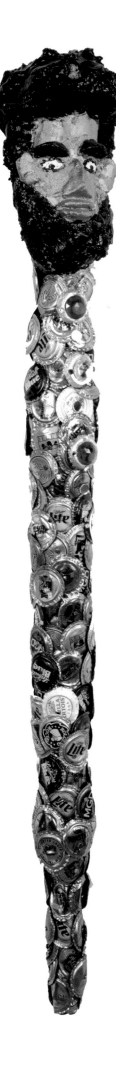

Self-Portrait Staff

2001
Bottlecaps, Wood
Putty, Paint,
Wood, 32$\frac{1}{2}$"h
Collection of
Robert Alter and
Sherry Siegel

"This piece began its first life as a turn of the century stairway spindle. Its second life began when we gave it to Mr. I. Mr. I doesn't work on just one thing at a time. The volume and variety of work that gets done are astonishing. He transformed the spindle in 4-5 days along with other pieces. Typically, his other pieces consist of totems, thrones, broom and brush heads, necklaces and pins."
— Sherry Siegel

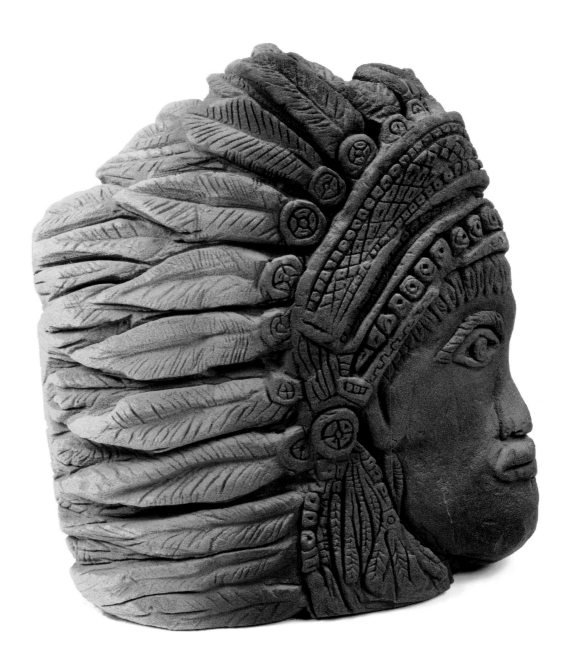

Native American Head, 1990
Sandstone, 24"h x 21$\frac{3}{4}$"w
Collection of Robert Alter and Sherry Siegel

"This is a mate to the one at the Smithsonian Institution, which faces the other way. Around 1980, I came upon a load of industrial sandstone that was dumped on the south side of Chicago. I brought a couple of them home and rubbed them over glue on the roof of the cardboard house I was working on at the time. I noticed that they are very soft rocks that can be carved. After that I would take a shopping cart and a shovel and go down there to that lot early in the morning and dig out these big blocks of sandstone."

SANDRA PERLOW

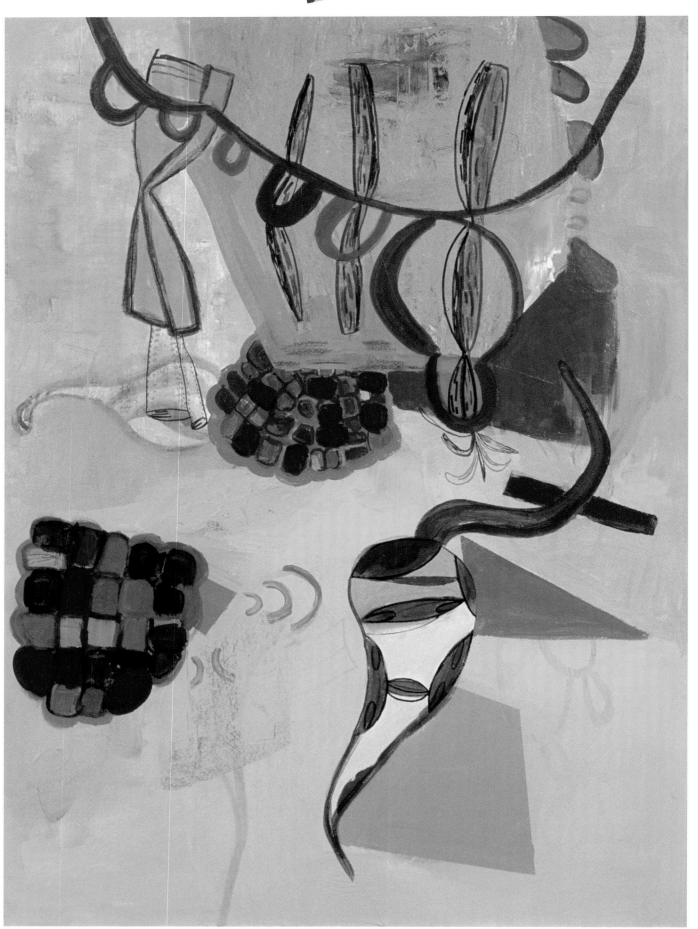

Bursting, 2003
Acrylic, Ink on
Paper
30"h x 22"w

"Organic and
geometric forms
quiver and sway in a
necklace-like shape.
The shapes exist on
layers of semi-
transparent
pigment."

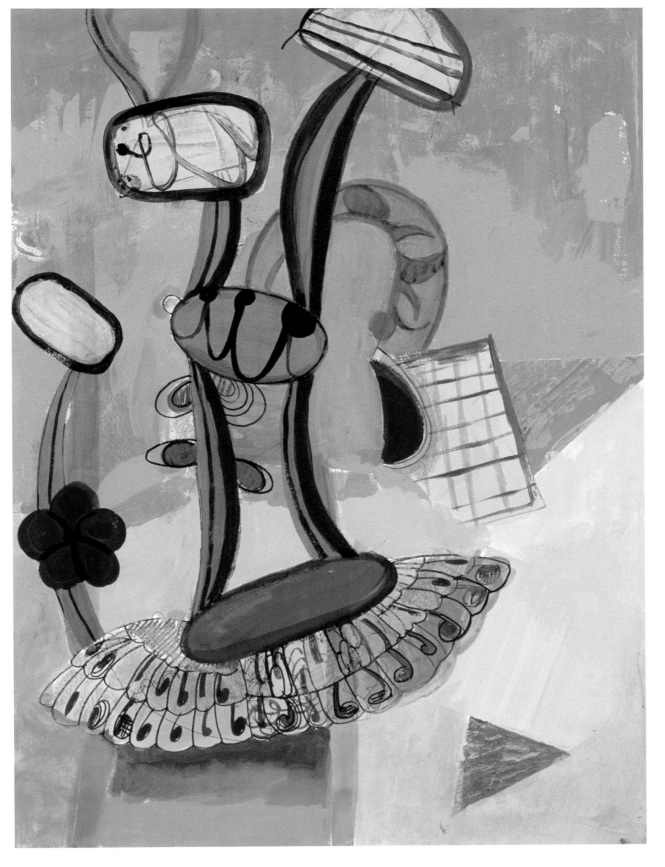

A Light Push
2003
Acrylic, Ink on Paper
30"h x 22"w

"This painting relates to flower and plant forms. The patterned surfaces conjure up memories of wallpaper and drapery designs."

Sandra Perlow received her Bachelor's degree and her Master of Fine Arts from The School of the Art Institute of Chicago. She also holds a Master's degree from Illinois Institute of Design.

In recent years Perlow has had solo exhibitions at the Chicago Cultural Center, Union League Club, Oakton Community College, and Freeport Art Center in Illinois, and at the Blue Mountain Gallery in New York City. She has also exhibited at the Evanston Art Center in Illinois, Uihlein Peters Gallery in Milwaukee, and The Painting Center in New York City. She has received awards from Artigas Foundation in Galifa, Spain and the Virginia Center for the Creative Arts. Perlow is represented by Gallery 72 in Omaha, Nebraska, and Morgan Gallery in Kansas City, Missouri.

DEBORAH PIERITZ

"Necessary to my working process is the rearranging and assembling of everyday materials—wood, string, paper, game pieces, schoolbooks, tin cans, toy parts—to create a slight shift from the original intention of these items. My curiosity with specific symbols, materials, words and numbers relates to the puzzles and problems of my early schooling and the subsequent reworking of that information into a more cohesive, metaphoric structure."

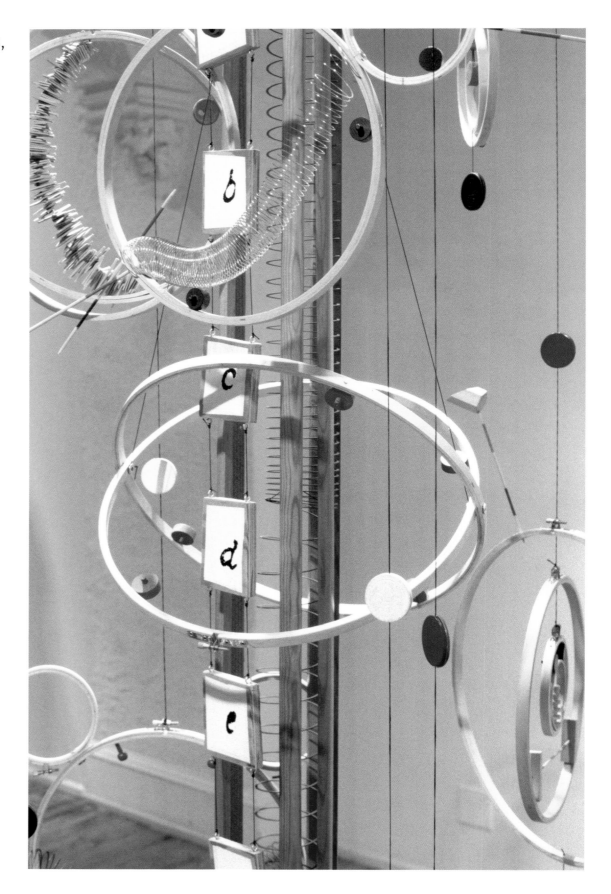

The Structure of Elementary Particles
(detail), 2002
Wood, String, Found Objects
90"h x 24"w x 24"d

"I did a massive cleanout of my studio and what was left was an odd assortment of items —erasers, hairpins, poker chips, pick-up sticks... I was reading a bit about matter and space and particles and such..."

Additions and Subtraction

2002
Wood, Flash Cards
8"h x 120"w x 6"d

"I'd been reading about additions and subtractions and how subtraction is as important as addition in physics and I just got the notion to use the whole set of flash cards in a see-saw fashion. Because the piece is ten feet long, the bars of cards tend to move up and down slowly, thus contradicting the notion of 'flash'. I like that."

Deborah Pieritz received her Bachelor's degree from Barat College, and her Master of Fine Arts from The School of the Art Institute of Chicago. Her many invitational exhibitions include Viridian Gallery in New York City, Fine Arts Building Gallery in Chicago, and Cedarburg Cultural Center in Wisconsin. Recently she had a solo exhibition at the Fine Arts Building Gallery, which represents her, and a two-person show at the new Beverly Art Center in Chicago.

Pieritz' work is in the collections of the Chicago Public Library, The Art Institute of Chicago Print Department, the Pratt Graphic Center in New York City, Barat College in Lake Forest, Illinois, Third Unitarian Church in Chicago, as well as numerous private collections.

When not creating artwork, Pieritz helps run Pieritz Bros. Office Supplies, her family's 109-year-old Oak Park stationery store.

ERIC B. SEMELROTH

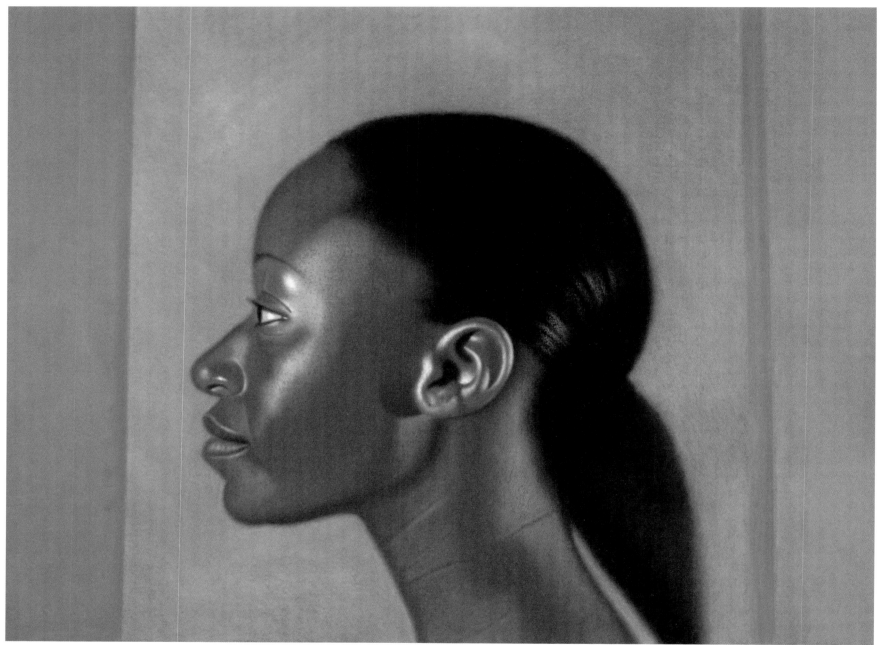

Casundra

2003

Pastel on Paper

20"h x 29"w

"I wanted to challenge myself with a profile portrait. A profile is flatter than a frontal or three-quarter view. Like a silhouette, there is an emphasis of shape over volume. I wanted an interplay of illusory space and flat two-dimensional space. The background went through several color changes. I borrowed a zip from Barnett Newman and a color combination from an Ellsworth Kelly painting. I added the green stripes to energize the space."

Muslim Madonna

2002
Pastel on Paper
29"h x 21½"w

"This portrait was inspired by the events of September 11. I aimed to fuse Christian and Muslim together in a single, nonviolent image. I recalled the ubiquitous blue robe of the Virgin Mary by coloring Muslim Madonna's veil blue. The sitter is the sister of a former coworker."

Eric Semelroth received his Bachelor of Fine Arts from the University of Illinois at Urbana-Champaign and his Master of Fine Arts from Northwestern University. He has been teaching art at the College of DuPage since 1991. He has also taught at Harper College, Northwestern University, and Triton College in the Chicago area.

Semelroth has had one person shows at the Union League Club, Contemporary Art Workshop, and the Triangle Gallery of Old Town, as well as at the Northern Indiana Arts Association in Munster. He has also exhibited at the Chicago Athenaeum, Chicago Art Open, Fine Arts Building Gallery, ARC Gallery, Rockford Art Museum, Riverside Arts Center, Galesburg Civic Art Center, College of DuPage and Harper College. He is the recipient of many awards and grants. His work is in the collection of the Harper College Educational Foundation.

VANESSA L. SMITH

"My challenge is to capture a sense of motion and change while playing with cross-exchanges and the visual likeness between the complexities and simplicities of the inner and outer self."

Ring of Fire

2002

Ceramic

$8\frac{1}{2}$"h x $16\frac{1}{2}$"w x 15"d

"Fire is an integral part of Ceramic Arts, as well as one of the most important earth elements. Fire can aid in creation yet it can also consume and destroy. The beauty of fire's devastation is that through burning, ground is left for new growth."

Crista

2002

Ceramic

$16^{1/2}$"h \times $8^{1/2}$"w \times 12"d

"Crista refers to crests or ridges. It can also refer to an inward projection of the inner mitochondrial membrane in cells of living organisms, which contains enzymes that convert food into energy. Here I am drawing attention to the necessity of a strong inner richness."

Vanessa Smith received her Bachelor of Fine Arts from University of Akron in Ohio in 1987 and her Master in Fine Arts from The School of the Art Institute of Chicago in 1993. She has been teaching at museums, schools, art centers and university programs in Illinois and Ohio since 1987. In 1997 she started teaching at the Evanston Art Center in Illinois. Her work has been exhibited at the Fine Arts Building Gallery in Chicago, Evanston Art Center, Northeastern Illinois University and Aron Packer Gallery in Chicago.

YVETTE KAISER SMITH

"I am interested in patterns and issues that play a role in the construction of one's identity."

Misconception (with detail), 2002
Crocheted Fiberglass, Polyester Resin, Enamel
79"h x 111"w x 39"d

"This piece speaks to our relationship with the group that shapes us, to expectations of us based on assumptions, preconceptions, stereotypes and preset standards. Front on, it organizes color like a painting. On approach, you experience movement, soft containment and the carving of space. The back of the resin-painted bowls drip messily in ugly presentation on the work's front."

Unique, 2002,
Crocheted Fiberglass,
Polyester Resin, Enamel
103"h x 87"w x 15"d

"The group of flowers
uses a traditional doily
form called Teardrop.
Each of the 61 teardrops
were crocheted to be
exactly the same. I used
the same blue dye in the
resin in varied degrees.
After sanding, I used
Rust-o-leum Enamel to
paint over colors. The
work deals with subtle
differences. Much like a
community where
people appear to be the
same—same ethnicity,
same value system,
same dress code, etc.
Yet individuality still
appears."

Yvette Kaiser Smith was born in Prague, Czechoslovakia. She received her Bachelor of Fine Arts
from Southern Methodist University in Dallas in 1990 and her Master of Fine Arts from the
University of Chicago in 1994. Smith is the recipient of three Community Arts Assistance Program
grants from the City of Chicago. She was given the 'Best of Show Award' in the 2000 *Midwestern
Exhibition* at the Rockford Art Museum in Illinois, and the 'Connoisseurs Award' in the 2002 *North
American Sculpture Exhibition* in Golden, Colorado. She has exhibited nationally and in Moscow,
Russia. Her recent Chicago venues include Gallery 312, Illinois State Museum Chicago Gallery,
Contemporary Art Workshop, Rend Lake Gallery, The Three Arts Club, Evanston Art Center, and
the Chicago Cultural Center. She has also exhibited at the Indianapolis Art Center. In 2005 she will
be having a solo exhibition at Riverside Arts Center, Chicago.

DOUG SMITHENRY

"I recycle pictures found on the internet by using them as subject matter for my paintings. I like photographs of people staring back into the camera. I print these pictures and crumple up the ones with people. Then I take a rolling pin and flatten them back out, leaving creases wherever they occur. I spend a lot of time figuring out which picture of a person ought to go with which background. Finally I turn off the computer, go to my studio and start painting."

Doug Smithenry holds a Bachelor of Fine Arts degree in Painting and a Master in Art Education, both from the University of Illinois at Champaign-Urbana. He also earned a Master of Fine Arts in Painting from Washington University in St. Louis in 1991. From 2001 to 2003 Smithenry was awarded residencies at the Ragdale Foundation in Lake Forest, Illinois annually. He has had solo exhibitions at Aron Packer Gallery in Chicago and Atelier 31 Gallery in Seattle, both of which represent him, as well as at Coker College, South Carolina; Lakeland College, Wisconsin; Indianapolis Art Center; and Northeast Community College in Nebraska. Twelve of his painting were featured in the May 2003 issue of Harper's Magazine.

notthinkingstraightteenager
2003
Oil on Canvas
30"h x 12"w, 4 panels

"This teen's t-shirt proclaims that he can't even think straight. Now he can't even stand up straight."

floatingman, 2003
Oil on Canvas
24"h x 16"w, 4 panels

"A black and white image of a business man drifts through a dramatic sunset. His head acts as the centralizing point for the placement of his body."

astronaut, 2002
Oil on Canvas
36"h x 14"w, 4 panels

"The astronaut dangles with his feet in the sky on an upside-down waterscape of a lake and mountains."

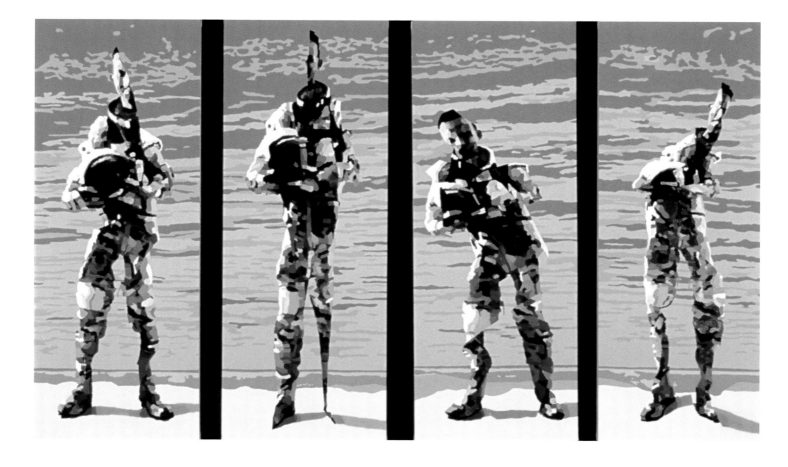

NATASHA SPENCER

"The tactile qualities of various types of synthetic hair become the catalyst for an exploration of line, shape, texture and form."

Coast Line
2003
Synthetic Hair, Nails,
Acrylic on Panel
40"h x 31"w

"The springing curls are stretched taut across a support with ends that are frayed to form a mass of fuzz. This visual correlation between medium and subject matter become a metaphor for man's persistent treatment of the landscape as ornament rather than something for which we have custodial responsibility."

Constellation #1

2002
Synthetic Hair, Pins,
Acrylic on Panel
12"h x 12"w
Private Collection

Natasha Spencer received her Bachelor of Fine Arts from the Cleveland Institute of Art in 1994, and her Master of Fine Arts in Time Arts from The School of the Art Institute of Chicago in 1998. She is the recipient of many awards, grants, and scholarships, including a 2000 Video Lab residency at the Wexner Center for the Arts in Columbus, Ohio where she produced *The House She Flew In On* and *Somewhere.* Her work has been screened internationally. *The House She Flew In On* was recorded at the Video Lounge in New York City and the audio portion of the piece was included in a compilation CD, *Extracted Celluloid,* produced by Illegal Art, Records and RtMark.

Aside from showing her work at Zg Gallery, which represents her, Spencer has exhibited at the Evanston Art Center in Illinois, Standard Gallery in Chicago, Gallery 222 in Grand Rapids, Michigan, and the Pittsburgh Filmmakers' 30th Anniversary Exhibit.

JÖZEF SUMICHRAST

"I visualize a subject the way an architect would view a blueprint. There are top, sides, front and back views. I start with a drawing or a maquette two-dimensionally and then transform it into a three-dimensional sculpture. The original is created out of an industrial cardboard that is made for me. This cardboard is thin enough to bend, saw, file and laminate additional layers to create volume. Then the sculpture is cast into bronze."

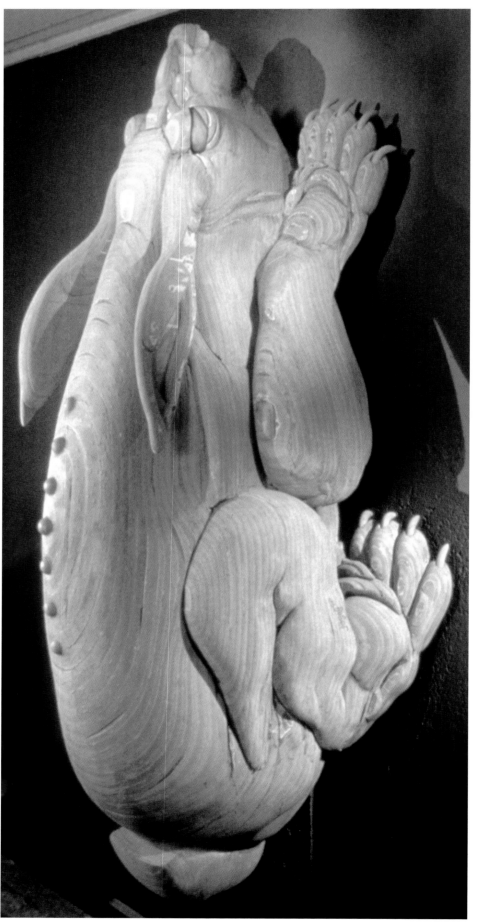

Wall Rabbit, 1997
Cardboard
62"h x 37"w x 30"d

"Sometimes when I work for a couple of days without sleep fatigue sets in. These are the times I see movement. Out of the corner of my eye a shape or object moves across the floor or falls from the ceiling. Recently one of these shapes was a large rabbit. This rabbit slid down the wall and disappeared. But its image remains with me. Whenever I see wall rabbits, I know it's time to get some sleep. The image came and vanished so quickly that I felt it needed an unfinished appearance."

"Sculpting in bronze is very dirty. I'm always cutting myself, getting dust in my lungs. I'm constantly working on a piece, filing and sanding it. But when it's finished, it's something incredible that will last a long time. There's a certain immortality in it. *Swimmer* was made in sections that were later bolted together. I had an accident the year before that required my legs to be reattached at the knees. The experience heightens my interest in anatomy."

Swimmer, 2001
Bronze, 7'w

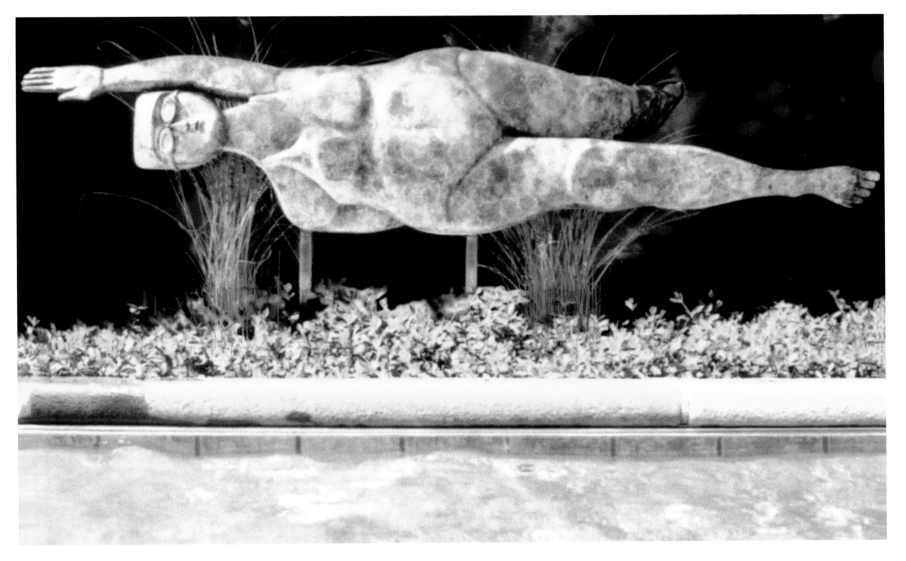

Józef Sumichrast attended Indiana University, Illinois Institute of Technology, and the American Academy of Art in Chicago. In 1974 he became a freelancer and has been ever since. His work has been showcased at the United Nations Building in New York, Evanston Art Center in Illinois, the Navy Pier in Chicago, Center National d'Art Contemporin et de Cultural Georges Pompidou in Paris, the *Toyamura International Sculpture Biennale* in Hokkaido, Japan, the *Sculpture Show* at Cantigny in Canada, and the *International Art Exhibition* in Cyprus.

BRUNO A. SURDO

"My paintings are allegories of modern life. Although the techniques I use are learned from the old Masters, my subjects are contemporary people grappling with the problems of daily living. The characters in these scenes live in separate worlds of self-involvement. They walk through crowded streets in isolation from one another. Some loudly call out for attention while others absorb themselves in their own private worlds."

Set It Free
2003
Oil on
Canvas
49"h x 46"w

Bruno Surdo attributes his interest in studying the great masters to his studies at the American Academy of Art in Chicago. In 1983 he enrolled in the Atelier Lack in Minneapolis, which is a school structured like the ateliers that flourished in western Europe in the 18th and 19th centuries. He later attended the Studio Cecil-Graves in Florence, Italy in 1997.

...And Life Goes By

2003
Oil on Canvas
76"h x 136"w

Surdo is the Founder and Director of the School of Representational Art and has been teaching there since its inception in 1992. This atelier is the only place where Chicago area students can study in a structured curriculum modeled after the schools of the great European masters. He has also taught at the Illinois Institute of Art since 1988, and gives lectures and critiques at other art institutions.

Surdo has had numerous solo exhibitions at Ann Nathan Gallery, which represents him in Chicago. In 1995 the Chicago Department of Cultural Affairs sponsored a show of his works entitled *Life, Struggle and Hope*, which featured his *AIDS Triptych* and his *Right to Bear Arms*. In 1997 he created a 20' x 30' mural for the College of Lake County Cultural Arts Center. In 2002 his *Re-emergence of Venus* was shown at the Arkansas Arts Center. Other recent exhibitions were held at Navy Pier in Chicago, Frye Art Museum in Seattle, and Koplin Gallery in Los Angeles. Surdo is also represented by Acadia Gallery in New York City.

 JILL SUTTON

"This series began with an old scrapbook containing newspaper clippings and photos of my grandmother with the various Chicago dance troops she was with in the 1930s. What struck me was the visual language surrounding the dancers. The photos reveal costumed women on stage, balancing on large decorated balls. In these paintings I have removed the dancers and have therefore shifted the subject to the balls."

(opposite)
Ball 3 (Green)
2002
Oil on Canvas
42"h x 42"w

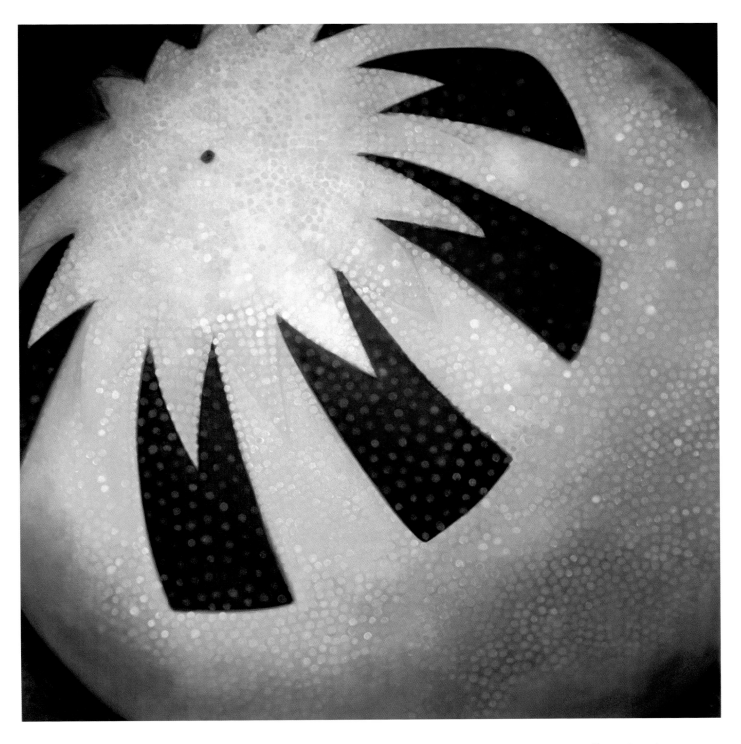

Jill Sutton received her Bachelor of Fine Arts from Washington University in St. Louis in 1992 and her Master of Fine Arts from California College of Arts and Crafts in San Francisco in 1995. She has taught at the Old Town Triangle Association in Chicago, Civic Arts Education in Walnut Creek, California, Laumeier Sculpture Park in St. Louis, and is now teaching at the Evanston Art Center in Illinois.

Sutton has had solo and two-person exhibits at Gallery V in Columbus, Ohio, as well as at Illinois locations such as University of Illinois at Chicago, Triangle Gallery of Old Town, Barrington Area Arts Council Gallery, and Saint Xavier University. She has also shown at the San Francisco Museum of Modern Art Rental Gallery, and at Gallery 2 of The Art Institute of Chicago.

Ball 2 (Star)
2002
Oil on Canvas
42"h x 42"w

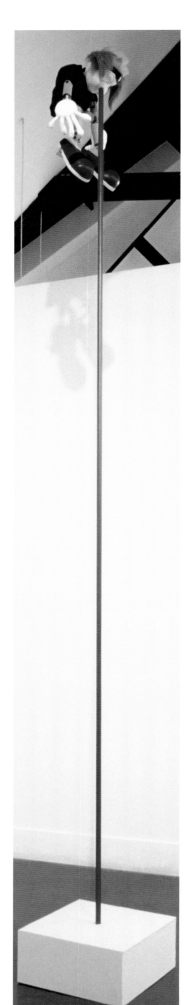

ATSUSHI TAMEDA

"My work focuses on feelings of intellectual uncertainty and fear. They are often inspired by modern films and animations where a sudden birth leads to the horrors of life. Memories and experience of my childhood also play a vital role in my work."

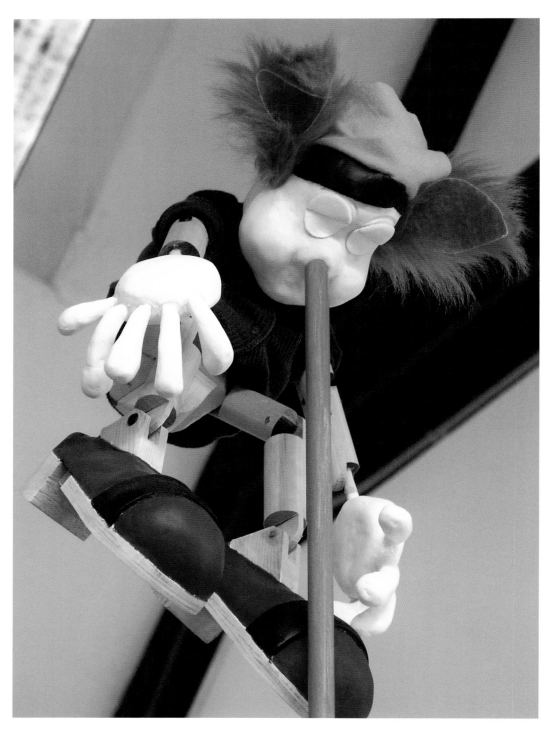

"Suicidal Pinocchio is a tragedy about the unwilling life of a boy. He lies to no one but himself."

Suicidal Pinocchio, 2002
Wood, Plaster, Modeling Foam, Metal Tube
110"h x 20"w x 20"d

No man dies for what he knows to be true...
Installation, 2002
Birth Note, Binoculars, Toilet Paper, Canvas Boxes, Moving Image, Sound

"This installation has a two-minute moving image and a sound. It addresses the memories of my childhood, of my parents, and feelings of expectations, betrayal and escape."

Atsushi Tameda holds a Bachelor's degree from Nihon University College of Art in Tokyo, Japan, two Master's degrees from The Nottingham Trent University and the University of Newcastle upon Tyne in England. After his recent graduation from the MFA program at the University of Chicago, he moved to Los Angeles.

Tameda has shown his work at the Tokyo Metropolitan Museum in Tokyo. His work has also been exhibited at numerous galleries in England, such as Waygood Gallery and Globe Gallery in Newcastle, Gallery CUBE in Manchester, RIBA Gallery in London, and The Lighthouse in Glasgow. Recently he has exhibited at the Smart Museum and ATC Space in Chicago.

CHARLIE THORNE

"It started with a gallery on the West Coast calling for entries to a 'petite show'. There was a 12" maximum but I felt I wanted to go more petite than that. I asked myself 'What is the biggest thing I can put in the smallest thing I can think of?' I had the answer immediately—the Sears Tower in a lipstick tube. I use techniques of paper modeling well known in Europe. Coloring is done with graphite, colored pencil, inks and watercolors. I am now approaching the completion of 100 of these micro-sculptures. "

(left)
The Chrysler Building, New York
2003, Constructed Relief Drawing, Ink
$1^{5/8}$"h x $^{1}/_2$"w

"The beauty of this Art Deco icon with its chrome-nickel spire is complimented by the banded silver case that contains its replica."

(right, top)
Chicago Tribune Building, 2002
$1^{5/8}$"h x $^{1}/_2$"w

"This Gothic beauty from 1925 was a challenge to model. I melded the octagon crown into the square building by alternating flat spans of windows on the sides of the building with bay windows at the corners."

(right, bottom)
Chicago Water Tower, 2001
$1^{5/8}$"h x $^{1}/_2$"w

"This landmark is the well-known survivor of the Great Chicago Fire of 1871."

(left, top)

White Lighthouse, 2003

$1^{5/8}$"h x $^1/_2$"w, Private Collection

"Based loosely on Evanston's Grosse Point Lighthouse. The 'glass' housing around the beacon is the material from the window of an envelope."

(left, bottom)

Phone Booth, 2004

$1^{5/8}$"h x $^1/_2$"w

"The discerning viewer will notice the empty whisky bottle tossed on top of the booth. The 'glass' is the cellophane from a pack of cigarettes."

(right, top)

Home from the Office, 2004

$1^{5/8}$"h x $^1/_2$"w

"This shows how people shed their daytime personas when they get home. This home has a parquet floor and a modern chair. On the seat is a stainless steel travel mug and some mail. The rolled-up newspaper has fallen next to the attaché case."

(right, bottom)

Palm Tree, 2000

$1^{5/8}$"h x $^1/_2$"w, Private Collection

"This was an early commission."

Charlie Thorne was born in Bensenville, Illinois. His first recognition as an artist came when a class assignment ended up in a Red Cross-sponsored exhibit of youth art around the world. Later he moved to Chicago's north side to attend the American Academy of Art. His oil pastels are shown in many Chicago area locations. In response to a call for artwork for a 'petite show' in the West Coast in 1995, he began constructing micro sculptures contained in lipstick cases. Belloc Lowndes Fine Art became aware of this art while selecting work for the 1999 group show of artists from the book, *The Chicago Art Scene,* and has since brought his lipstick art to New York, San Francisco, Palm Beach, Montreal and London.

 # TREEWHISPERS
PAMELA PAULSRUD & MARILYN SWARD

"Trees speak in whispers...we are sure of it. Treewhispers is an installation involving paper, art and stories relating to trees as a symbol and resource. We gather round pieces of handmade paper from an international association of hand papermakers and calligraphers, and from families at Chicago's Field Museum, adults at the Morton Arboretum, children at Kohl's Children Museum, inner city schools and university art galleries. People make the paper from recycled tree pulp and they share their stories and images of trees on the handmade paper. This paper is bound together to create large tree assemblages and ultimately a forest. This is what trees around the world say to each other and to us. We have been gathering it for five years."

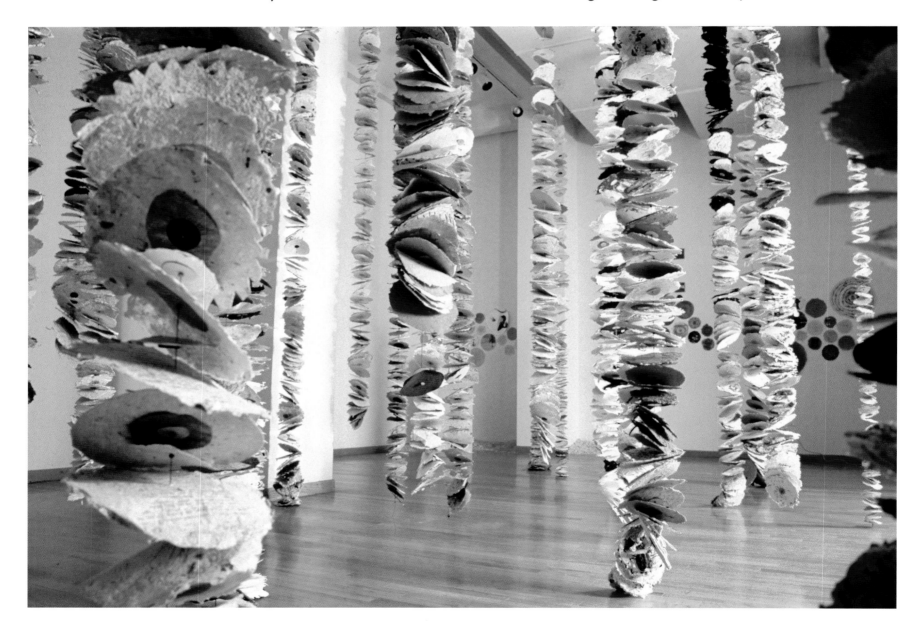

Treewhispers

Installation, 2001

Handmade paper

Individual Work
(counterclockwise from top right)

Keep a Green Tree,
Catherine Whiteman, Scotland
Bob, Stacey Shintani, Chicago
One Touch of Nature...
Tree of Knowledge, Debbie Wilson,
Guelph, Ontario, Canada
Stories from *Bookmarks* event at
Link's Hall, Chicago
Works from *It's Wild in Chicago*,
a festival celebrating the environment
at the Field Museum, Chicago

Pamela Paulsrud received her Master of Fine Arts from Columbia College in Chicago with a concentration in Book and Paper. She freelances and teaches workshops in lettering and book arts. Her work can be seen on the ceramic floor map in the *Traveling the South Pacific* exhibit at the Field Museum, in the *Letter Arts Review,* in the Rockport publication *Making Memory Books by Hand,* and in the permanent collection of the Newberry Library in Chicago.

Marilyn Sward is the founder and former Director of the Columbia College Center for Book and Paper Arts. She has recently retired from teaching in the Fiber Department of The School of the Art Institute of Chicago. She is on the board of advisors of *Haystack, Hand Papermaking Magazine,* and is a member of the International Association of Hand Papermakers. Her work is in private and public collections in the U.S. and abroad.

BETH WEISGERBER

"Ultimately I want my paintings to mirror the murkiness of life, where the process of moving forward creates both stability and uncertainty. This activity demands acceptance of conflicting viewpoints and the resolution of opposing languages. I often stop when the canvas reflects a hopeful future."

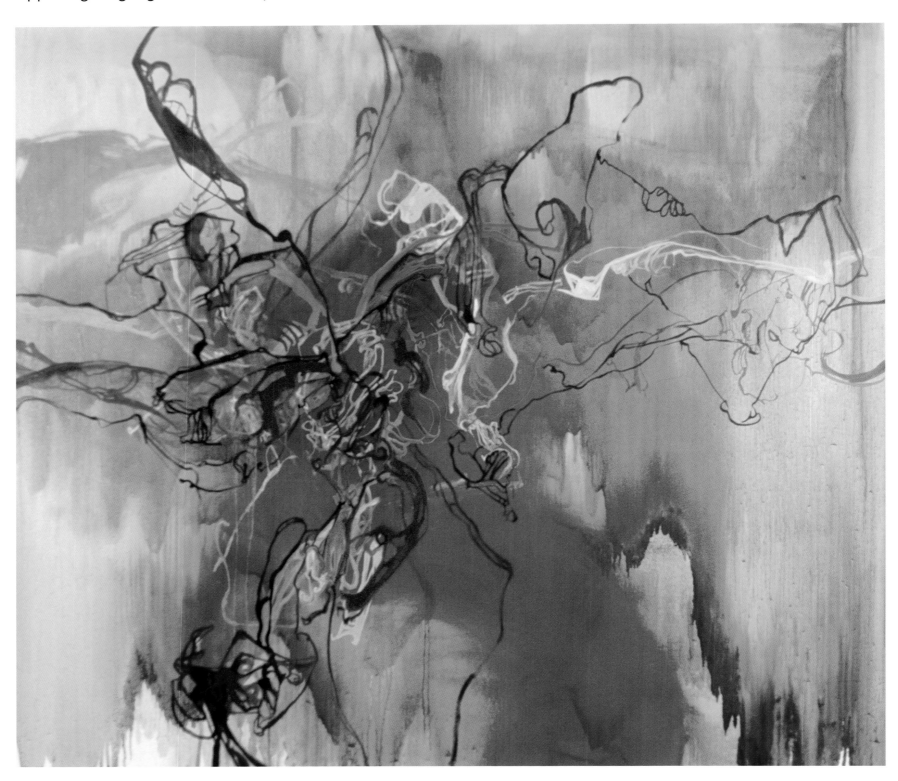

Stratospheric Hope, 2003, Oil on Canvas, 60"h x 70"w

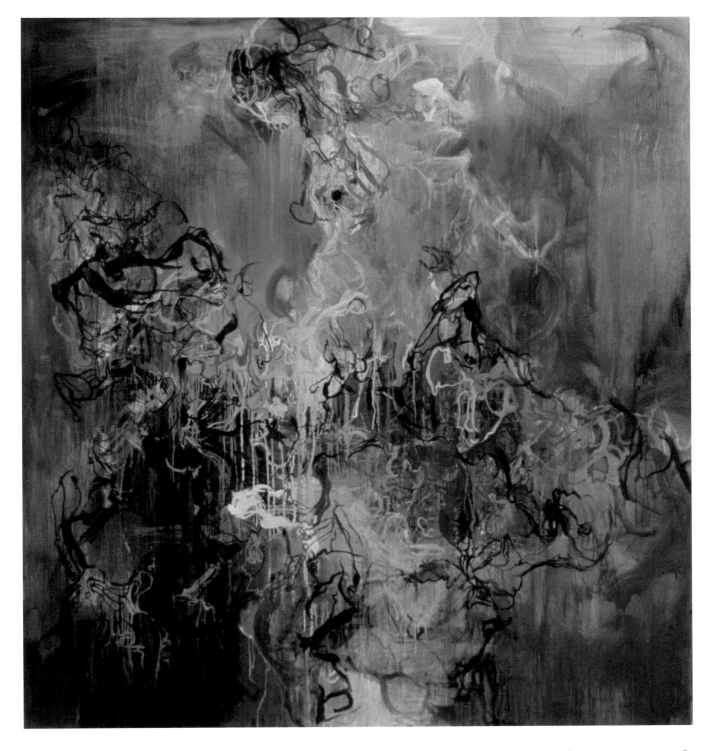

Elastic Cleft
2001
Oil on Canvas
68"h x 64"w

"Finding form in paint is like stuttering to find the right words for a thought. *Cleft* alludes to this teetering at the edge of a precipice or thought, which may be at the tip of your tongue."

Beth Weisgerber received her Bachelor of Fine Arts from University of Cincinnati in 1997 and her Master of Fine Arts from Virginia Commonwealth University in Richmond in 2001. She was the Assistant Director at Rena Sternberg Gallery in Glencoe, Illinois before moving to White Plains, New York. In 2003 she taught drawing at Moraine Valley College in Palos Hills, Illinois.

Weisgerber has had solo exhibitions at 840 Gallery in Cincinnati, Malovat Gallery in Chicago and the University of Illinois at Chicago. Her work was exhibited at the Painting Center in New York, St. Mary's College of Maryland, and Unit B Gallery in Chicago. In 2004 and 2005, her work is in a traveling exhibit, *Pivot Points*, from Virginia Commonwealth University to The Peninsula Fine Arts Center in Virginia, Phillips Academy in Massachusetts, and Galeria ICPNA Miraflores in Peru.

ERIC WERT

"I love science fiction and horror movies. They often depict fear and anxiety towards nature and the unknown. In everyday urban experience, plants are used as harmless decorations that make us feel comfortable and safe until you look at them closely."

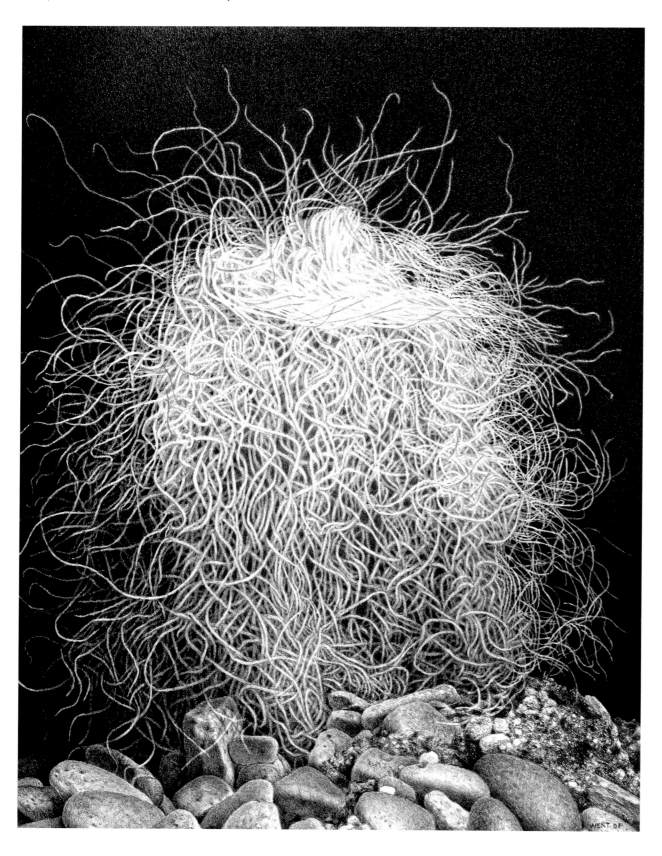

Hairy Cactus
2001
Graphite on Paper
13"h x 10"w

"I bought the cacti in these drawings in the garden department of a Home Depot. Every cactus has its own unique character and peculiarities. I exaggerate those visual qualities that are the most interesting."

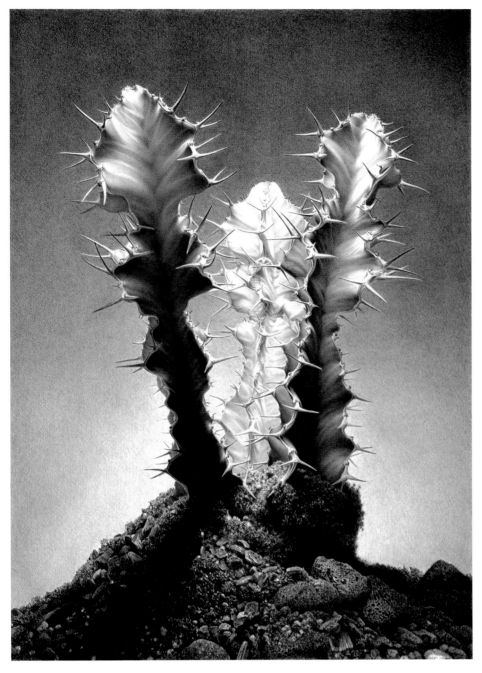

Visitation
2003
Graphite on Paper
30"h x 20"w

Eric Wert received his Bachelor of Fine Arts from The School of the Art Institute of Chicago in 1997 and his Master of Fine Arts from Northwestern University in Illinois in 2001. He was a Scientific Illustrator at the Field Museum of Natural History in Chicago, and has taught at Moraine Valley Community College in Palos Hills, Illinois.

Wert has had solo exhibitions at the Contemporary Art Workshop in Chicago and at gescheidle, which represents him. He has also exhibited at various Illinois locations including the International Museum of Surgical Science, the Union League Club, and Aron Packer Gallery in Chicago, Suburban Fine Arts Center in Highland Park, and Evanston Art Center. In 2002 he participated in the *International Triennial of Drawings and Works on Paper* at Ostrobothnian Museum in Finland. He is also represented by Klaudia Marr Gallery in Santa Fe, New Mexico.

White Poinsetta
2003
Oil on Canvas on
Panel
24"h x 48"w

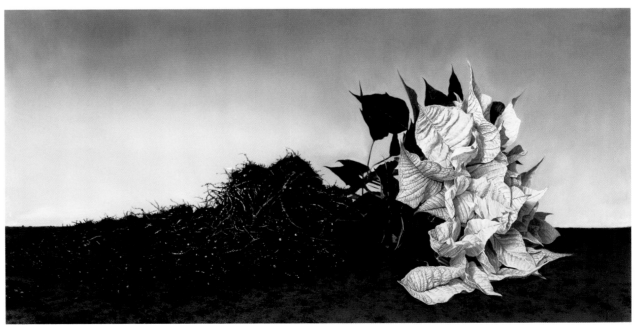

ANN WIENS

"I am interested in disrupting the viewer's perception by asserting the background against the central subject, and having a deliberate play between the animals' markings and color and those of the background."

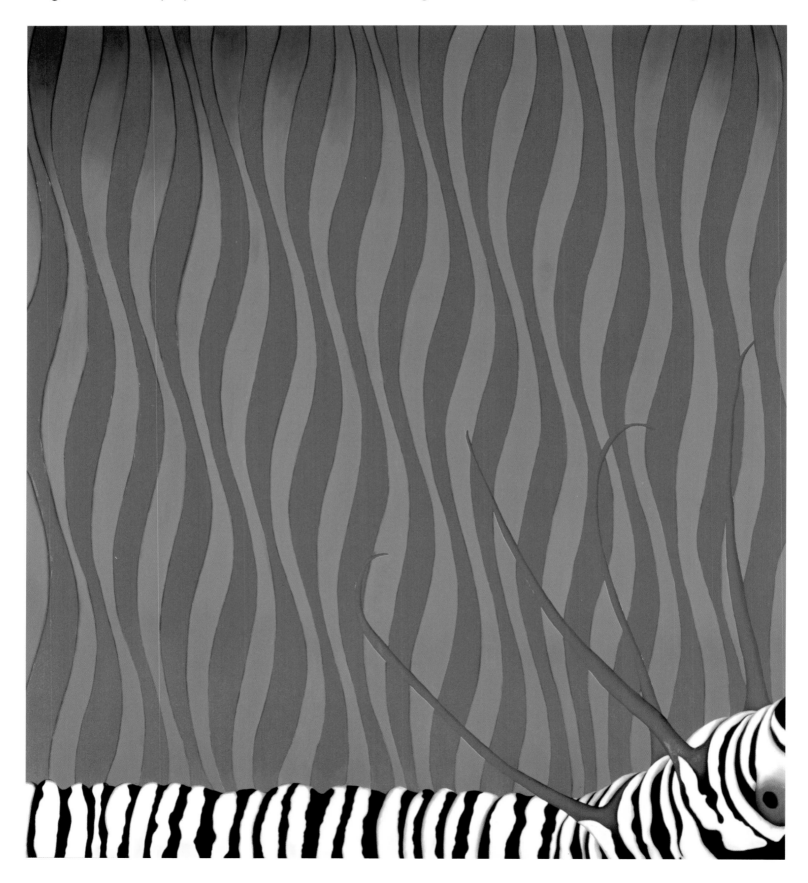

(opposite)

Queen, 2001

Oil on Panel

40"h x 36"w

"This is the larva of a Queen butterfly. It is just a slice along the bottom, causing it to flip between a recognizable animal and a purely visual element."

(right)

Swallowtail II

2001

Oil on Panel

14¹/₂"h x 14"w

"I paint caterpillars, salamanders and beetles because they are fantastically formed, colored and patterned."

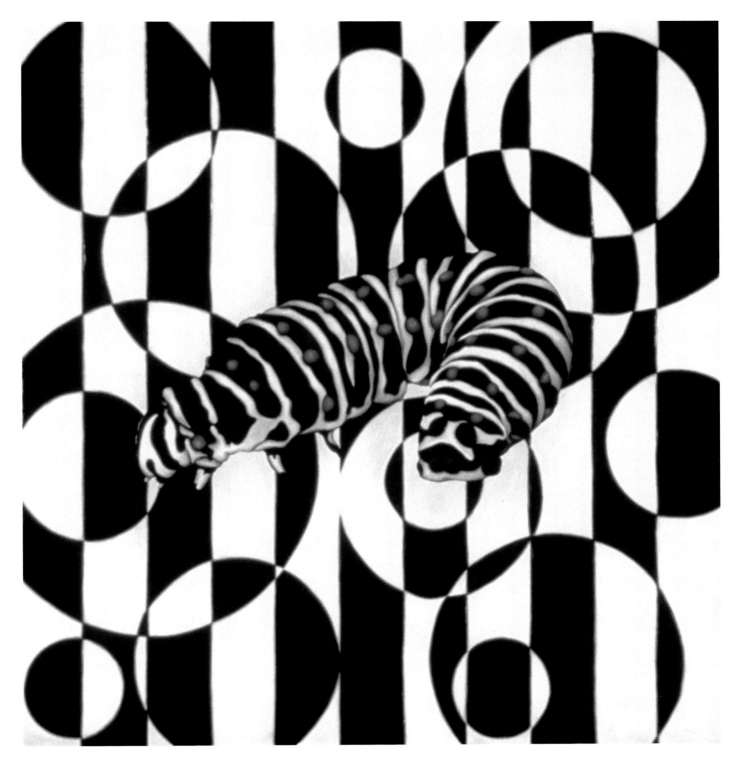

After studying art and journalism at the University of Oklahoma, Ann Wiens transferred to The School of the Art Institute of Chicago and received her Bachelor of Fine Arts in 1986. She received her Master of Fine Arts in Painting from the State University of New York at Stony Brook in 1990. Upon her return to Chicago, she became the East Coast Editor of the *New Art Examiner*. Wiens went on to serve as Senior Editor of the *Examiner* until she left in 1998 to focus on her art and freelance writing. She has contributed to other publications such as *dialogue, Chicago Magazine, CS, The Chicago Collection,* and *New City,* where she served as art critic from 1998 to 2000. Wiens has shown her work recently at The Cliff Dwellers, Lyons Wier Gallery, and Byron Roche Gallery in Chicago, which represents her. In 2004 she completed a series of five site-specific paintings for the Chicago Center for Green Technology, and was commissioned for a permanent installation at Columbia College, Chicago.

DANN WITCZAK

"Reminiscent of mountain peaks, seascapes and crests of waves, my work draws inspiration from nature. I respond to it by transforming its essential visual properties into a new experience."

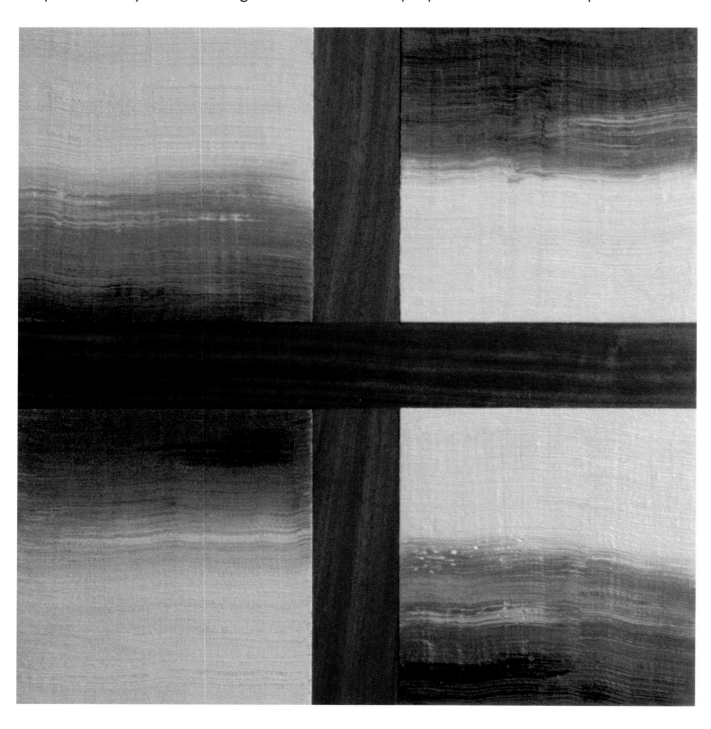

Reflection

2000

Oil on Linen with Padauk Wood

24"h x 24"w

(opposite, top)
To and Fro
2001
Oil on Linen
13"h x 13"w each
43" x 73" overall

"A black and white palette allows the stroke of the brush to play a key role in creating light and space. By implying a sculptural presence through the handling of paint, an illusion of volume is created and a sense of depth achieved. Multiple panels both fracture and unite the imagery, implying movement while freezing it in time."

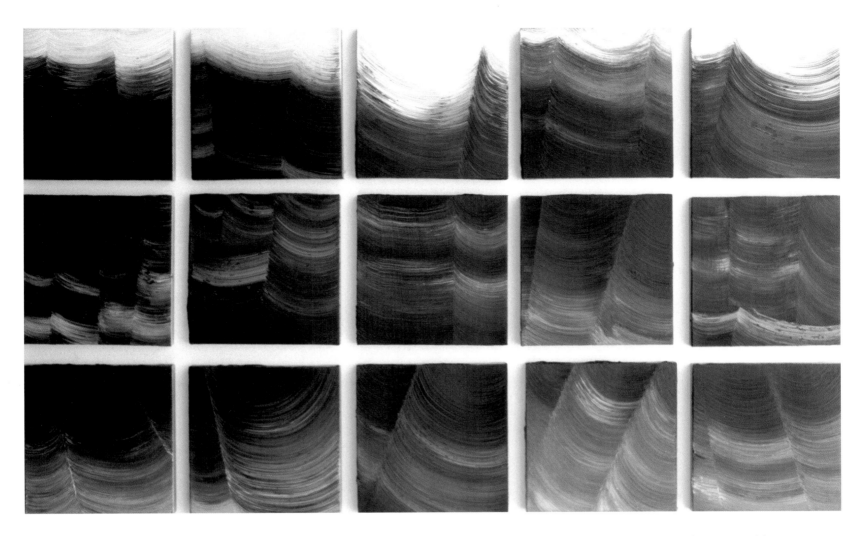

(right)
Spring Light
2003
Acrylic, Dowel
Rods on Panel
14½"h x 14½"w

"This series of painted constructions changes form as the viewer moves past, much like how our perception changes with light and the movement of nature."

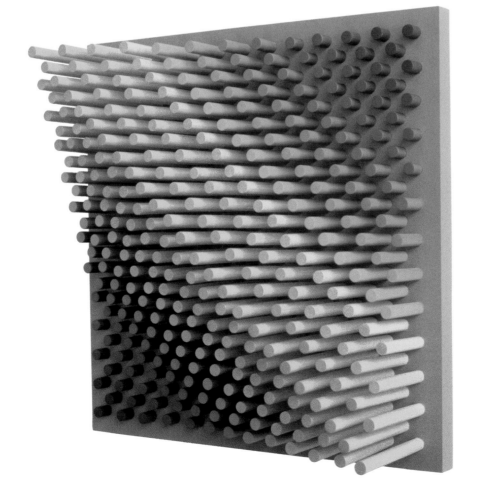

Dann Witczak received his Bachelor of Arts from the Cleveland Institute of Art in 1988. He has received numerous grants and fellowships including a Fellowship from the Andy Warhol Foundation. Witczak has had solo exhibitions at Zg Gallery in Chicago, which represents him. In recent years he has also exhibited at various Illinois venues such as ARC Gallery, Northeastern Illinois University and Loyola University Medical Center in Chicago, Wesleyan University in Bloomington, Elmhurst Art Museum, and Evanston Art Center. His work is in many private and corporate collections.

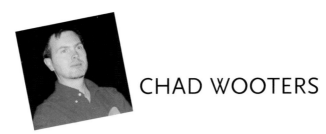

CHAD WOOTERS

The Caulk Gun

2002

Oil on Canvas

16"h x 20"w

"It's amazing that something with so much personality can be purchased at any hardware store. Its blue finish, though besmirched with patches of dirtied sealant, shines brilliantly. The strong precise verticals of the wind-chimes and the dramatically torn top of the grout encourages the eye to move in and around the arrangement."

(left)
The Twine
2003
Oil on Canvas
16"h x 20"w

(below)
Oil Can and Vice
2002
Oil on Canvas
16"h x 20"w

"This was the first of the 'manly' still life series, something besides fruits-in-a-bowl and flowers-in-a-vase."

Chad Wooters was born and raised in central Iowa. He received his Architecture degree from the Illinois Institute of Technology in 1989. He also studied printmaking at Harold Washington College in Chicago, and oil painting techniques at Expressions Graphics in Oak Park and the Palette and Chisel Academy in Chicago. In 2001 he toured the Gamblin paint factory and has since used Neo-Meglip in his paintings. Wooters had his first solo show at Expressions Graphics in 2001. He has exhibited in group shows with the Elmhurst Artists' Guild and at various regional juried shows. He is represented by the Illinois Artisans Shop in Chicago, The Steeple Gallery in St. John, Indiana, and Legacy Art in Columbia, Missouri.

Directory of Artists

Name	From/To	Gallery Representation	Telephone	E-Mail Address/Web Site
Bardusk, Maureen		Vale Craft Gallery, IL Illinois Artisans Shop, IL Green Lantern Studios, WI Gallery 323, WI	(815) 777-1242	maureenbardusk.com
Barlow	Indiana/	Nicole Gallery, IL	(773) 356-7251	slystone@ameritech.net
Bartone, Curtis	/Georgia	Byron Roche Gallery, IL	(312) 654-0144 (g)	byronroche.com
Basick, Christine			(312) 922-4938	christinebasick.com
Bent, Geoffrey			(630) 260-5869	jalexander5870@yahoo.com
Bullock, Scott	So. Carolina/	Byron Roche Gallery, IL	(312) 654-0144 (g)	byronroche.com www.penumbrastudios.net
Bumiller, Trine	Ohio/Colorado	Zg Gallery, IL Robischon Gallery, CO	(312) 654-9900 (g)	zggallery.com
Butler, Ben	/Maine, New York	Zg Gallery, IL	(312) 654-9900 (g)	zggallery.com
CarianaCarianne	New York/New York		(773)425-3726 cell	polvo.org/carianne.html
Chidester, Paul	Maryland/Ireland, Pennsylvania	Zg Gallery, IL	(312) 654-9900 (g)	zggallery.com
Cole, Grace		Fine Arts Building Gallery, IL Malovat Gallery, IL Anne Loucks Gallery, IL Portraits, Inc., NY	(312) 362-9890	gvecole@aol.com gracecole.com
Comnick, Julie	Ohio/Arizona	Zg Gallery, IL	(312) 654-9900 (g)	zggallery.com juliecomnick.com
Contro, Antonia		Carrie Secrist Gallery, IL	(312) 491-0917 (g)	artnet.com
Cooper, Barbara	Ohio/		(773) 784-4832	barcooper@earthlink.net
Cosnowski, Chris	So. Carolina/	Gescheidle, IL Lyonswier Gallery, NY Dolby Chadwick Gallery, CA	(312) 654-0600 (g) (212) 242-6220 (g) (415) 956-3560 (g)	gescheidle.com lyonswiergallery.com dolbychadwickgallery.com
Culver, Sean			(773) 604-4733	seanculver.com
Davis, Rachel		Zg Gallery, IL	(312) 654-9900 (g)	zggallery.com
Dawson, Sandra		Byron Roche Gallery, IL	(312) 654-0144 (g)	byronroche.com
Deal, Melanie	Indiana/		(847) 570-0815	melaniedeal@comcast.net
Dettmar, Brian		Aron Packer Gallery, IL	(312) 226-8984 (g)	aronpacker.com
Emser, Bob		Modern Sculpture Services, IL	(773) 551-8897	bobemser.com

Name	From/To	Gallery Representation	Telephone	E-Mail Address/Web Site
Fisher, Beatrice	Michigan/	Gillock Gallery, IL	(847) 864-3799 (g) (847) 869-2098	gillockgallery.org beatricef@aol.com
Grossfeld, Katherine	Colorado/ North Carolina	Byron Roche Gallery, IL	(312) 654-0144 (g)	byronroche.com
Hall, Susan	Michigan/	Melanee Cooper Gallery, IL Butters Gallery, OR Lyonswier Packer Gallery, NY	(312) 202-9305 (g)	melaneecoopergallery.com
Heinz, Cynthia Hellyer			(630) 393-1071	cynthiahellyerheinz.com
Henderson, Mary	California/ Pennsylvania	Zg Gallery, IL	(312) 654-9900 (g)	zggallery.com
Hild, Nancy	Ohio/Illinois, Mexico		(773) 278-9233	nancyhild@hotmail.com
Huss, Nikkole			(773) 343-9900	nikkolehuss.com
Igor & Marina	Russia/	Thomas Masters Gallery, IL Lisa Kurts Gallery, TN Fay Gold Gallery, GA Artemise Gallery, France	(847) 869-1364	igor-marina.com
Jacobsen, Gregory	New Jersey/	Zg Gallery, IL	(312) 654-9900 (g)	zggallery.com
Kedzior, Beverly		Kraft Lieberman Gallery, IL	(312) 948-0555 (g)	KLFineArts.com
Kina, Laura	Washington/	Diana Lowenstein Fine Arts, FL	(773) 671-6601	laurakina.com
King, Kathleen		Viridian Artists @ Chelsea, NY Fine Arts Building Gallery, IL The Steeple Gallery, IN	(212) 414-4040 (g) (312) 913-0537 (g) (219) 365-1014 (g)	viridianartists.com fabgallery.com thesteeplegallery.com
Kriese, Niki	Wisconsin/		(773) 486-5981	nikikriese.com
Kulla, Roland	Missouri/	Fine Arts Building Gallery, IL Aron Packer Gallery, IL George Billis Gallery, NY The Steeple Gallery, IN	(312) 913-0537 (g) (312) 226-8984 (g) (212) 645-2621 (g) (219) 365-1014 (g) (773) 324-2549	fabgallery.com aronpacker.com georgebillis.com thesteeplegallery.com kulla@ameritech.net
Leinberger, Rena	Michigan/ New York	Zg Gallery, IL	(312) 654-9900 (g)	zggallery.com
Licht, Sydney	New York/ New York	gescheidle, IL	(312) 654-0600 (g)	gescheidle.com
Macdonald, Shona	Scotland/		(773) 342-8430	shonamacdonald.com
McGinnis, Renee			(773) 227-0702	reneemcginnis.com
Mladenoff, Nancy	Wisconsin/	Aron Packer Gallery, IL Wendy Cooper Gallery, WI	(312) 226-8984 (g) (608) 287-1100 (g)	aronpacker.com wendycoopergallery.com

Name	From/To	Gallery Representation	Telephone	E-Mail Address/Web Site
Mr. Imagination	/Pennsylvania	Koelsch Gallery, TX Grey Carter Object of Art, VA Primitive Kool, CA Home and Planet, PA	(713) 626-0175 (g) (703) 734-0533 (g) (619) 222-0836 (g)	koelschgallery.com greyart.com primitivekoolart.com mrimagination@verizon.net
Perlow, Sandra		Gallery 72, NE Morgan Gallery, MO	(312) 922-9511	sandraperlow.net
Pieritz, Deborah		Fine Arts Building Gallery, IL	(708) 848-3308	pieritz@excite.com
Semelroth, Eric			(847) 534-0176	esemelroth@hotmail.com
Smith, Vanessa	Ohio/		(312) 939-6949	vlynn58@hotmail.com
Smith, Yvette Kaiser	Czechoslovakia/		(773) 395-2981	kaisersmith.com
Smithenry, Doug		Aron Packer Gallery, IL Atelier 31 Gallery, WA	(312) 226-8984 (g) (206) 448-5250 (g)	aronpacker.com atelier31.com
Spencer, Natasha	Ohio/	Zg Gallery, IL	(312) 654-9900 (g)	zggallery.com
Sumichrast, Józef	Indiana/		(847) 295-0255	jozef.com
Surdo, Bruno		Ann Nathan Gallery, IL Arcadia Gallery, NY	(312) 664-6622 (g) (212) 965-1387 (g) (847) 491-6630	annnathangallery.com arcadiafinearts.com representational-art.com
Sutton, Jill	Ohio/		(773) 973-5652	chicagoartnow.com
Tameda, Atsushi	Japan/California		(773) 301-1677	tameda@yahoo.com
Thorne, Charlie		Belloc Lowndes Fine Art, IL	(773) 486-0076	
Treewhispers - Paula Paulsrud - Sward, Marilyn	Iowa/		(847) 251-5381 (847) 492-9647	treewhispers.com
Weisgerber, Beth	Ohio/New York		(914) 397-0021	bethweisgerber.net
Wert, Eric	Oregon/	gescheidle, IL Klaudia Marr Gallery, NM	(312) 654-0600 (g) (505) 988-2100 (g)	gescheidle.com klaudiamarrgallery.com
Wiens, Ann	Colorado, New Mexico, Oregon/	Byron Roche Gallery, IL	(312) 654-0144 (g)	byronroche.com
Witczak, Dann	Ohio/	Zg Gallery, IL	(312) 654-9900 (g)	zggallery.com
Wooters, Chad	Iowa/	Illinois Artisans Shop, IL The Steeple Gallery, IN Legacy Art & Book Works, MO	(312) 814-5321 (g) (219) 365-1014 (g) (573) 442-0855 (g) (630) 279-8057	thesteeplegallery.com legacyart.com chadwooters.com

The From/To column indicates where the artist grew up before coming to Illinois, and to where he/she has moved, if applicable.
(g) means the telephone number belongs to the gallery.